TRAMP

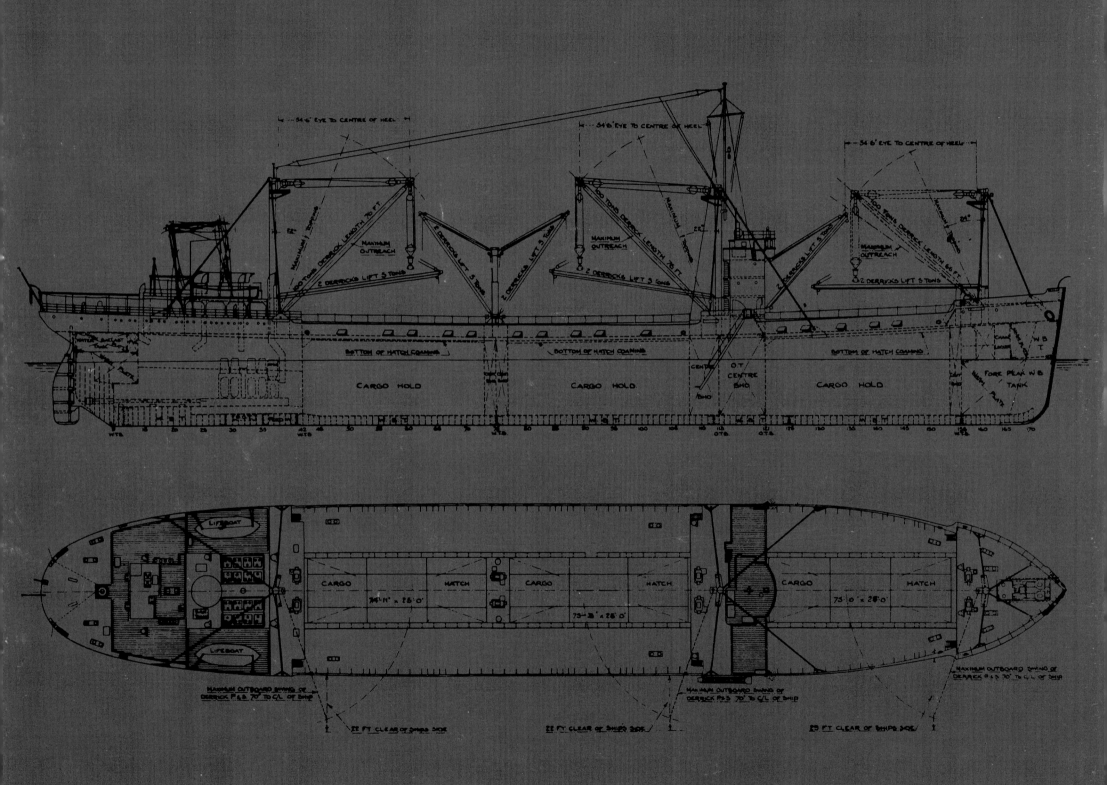

TRAMP

*Sagas of High Adventure
in the Vanishing World
of the Old Tramp Freighters*

Michael J. Krieger

Photography by Judy Howard

Chronicle Books • San Francisco

Library of Congress Cataloging-in-Publication Data

Krieger, Michael J.
 Tramp : sagas of high adventure in the vanishing
world of the old tramp freighters.

 Includes index.
 1. Tramp steamers. I. Title.
HE566.T7K75 1986 387.5'44 86-9699
ISBN 0-87701-343-8

Printed in Japan.

Book and cover design: Dana Levy, Perpetua Press
Typography: Continental Typographics Inc.

Distributed in Canada by
Raincoast Books
112 East 3rd Avenue
Vancouver B.C.
V5T IC8
10 9 8 7 6 5 4 3 2 1

Chronicle Books
One Hallidie Plaza
San Francisco, CA 94102

CONTENTS

To Alfred P. Krieger, Comdr. USNR, Ret.,
a fine sailor, a great man

PREFACE

There are fewer large, old oceangoing freighters (built before 1940) still in existence than there are square-rigged sailing ships. A greater number of small prewar cargo vessels and some built in the twenty years following World War II still operate, but they are on their way out, as well. Their replacements are automated, computerized, specialized freighters, which resemble the old tramps only superficially and are as different from them as a supersonic Concorde is from a 1914 biplane.

This book is about the old ships. Incorporated into their stories are those of the men who sail them in the traditional way, without computers and push buttons, the people and companies who own them, as well as the isolated communities that depend on these men and their vessels. The sailors and the communities are in many cases as unique as the ships themselves. With vessel modernization comes a different, more technologically oriented sailor. With the spread of tourism to remote corners of the world comes contemporary development until those remote places become homogenized replicas of their urban counterparts. So it is not just the ships but the entire subcultures surrounding them that are disappearing.

A tramp freighter is one that sails on no scheduled route but travels when and to wherever the owner or agent can find it a cargo. Some of the vessels in this book may not technically be operating as tramps, but all have operated that way and all carry the spirit of the tramp freighter. I hope this book will help preserve a little of that spirit.

Without the cooperation and assistance of the owners, agents, officers, and crews of the vessels, this book would never have been written. I wish to thank them all! I also thank the following for their help and encouragement: Peter Stanford, president of the National Maritime Historical Society; the Reverend Peter Van der Linden, editor of the *Detroit Marine Historian;* Douglas Pfaff, formerly managing director, Pacific Northwest Region, and Peter Boyce, managing director, Hong Kong, both of American President Lines; Lauritz Pettersen, director of the Bergen Maritime Museum; Capt. Unal Aksoz, Istanbul; Keith Sternberg, Lopez Island, Washington; Jerry Heermans, Tigard, Oregon; Richard Schuettge, Berkeley, California; and all the other people around the world who gave their assistance and friendship. I also extend my heartfelt appreciation to Carol Eriksen and Jackie Abbott for their diligent and perspicuous editing and typing of the manuscript. Last but not least, words do not convey my appreciation to Judy Howard, a fine photographer and traveling companion during five months of smooth and rough sailing.

FOREWORD

Just about a century ago, in the mid-1880s the tonnage of steamships under the British Red Duster overtook the tonnage of sailing ships. The same inevitable transition took place two decades later under the U.S. flag. Of the deepwater sailing ships that were driven from the world's oceans in the next decades, over a dozen have been preserved and can be seen today, including a few that still go out under sail.

Of the newfangled steamers that drove them from the sea, only two have been preserved for public exhibition: the little British coaster *Robin* (1899), maintained by Great Britain's Maritime Trust in London and the Liberty ship *Jeremiah O'Brien* (1943) preserved by the National Liberty Ship Memorial at Fort Mason, San Francisco. The day of the steam-driven tramp steamer—the ship that retired the sailing ship to the museums—is now ending. Soon you will search the seas in vain for her telltale smudge of coal smoke on the horizon. And the wheeze and thump of her gigantic reciprocating machinery spurting steam and smelling of hot oil will be as forgotten as the splash and heave of Jason's oarsmen.

The heavy, bluff-bowed products of the age of steam that changed the shape of the world with their varied traffics around its oceans—and its lakes and rivers—had their admirers. Rudyard Kipling cherished workaday things and wrote a virtual hymn to the machine age at sea in his lovely "The Ship that Found Herself"—the story of a brawny young freighter learning her role in Atlantic gales. But not many cared as Kipling cared. Oh, there are Joseph Conrad's Captain McWhirr, and Guy Gilpatric's Chief Engineer Colin Glencannon of the S.S. *Inchcliffe Castle*, and there are other heroes of steamship sagas written by people with some feeling for the life. But not enough people have cared sufficiently about these ships as they steamed over time's horizon—you won't find one of the breed, not one, in New York harbor today.

And they were different, utterly different, from the huge motorized cargo liners, (tying together integrated transportation systems) that speed across the seas today, or the supertankers that have elevators to the superstructure and sensors to tell the people in the floating office tower when any part of the structure is in trouble.

The essence of the tramp steamer is her sturdy independence. She has near-complete independence of the wind which holds her sailing sisters in bondage; considerable independence of primitive shore facilities that often cannot cope with her machinery breakdowns (the achievements of tramp engineers in mending things for themselves are the stuff of legend); and as near as is possible to independence of the ultimate master, cargo, that is, if she can't find the cargo she came for, she'll go up the coast to another port to try her luck, or across the ocean she came over. She'll keep moving somehow, until she is finally pushed aside to die.

But a surprising number still live today, not in museums, but pursuing their ways in odd corners of a world that is so different from the world they were born into. In these pages you'll encounter copra traders in the Pacific Islands and others who pursue the age old ways of the tramp steamer in areas too remote and unprofitable for "liner" service by the giant container ships and computer-governed tankers and bulk carriers that move the lion's share of the world's cargoes today.

Rugged individualists and jacks of all trades are the people who drive these surviving tramp steamers. They have to be! No one is going to go to much trouble or expense to keep them running when their machinery fails or haul them off when a fogbank misleads their navigation systems. No one but the people whose lives are bound up in these aging ships and their vanishing ways.

But someone does care enough, and knows enough, to take you out to these ships, to bring you into their world, and let you share in their voyages and their people's lives. That person is Mike Krieger, tramp steamer man extraordinaire.

Mike Krieger, when he was still in his twenties, chartered tramp steamers himself. He took them up the jungle rivers of Sumatra to buy logs from the Indonesian government and shipped them to Taiwan and Singapore. He usually sailed aboard the ships since everything he had was invested in their cargoes. But let Mike himself explain, "I found myself working and living aboard the old European prewar built steamers as they thrashed their way through the jungle rivers into central Sumatra. Sometimes loading would take as long as three weeks, so I came to know the men and ships well. The throb of those giant connecting rods pulsates through me, still! And the men, they were of another age, too. Old China hands, many of them—mostly Scandinavian officers and Chinese crews." Mike's later career did not involve him personally in shipping, but he never forgot his early experiences.

What he has done for the tramp steamer and her people and their way of life is a boon to history, and may play a vital role in saving some of that history before it is too late. But a real treat is in store for you! In these vividly colorful, accurately recorded pages you'll find that the immediate—and lasting—boon is to you, the reader.

Cast off for'ad there, and let Mike Krieger's engines take up the beat!

Peter Stanford
President
National Maritime Historical Society

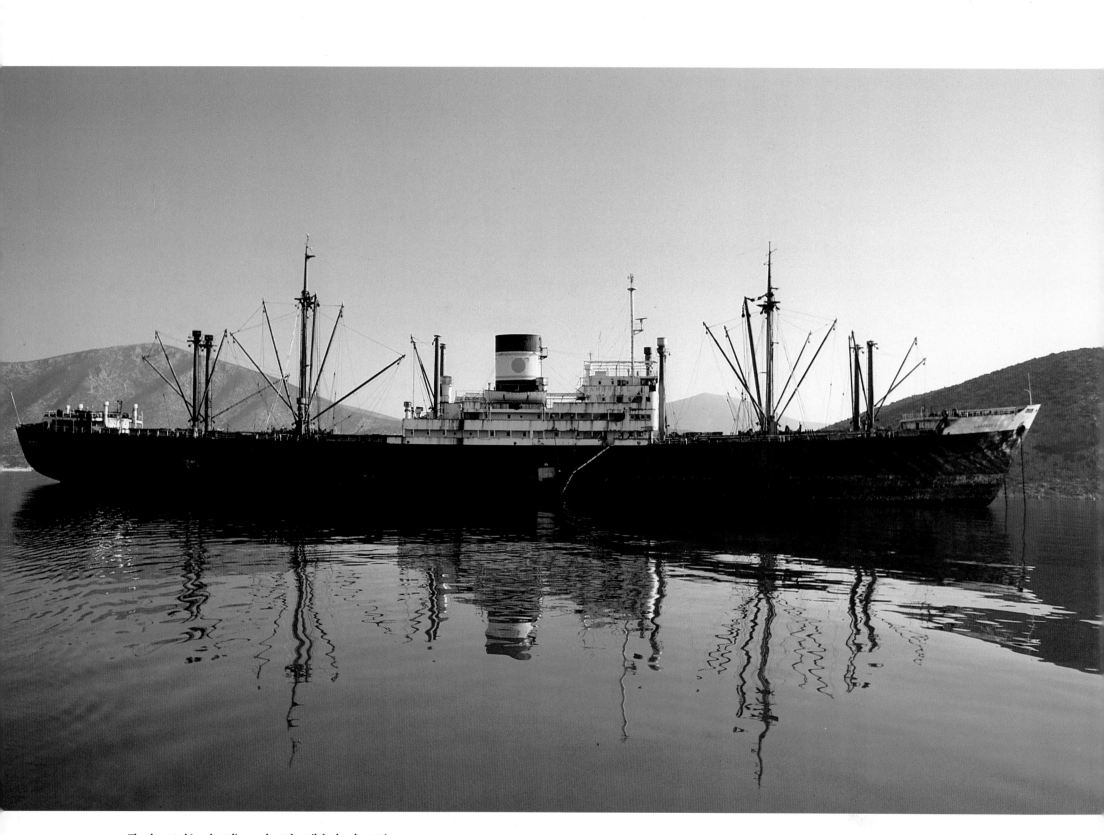

The deserted *Lambros* lies neglected until the legal questions surrounding her are settled. Then she may be scrapped. Fire

10 damage, mostly confined to her after holds, is not visible.

LAMBROS L

Fire on Board

*I*t was early on a beautiful spring morning in Kilada, Greece, when the fire broke out. Mayor Andreas Lekkas was in his grocery store waiting on customers. Corpulent Mrs. Kampouridis, mother of the customs agent, was at the counter and smelled it first. She wrinkled her nose questioningly, which sent a small involuntary shudder down the mass of flesh under her black widow's dress. The other women and Lekkas himself stopped what they were doing as they, too, became aware of the acrid smell. Just then little Nikolaos Boufis, the curly-haired son of a fisherman, burst in and shouted, "Mayor, come quickly. The *Lambros* is on fire!"

Lekkas ran out, joining, it seemed, all of Kilada's 1,600 inhabitants as they raced to the edge of the village. White clouds of smoke covered the huge freighter lying out in the bay. The smell was overpowering. Nobody knew what to do. Fishermen ran to their boats, taking with them many of the other village men. Perhaps they could help the skeleton crew that had been left on the ship. Or at least they could get a ringside seat for the biggest event in the history of Kilada.

On board the *Lambros L* the chaos was even greater than in the village. Some of the crew were trying to uncoil firehoses stored against the after deckhouse and aft of the superstructure. Villagers tried to help, in their eagerness often tripping over each other or over the hatchboards that had been ripped off the hatches and now lay strewn around the deck. Smoke billowed from No. 5 and No. 6 holds, covering the deck in a choking white cloud. The heat had become intense. Men trained hoses into the holds, but the water pressure was so low that only dribbles fell on the fire. The ship's automatic carbon-dioxide fire-extinguishing system was malfunctioning and just a few of the nozzles were spraying. Georgios Kaloudis, the senior engineer on board, tried to start the main propulsion system to provide greater power for the pumps. Men kept arriving and succeeded only in getting in the way of those who were already working. Everyone yelled orders at everyone else. The excitement was palpitating. More adrenalin was pumping than water. Here God was providing an opportu-

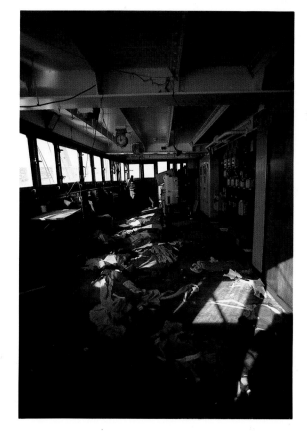

Vandals boarded the ship after the fire and took whatever valuables they could find. The signal-flag locker was emptied on the bridge.

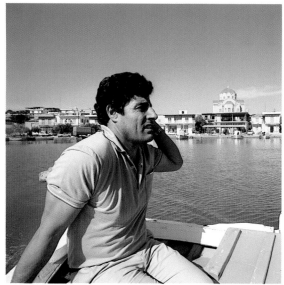

Mayor Lekkas guides visitors to a large cave across the bay from his village. The local people say that Ulysses once occupied the cave and they may be right. University of Pennsylvania archaeologists have been conducting research there.

nity to be a *man*, and oh, what stories would be told! The emergency was momentous, and it was the best kind, a real Greek emergency...non-life-threatening.

Finally the ship's two Sulzer diesels came to life. Immediately the water pressure increased, whipping the unsuspecting hose crews around the deck and knocking them into each other. Other men joined forces to steady the hoses but to little avail. Many of the hoses were old and split under the sudden pressure, spraying everything except the fire. Three of them held, however, and streams of water were soon being played on the fires in the two holds. Dominating all this confusion was the putrid smell of the *Lambros*'s roasting cargo—soybeans.

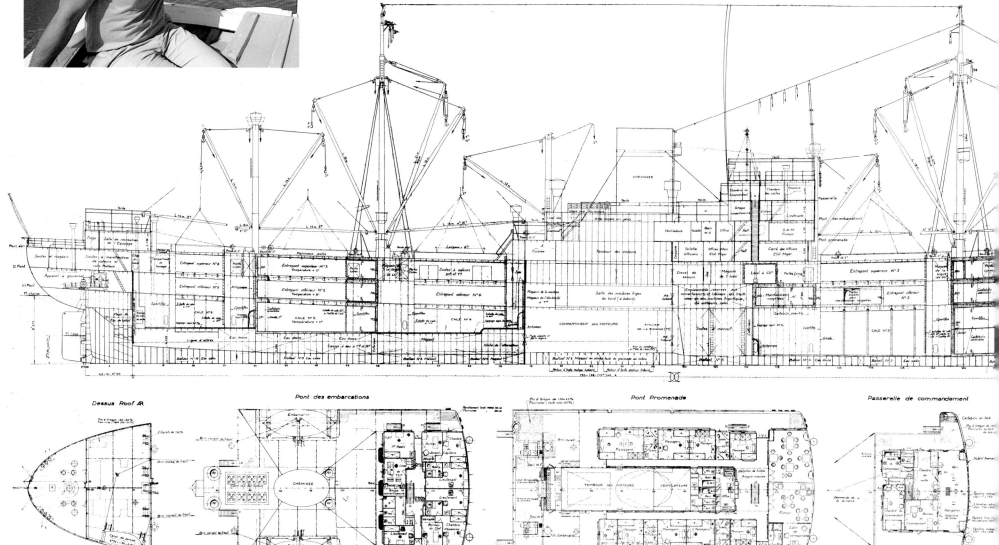

The village of Kilada lies along a lovely, serene bay fringed with hills on the eastern tip of the Peloponnesian Peninsula. Because of the bad roads, it is nearly a full day's drive from Athens, only 110 miles away, so the area's great beauty draws few tourists—a fact mourned by some of the town's inhabitants and applauded by others. The village has two small, six-room hotels and a

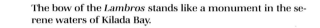

The bow of the *Lambros* stands like a monument in the serene waters of Kilada Bay.

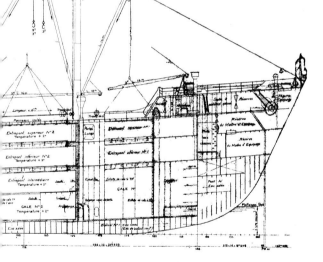

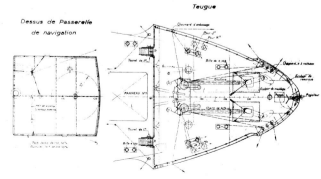

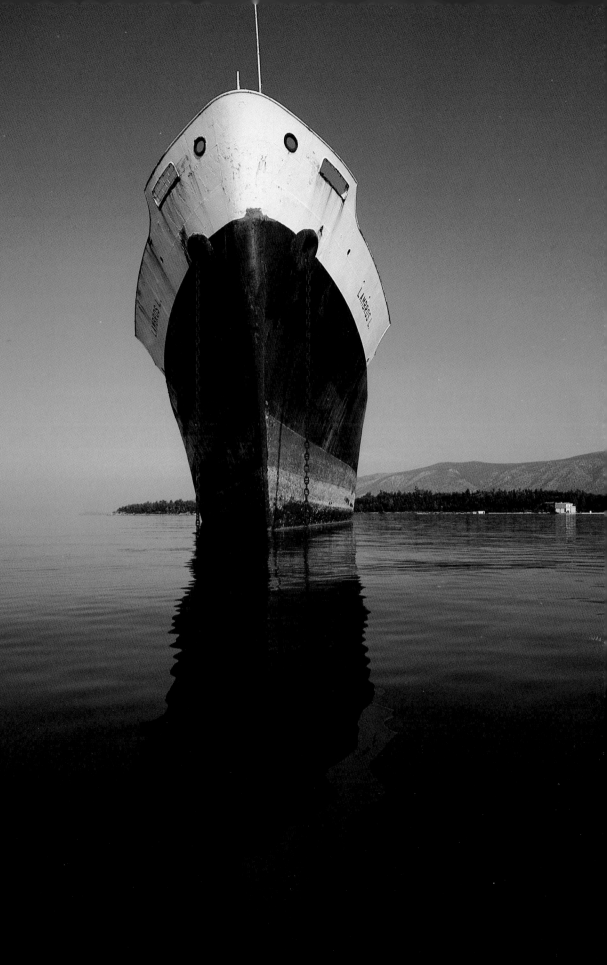

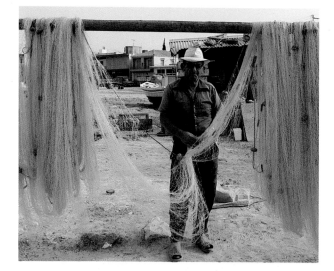

A local fisherman dries his nets in the afternoon sun.

One of the specialties in Kilada's homes and tavernas is marinated octopus, served as a snack with ouzo, the anise-seed-flavored Greek liqueur. Throughout the town octopuses hang from clotheslines to dry in the sun.

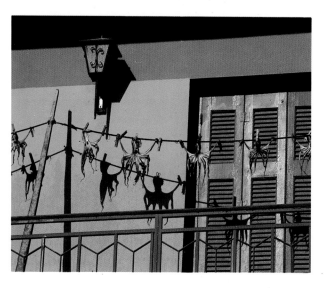

gorgeous, unspoiled beach not far away. By herself in the cobalt blue waters of the bay, the *Lambros* lies abandoned now.

Kilada is a poor village. Most of the men are fishermen. Some build traditional boats, but the most successful go to sea, serving as crewmen on various Greek freighters and tankers. In 1938 the Companie Transatlantique, a French steamship operator, decided it needed a cargo vessel with a large refrigerated capacity and some passenger space for the company's service to Martinique and other islands in the Caribbean. The contract was let to Sainte des Ateliers et Chantiers de Saint Nazaire-Penhoêt, but before construction was far along, France fell to Germany and all work on the ship came to a halt. Not until 1949 was the vessel completed. She was named the *Winnipeg* and after her commissioning made 168 transatlantic crossings to the Caribbean. A Greek company bought her in 1975 and renamed her *Lambros L*. Subsequently she traded between Italy and Nigeria with general cargo and carried soybeans from Brazil and Argentina to ports in Spain and Syria.

The final voyage of the *Lambros* was very unusual. Chartered by a Syrian company, she sailed from Brazil late in 1976 for the Syrian port of Latakia with a partial cargo of soybeans. The charterers were supposed to pay demurrage installments (rental charges) to the ship's owner, a Mr. Diapaniotis, every fifteen days. This, apparently, they did not do. After forty-five days of no payments, the owner withdrew the *Lambros* from charter and initiated legal proceedings to recover the money he felt was owed him. The *Lambros* by now was in Latakia, her cargo still on board and her owner determined that the soybeans would stay there until he was paid.

Five months later, Diapaniotis finally ordered his vessel to Cyprus, where he planned to sell her cargo to another buyer in hopes of regaining at least some of his lost revenue. At this

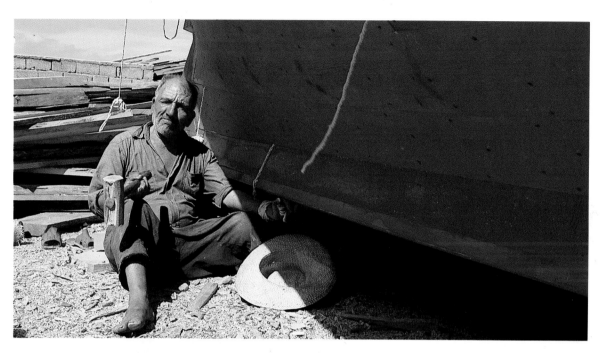

This old gentleman works part time for a local boatyard. He has worked hard all his life and now, in his seventies, is as strong as many men half his age. He is caulking a new fishing boat.

point the story becomes more entangled. Perhaps the Syrian charterers were influential in their country, or perhaps they bribed someone in the government. In any case the Syrian government put heavy pressure on the authorities in Cyprus not only to prevent the cargo from being discharged, but also to impound the ship. So in the middle of the night Theodoros Vourlidis, then captain of the *Lambros*, snuck her out of the harbor and made a dash for Greece.

The escape was successful. Diapaniotis ordered Captain Vourlidis to anchor in the little bay at Kilada and await further developments. Kilada was close to the owner's home island of Spetses, was sheltered, and probably had very low (or nonexistent) harbor fees. The *Lambros* was there for five years while legal battles raged. Then on that spring morning in 1982, just after he won the court battle, Diapaniotis lost the war.

The design of the *Lambros* is transitional. That is, with her large steamer stack, her old-style merchant cruiser stern, her space-consuming after deckhouse, and her lavish use of fine cabinet woods below, she resembles prewar vessels. However, her semistreamlined superstructure, her heavily raked bow with its extended bulwarks, and the use of kingposts containing ventilators are indicative of more modern, postwar marine design.

At any rate, the days of the *Lambros* are numbered. The fire, which apparently started by spontaneous combustion, probably finished her. To recondition the thirty-three-year-old ship would likely cost far more than she is worth. Also, vandals have stolen many of her resalable fittings, and she is in a sorry state of neglect. When Diapaniotis comes to terms with the insurers, the *Lambros* will most likely be towed to the nearest ship-breaking yard. For now, she still swings on her anchor in peaceful Kilada Bay.

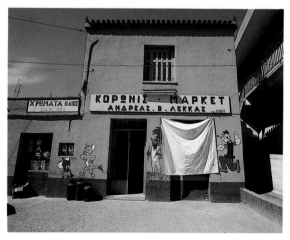

Mayor Lekkas owns the local grocery stores, which he decorated with the cartoon characters Tom & Jerry, Woody Woodpecker, and Popeye.

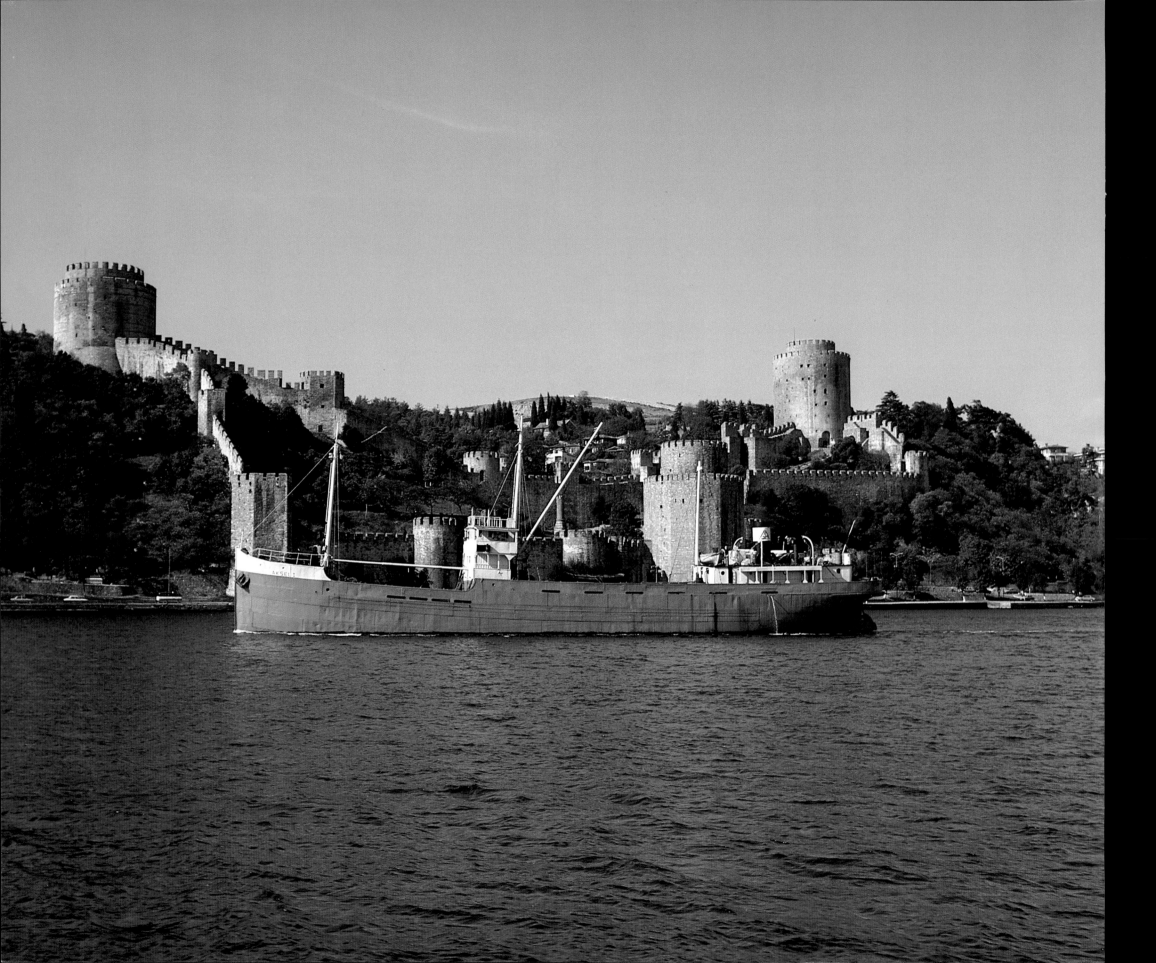

AKSEL I

An Antique Sailing among the Mosques

The office of O. Gazanfer Akar lies hidden in that part of Istanbul called Karakoy. It is a district of large and small shipowners, agents, chandlers, maritime banks, and other firms that in one way or another are connected to shipping. But Karakoy's own distinct flavor separates it from counterpart districts in the Liverpools, Marseilleses, and Piraeuses of Western Europe. To be sure, it is crowded with the same masses of employed and idle seamen, and the new modern buildings are sandwiched between office blocks that look old enough to have been built by Suleiman the Magnificent. The real difference is seen in the streets. They teem with people. One can see more pedestrians in a square block of Istanbul than probably exist in all of Los Angeles—and they are almost all men. This Moslem society still keeps its women locked up. Some female secretaries work in the larger firms, but men still do most of the clerical work. A European or American woman walking in this district is scrutinized as if she were a Martian trollop.

Gazanfer's office is here, in Karamustafapasa Sok. Guzel Bandirma Hani, which is an alley. You wend your way through the throng, past the streetside vendors until, gingerly stepping over a dead dog, you realize you are lost. Out comes the address, scribbled on a scrap of notepaper. The idlers all want to help, and each seriously studies your piece of paper, then points in a different direction. Finally one kind stranger (and there are many) takes you by the elbow and leads you back down the alley to a bustling hole-in-the-wall restaurant. Just inside is what appears to be a narrow fire escape that winds its way up past walls so filthy you don't want to touch them. You climb over boxes of vegetables conveniently placed on the stairs by the restaurant next door, and after reaching the second floor find the correct door at the end of a dingy, unlit hall.

For the visitor expecting, perhaps, a wizened old Turk wreathed in a pall of sweet tobacco, Gazanfer Akar, co-owner of the *Aksel I*, is a surprise. He is a young man, probably in his middle thirties, with straight black hair and a small, clipped moustache. He is very large and gregarious. In fact he looks like the Turkish equivalent of a football lineman who just last week quit playing. Gazanfer's bulk and amiability completely fill his tiny office, giving you a feeling

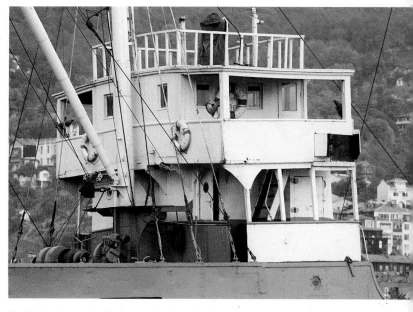

The bridge house is a fine example of early twentieth-century naval architecture. In fact, the *Aksel* is a floating classic. She is more rare than almost any other mechanical creation of her age.

The fortress of Rumeli Hisar stands guard over the Bosporus, fifteen miles from Istanbul. It was built by Mehmet II in 1452, and now serves as a tourist attraction.

somewhat akin to standing in a closet with "Too Tall" Jones.

Gazanfer and his brother, Yilmaz, have owned the *Aksel* for just a few years. She is their first and only steel ship. Before they bought her they owned a wooden coastal trader. From their profits they saved enough to make a down payment on the *Aksel*, but you sense it is nip and tuck to stay solvent—that every business possibility, every expense, is weighed carefully in their minds, then considered a hundred times again. You get the feeling that one false step and they and the *Aksel* will go under.

Gazanfer says that since they bought her,

the *Aksel* has been going to the Bulgarian Black Sea ports of Burgas and Varna carrying tea and wood, then returning to Istanbul with cargoes of scrap iron. She also takes fertilizer to Izmir, on the Aegean Sea, returning to Istanbul with bulk salt, then going to Black Sea ports in eastern Turkey with cargoes of coal, tea, and minerals.

Sailing in Turkish waters is dicey. Islands fill the Aegean between Turkey and Greece. Whichever way you look, the military forces of hostile and suspicious governments have little patience with or understanding of the results of a navigational error. To the west lies Greece, with whom Turkey has nearly been at war. To the

With the exception of her diesel engine and shortened stack, the *Aksel* is as close to original condition as any cargo vessel that is still sailing in southern Europe—and there are very few vessels of her age still sailing.

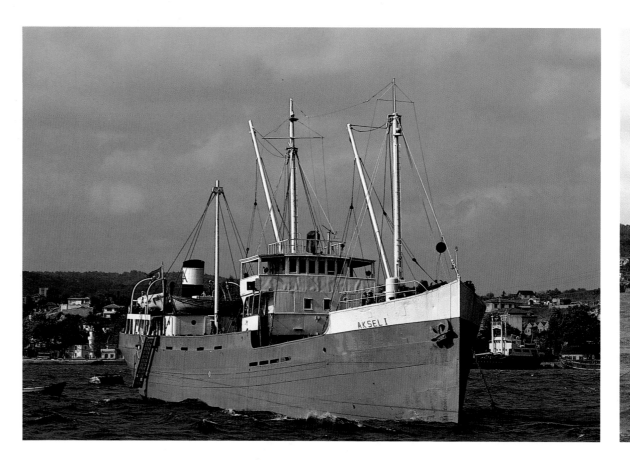

southeast are Syria, Lebanon, and Cyprus; to the north Bulgaria and, of course, the Soviet Union. Then there is the weather: the Black Sea, in particular, is notorious for its sudden and violent storms. Gazanfer described a near disaster there on the *Aksel*.

"A few years ago we were sailing near Sile—that's on the Black Sea coast—and suddenly we got a what-do-you-call-it, *phhhhh* [with frantic motions of upraised arms, he imitates a waterspout—which is a tornado at sea], and that happens to us at nine o'clock in the morning. When we see it is coming on to us, we change course toward the coast. If that thing hits the ship it will take away the gates to the stores [hatchcovers] and the water will come into the stores [cargo holds] and the ship one hundred percent will sank. That thing was about five hundred meters away from the ship and we looked at that thing and we saw that it was like a smoke going up, you know, and the thing was twenty-five or thirty meters around and we think that something is going to happen to the ship. Suddenly we saw that the air, it comes on to the stores and we see that the gates of the stores have been pushed by the air, down.

"Well, everybody was afraid but nobody tries to show that they are afraid to the other people, you know, and we are smiling and trying to look around with another face. The man who is directing the ship, the one at the wheel, you know, begins to pray to his God and begins to say some things religious, 'God save us,' you know, 'God bless us,' and I am the captain and I did not show, myself, that I am afraid as well because the crew will be more scared.

"So anyway, we change direction of the ship and go to the coastside and it pass us by and nothing happened to anybody."

The *Aksel* has not always escaped. In fact, her history is peppered with misfortunes. Before the Gazanfers bought her she had gone aground five times. Nonetheless, she is known as the "lucky *Aksel*"—a lucky ship. In 1947 and 1948, shortly after her first Turkish owner bought her, she was entering the small port of Amasra on the Black Sea with a bulk cargo of salt. She hit the breakwater and tore a small hole in her bottom.

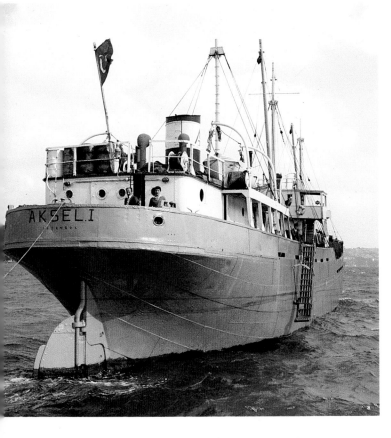

The *Aksel*, anchored in the Bosporus, awaits cargo. She has just arrived from the Turkish port of Zonguldak on the Black Sea.

This running light, battered but still operating, is an example of the age of some of the equipment on the vessel.

This crewman's cabin, except for the electric light and the "female art," could have existed on a merchant vessel of the 1880s. All the other cabin components date back to 1913, when the *Aksel* was built.

Yilmaz Akar is captain and half owner of the *Aksel*. He and his brother Gazanfer are third-generation Turkish seafarers. Both their father and grandfather were fishermen on the Black Sea.

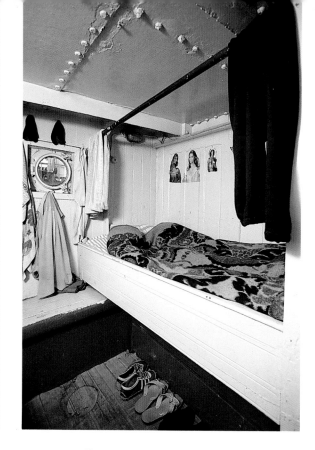

Water rapidly filled one of her holds, melting the salt. Fortunately she got off the breakwater under her own power and proceeded into the harbor, where her soggy cargo was pumped out and her hull repaired. In a little more than a week she sailed again.

Her next accident was in 1979. Loaded with pig iron and heading south near Gallipoli, she went aground. Her owner sent another of his vessels to transship the cargo. The *Aksel* sustained only a ten-centimeter dent in her hull, and she did not even need a new plate on her bottom.

Two months later, en route to Italy on ballast, she lost her bearings. Apparently visibility was poor and her radar was not functioning. She went aground on the Greek island of Corfu, where she stayed for two months. When she was finally towed off the sandbank, her overjoyed owner discovered she had escaped any damage whatever. However, she sailed only a short while before going aground again, this time at Ayvalik, on the Turkish coast. Her cargo of coal was transferred to another vessel, and again it was discovered when she reached port that she had sustained no damage.

Finally, just before she was sold to the Gazanfers, she had engine trouble and lost power completely just out of Iskenderun, a port on Turkey's southeast coast. She was rescued by the *Hilmiohgullari*, another freighter belonging to a Mr. Hilim, her former owner. On the way back to Istanbul the towing vessel ran aground on a small Greek island just off the Turkish coast. The *Aksel*, still with no power, drifted alongside the *Hilmiohgullari* until she, too, was aground. The only damage to the *Aksel* was a small dent in her hull.

With five groundings, the odds dictate that the *Aksel* would have received serious damage or even have sunk. It never happened, which is why she is known as the "lucky *Aksel*."

Groundings and other accidents are common with coastal trading vessels. Fathometers and radar do not always function well—if at all. The vessels are usually sailing near land forms and thus have more opportunities for accidents than do transoceanic freighters. Most accidents, however, are due to human error: poor seamanship or navigation on the part of the captain or, more often, inexperienced or unqualified crew. Many small vessels carry only one or two mates,

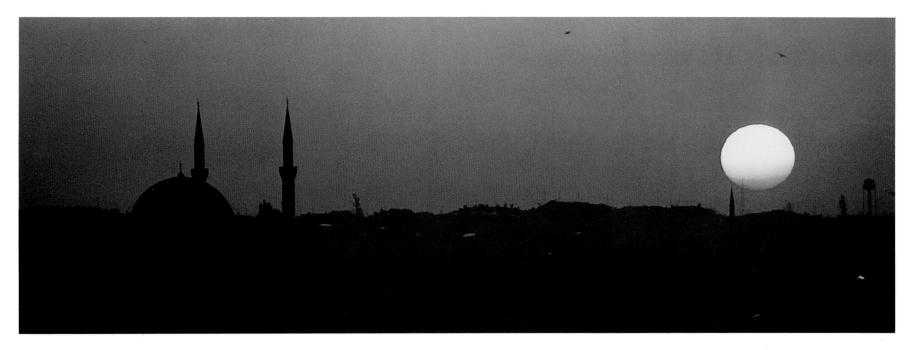

and these men are not always of the highest caliber. The captain has to sleep some time, and disaster usually hits when someone else is in control of the ship.

Despite all of the *Aksel*'s groundings, the only two hull plates that are new were necessitated by her collision with a dock. Some frames were changed in her No.2 hold, and her stack was modified from the tall, thin funnel that accompanied the original steam engine. The *Aksel* is, amazingly, almost the same as when she was built in 1913. She is a floating classic, a vessel that many a maritime museum would love to own. Built by R. Williamson and Son in Liverpool and named the *Kyle Queen*, she was one of a series of similar vessels probably designed for coastal trading and small enough to ply some of Britain's larger rivers.

Her first Turkish owner bought her in 1946 for $53,000. She was renamed *Kerdesler* and had two other owners before Gazanfer bought her.

The *Aksel* was first powered by a single- or double-expansion steam engine and burned coal. Her coal bunker, just forward of the engine room, still exists. Originally her anchor windlass and mooring windlass were operated by steam

off the main engine. Some cast-iron components of the windlasses are still in place, but both windlasses are now operated by gear drive off small diesels. Steering was by steam as well, pushing pistons located just aft of the pilothouse. A turn of the wheel to starboard activated one piston; to port, its counterpart. The wheel is now connected by gears to a chain drive that runs the length of the ship and is attached to the rudder shaft. The *Aksel* steers easily at sea, even in heavy weather, but apparently it is difficult to control her at slow speed, particularly when berthing. Because of international regulations the chart room and radio shack, which were previously on the deck below the bridge, are now located behind it, the bridge being reduced in size to accommodate them.

The *Aksel* is also endowed with a good hull shape for rough seas. She recently was seventy tons overloaded when she encountered a force-eight gale and sailed through it easily to deliver her cargo intact and bring a good profit for the voyage. This is the other reason she is called the "lucky *Aksel*": all her past owners have made a great deal of money with her. A family by the name of Steinmetz bought her as their first

Istanbul, with its mosques silhouetted against the sunset, is one of the world's most beautiful urban skylines.

steel ship after having owned only small wooden coasters. The family is now one of the largest shipowners in Turkey.

Leaving Gazanfer's little office and retracing your steps along Karamustafapasa Sok. Guzel Bandirma Hani alley, you hope the *Aksel*'s newest owners will also be blessed with prosperity.

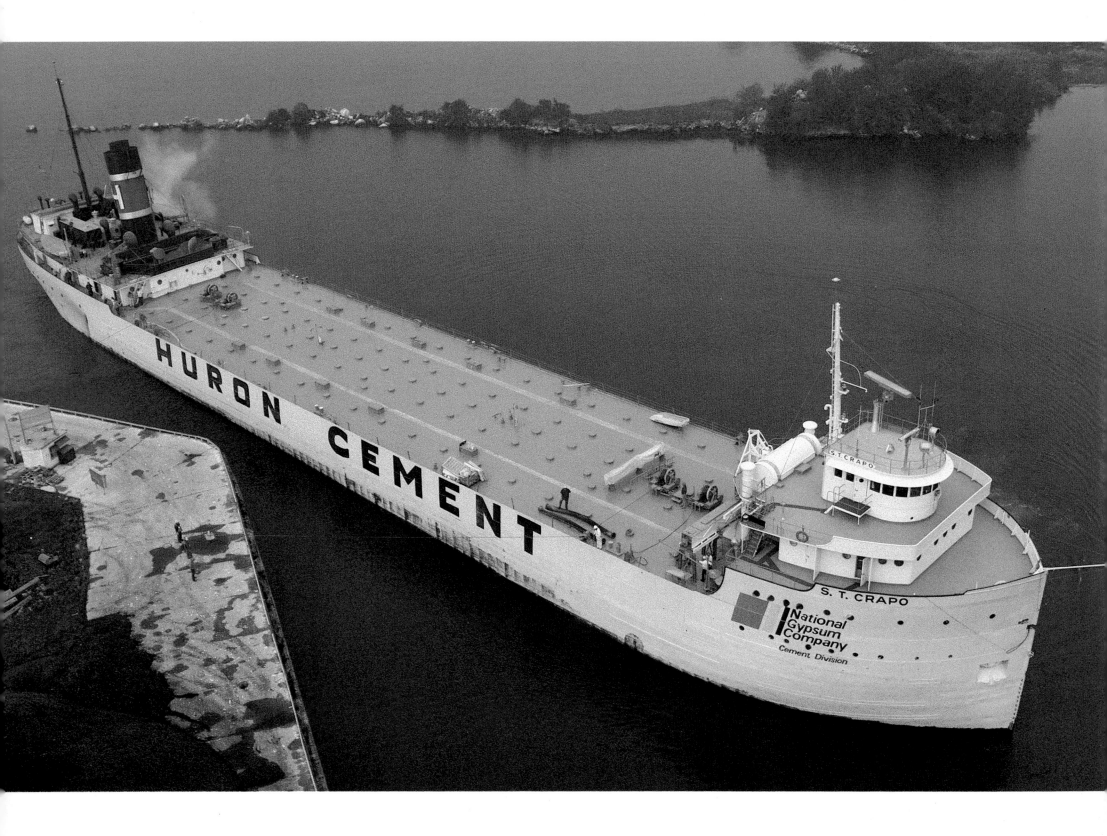

S. T. CRAPO

Sailing a Big Ship in a Little River

*A*ugust 4, 1984—2150 hours. Third mate Marv Kerr glances at the first set of lighted buoys as he speaks rapidly into the radio-telephone, "WB6252, *S. T. Crapo*, calling Saginaw River Coast Guard. We will be at front range light approximately one hour. Please advise visibility and traffic movement."

Silence, then a burst of static before a laconic voice responds, "WB6252, *S. T. Crapo*, this is Saginaw River Coast Guard. Visibility is two to three miles. No outbound traffic at this time. Saginaw River Coast Guard clear."

The channel buoys slide by at mile intervals. Third mate Marv Kerr stands at the pilothouse window picking them out with binoculars and relaying course changes to his wheelsman when another radio call comes in. It is the dredge *Northerly Isle*. She informs the *Crapo* that she is dredging the river between buoys 40 and 42 and is projecting fifty feet into the river channel. Unfortunately the dredge is operating right in the middle of the river's most dangerous curve. The two men are nonchalant but thoughtful. Marv Kerr logs the call and the position of the *Northerly Isle*.

The 402-foot *Crapo* (no, it's pronounced *cray-poe*), loaded with 6,900 tons of bulk cement, is in a channel leading from Lake Huron into the Saginaw River. She has come from Alpena, farther north on the Michigan peninsula, and she will deliver her cargo to Huron Cement's Saginaw River Distribution Terminal, seventeen miles upriver. While the *Crapo* sails over most of the Great Lakes, navigating the Saginaw River at night is one of her most difficult journeys. Not only is the river narrow with sharp bends, there are also a number of tight bridge openings through which she must squeeze, as well as the occasional vessel heading downstream or obstructing the channel. Tonight the ship's officers and wheelsmen are especially alert. They know they will have only seconds to correct any error before the *Crapo* goes aground or, worse, crashes into a bridge or another vessel.

John "Mac" McClinton, a cheerful, graying ex-Canadian, is the wheelsman. He, Marv, and the captain have more than 125 years of sailing experience among them. Each served in the U. S. Navy during World War II, Marv on destroyers and Mac first on merchant ships, then on the aircraft carrier *Bunker Hill*. After the war Marv

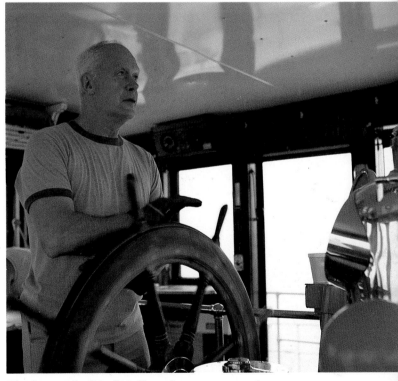

Wheelsman John "Mac" McClinton keeps one eye on the compass and the other on the river in front of him. The seriousness with which he takes his work shows on his face.

The *Crapo* slowly enters Huron Cement's harbor at Alpena, Michigan.

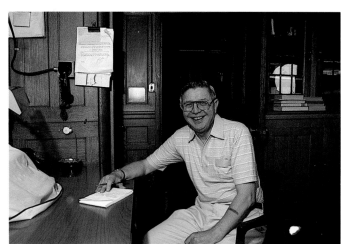

Capt. Ralph Knechtel sits in his beautiful oak-paneled office. His quarters, like most of the interior spaces on the *Crapo*, have been restored to their original condition.

Second mate Don Ghiato poses by the engine telegraph as the *Crapo* makes her way down Lake Huron.

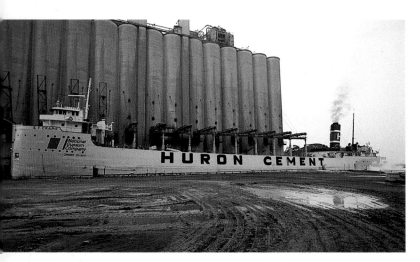

Loading the *Crapo* with cement takes only a matter of hours. In the past when the cement was loaded into bags, the job took a week.

sailed for eighteen years on the Great Lakes, and Mac sailed on freighters and tankers all over the world. The two men work well together, bantering back and forth but always keeping minds and eyes on the channel ahead. They also have great respect for Ralph Knechtel, the *Crapo*'s captain. Marv says Knechtel is considered one of the best shiphandlers on the Great Lakes. Tonight he will need to be.

Quietly the captain joins the two men in the wheelhouse. He is a kind, grandfatherly looking man who seems as though he would be happy running a candy shop. In 1942 he joined Huron Cement's vessel the *John W. Boardman* right out of high school, working as a deckhand. The following year he went into the navy and was on the cruiser *Savannah* during the invasions of Sicily and Salerno. He says, "The third day of the Salerno invasion we were hit by a radio-controlled bomb that killed everybody up forward. I was a lookout on the bridge. My entire division was killed. Then we came back around Christmastime. In 1946 I returned to the Huron Cement fleet, working my way up from deckhand to watchman to wheelsman, then to third mate, second, first, and skipper."

Ralph has been a skipper for nine years, all on the *Crapo*. In his gentle way he describes his only major collision. With a chuckle he says, "Some years ago I hit a roof in Milwaukee. My father-in-law couldn't believe it. Of course it was in a canal where the buildings extended over the water. The bow hit the roof. A single-story house. People were in the building and I guess it shook them up a little. It was kind of embarrassing—I had to report it to the Coast Guard."

As the *Crapo* leaves the channel and enters the river, the atmosphere changes. The banter stops. Ralph takes over the con from Marv and moves to the port-center window. He will spend the next four hours standing there giving orders to the wheelsmen and the engine room.

The *Crapo* is unique: she is powered by a coal-fired reciprocating steam engine. The triple-expansion engine is original equipment, built in 1927. It operates from three fire-tube boilers under 175 pounds' pressure. A small engine at the end of No. 3 cylinder powers reversals.

In the fireroom deep in the bowels of the ship, three firemen work in what can only be described as a scene from hell. The heat is suffocating. Flames shoot high in the air of the

Jim Stanley and Ralph Knechtel work as a team to back the *Crapo* out of the cramped Huron Cement harbor.

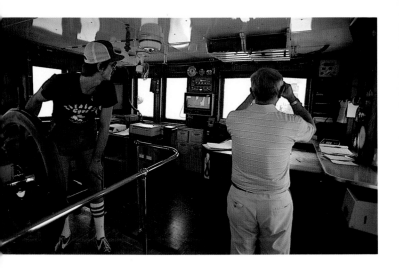

cramped space as the firemen rake out old burned coal from the fireboxes onto the deck. Coal ash obscures the scene like a fog. In spite of forced ventilation, metal surfaces here will scald the skin off your hand. Yet these men are not unhappy with their work. Fireman Joe McKay explained, "I've been doing this for twelve years. I don't mind the heat and I like the money. I could never make this much anyplace else."

He and the other two firemen make between $30,000 and $35,000 a year. Others might say that not all the money in the world could make them do this sort of work, then again, those naysayers may never have been out of work. The firemen see the job's unpleasantness as a small price to pay for their financial freedom. The *Crapo* was built for carrying cement. Loading bagged cement by hand originally took over a week; now it is done by air slides and takes only four or five hours. The pumps can discharge nearly 9,000 tons of cement out of the holds and

Looking aft at night from the *Crapo*'s bridgehouse. The hatches each will take a loading pipe, so loading can be accomplished very quickly. The winch next to the deckhouse is used to take in mooring lines when docking and helps to alleviate the need for a tug.

Fireman Joe McKay stands before an open firebox door.

into 400-foot-high silos in from sixteen to twenty-four hours.

Huron Cement operates the *Crapo* and five other ships to carry cement from its Alpena plant, the largest cement facility in the United States and second largest in the world, to thirteen ports around the Great Lakes. Not only do cement's components exist naturally in Alpena, but the plant's central location allows economic shipping of the bulky material to areas as distant as New York and Minnesota. Most of the operation's 700 employees have worked for Huron for over a decade—not a bad testimonial.

Three of the *Crapo*'s sister ships are also steamers. The *E. M. Ford,* built in 1898, has one of the few quadruple-expansion engines left in the world. Unfortunately the *Ford* is laid up in Milwaukee awaiting more business. Both the other vessels, the *John W. Boardman* and the *Louis G. Harriman,* were built in 1923, the first as a cement carrier and the other as a general bulk carrier.

The *Crapo* is making six knots as she approaches the first bend in the river, opposite the Bay Harbor Marina. Ralph tells his wheelsman, "Start her left, slow, Mac. Head her on the red buoy."

Mac turns the large, spoked wheel a quarter-turn and replies, "Steady on red buoy, Cap." The *Crapo* slowly eases into the first turn.

"Now come left on the green range, Mac," Ralph orders, looking at a range light beyond the turn. When the ship nears the middle of the curve, he says again, "Start her right, Mac. I'll steady up."

The wheelsman answers, "Coming right slow, Cap," as the vessel leaves the curve and faces a straight stretch of river.

Almost immediately out of the turn stands the Detroit-Mackinaw Railroad bridge. It is closed. Marv eyes it uneasily through the binoculars. "Cap," he bursts, "there's a train on the bridge!"

A long freight blends into the rust-colored metal of the bridge. Neither the engine nor the caboose is visible. The train crawls across the river so slowly that it hardly seems to be moving.

Ralph jerks up, sees the train, and rings "stop" on the engine telegraph, then "slow astern." The *Crapo* is now only 400 yards from the bridge. She noticeably slows but still coasts toward the span. It looms closer and closer. The

captain rings a long and a short on the whistle for the bridge to open and a roaring *hunnh—hunnh* vibrates over the river.

Before the *Crapo* has to come to a stop, the caboose clears and the two sections of the bridge rise. The *Crapo* continues on, hardly missing a beat. Ralph orders Mac to come to the center of the bridge draw, then to the center of the right-hand draw. The bridge opening is ninety-four feet wide, the *Crapo* sixty. Marv is outside, on the starboard wing of the ship's bridge. As the *Crapo* slides through, he shouts, "Nineteen feet port side forward, fifteen feet starboard side forward, Cap." From high on the pilothouse wing, the distance between the *Crapo*'s hull and the bridge abutment looks like an eyelash. Marv, now facing aft, repeats distances amid ships, then calls, "Stern clear, Cap." The *Crapo* steams on her way, white clouds of smoke billowing above her in the summer evening.

Another curve and two miles upriver is the Independence Highway bridge, a main traffic artery between Bay City and Essexville. As the *Crapo* approaches, warning bells ring and the traffic gates go down. Motorists get out of their cars and lean over the bridge, gawking at the

A fireman uses a hoe to rake out the burned coal from the fireboxes. The used coal, called "clinkers," must be removed before it plugs the air passages between the grate bars and retards the furnaces' efficiency. After it is raked onto the deck, it is extinguished with a hose.

The fire room fills with ash when the fireboxes are raked. The firemen break up fused clinkers with a slice bar to keep the fires burning evenly.

The "black gang" poses midway through their watch. Except for the addition of an automatic stoker for shoveling coal into the fireboxes, the fireman's job has changed little in a hundred years.

huge steamship passing beneath them.

5 August—0011 hours. The watch changes. Marv stays on the bridge since on this short trip the first mate will join the vessel at Saginaw. Ralph, also, will not leave the bridge until the *Crapo* reaches her destination. Jim Stanley is now the wheelsman. He is twenty-eight years old, but in his cutoff jeans and sneakers he looks eighteen. Having sailed for nearly ten years, he already has his mate's license. He has paid his dues and he is trusted: five miles ahead lies the Airport Curve, potentially the most hazardous spot on the river.

The chart of the Saginaw River shows its channel to be 200 feet wide. For a ship the size of the *Crapo*, though, only 100 to 150 feet of that width are usable. If a large vessel is close to the edge of the channel, the slope of the embankment together with the suction created by the ship's propeller produce a vacuum that inexorably pulls the vessel's stern into the bank until she grounds. This fact is common knowledge among officers and wheelsmen. To be aware of it is one thing, but to overcome it in the few seconds available before grounding is something else again.

0126 hours. The *Crapo* enters the curve adjacent to the James Clement Airport. The vessel's speed is now only five knots, about the slowest she can go and still maintain good rudder response. The curve itself is ninety degrees and encompasses about a mile and a half of river. In the center is a straight stretch with a forty-five-degree turn at each end.

Ralph Knechtel lines Jim Stanley on a light at the Block Marina. This will keep the *Crapo* on the port side of the river, since the dredge *Northerly Isle* will be jutting into the starboard side of the channel at the other end of the curve. Then the captain orders Jim to come to a white light on the center of the Cheboyganing Creek bridge, which lies at a creek entrance outside the channel. The *Crapo* sails slowly into the straight stretch at the center of the curve. Visible finally are two white lights flanked by two red ones atop the *Northerly Isle*'s pilothouse. The dredge looks like a small freighter without masts and is sticking out into the channel right at the apex of the turn ahead. This is unfortunate because now the *Crapo* cannot cut the corner.

Still in the straight, Ralph says, "All right, Jimmy, come to the center of the billboard." Jim

quickly brings the wheel nearly a turn to starboard to line up the bow on a lighted billboard on adjacent Highway 13.

There is a moment of hesitation, and another. Suddenly Jimmy swings the wheel all the way over to starboard. "Cap, nothing's happening," he says. "I've got the wheel hard right and she's not answering!"

The *Crapo*'s stern and midsection are being sucked closer and closer into the bank. Ahead only 300 yards lies the second turn. If the *Crapo* does not hit the bank, she will certainly plow directly into the Cheboyganing Creek bridge.

Ralph Knechtel has moved instinctively to the engine telegraph. Without hesitation he rings "full ahead" on the telegraph and shifts the bow thruster hard left. He tells his wheelsman, "Keep the wheel hard right, Jimmy."

Brown water boils at both ends of the *Crapo*. Jimmy is in anguish. "She's still moving left, Cap. She's not coming at all."

"Marv," the captain orders, "tell John to give us everything he's got."

Marv Kerr is already at the engine-room phone. "John," he yells to the third engineer,

This oiler is checking a crosshead bearing on the vessel's main engine.

"give us everything you've got—maximum rpm's!"

Almost immediately a maelstrom erupts aft of the *Crapo*'s propeller, as tons of water thrash over the rudder. The ship tears itself away from the bank and cuts into the turn at speed.

Jim rapidly swings the wheel back to port and "slow ahead" rings out on the telegraph as the *Crapo* flashes by the *Northerly Isle* with fifteen feet to spare at most. A collective sigh of relief fills the wheelhouse.

Two curves and an hour and fifteen minutes later, the *Crapo* reaches her destination. At 0310 hours the lines are out, the *Crapo* is secured alongside the dock, and a very tired Captain Knechtel rings "finished with engine."

The Alpena Connection

The historic meeting occurred on a cloudy day early in August 1984, on the Michigan peninsula. At Huron Cement's small harbor, the world's two oldest coal-burning steamships of their size met the world's oldest operable steam-powered cargo vessel. It was a momentous occasion, but hardly anyone noticed.

This all happened in the sleepy little Michigan city of Alpena (population 40,000), located on the shores of Lake Huron, one hundred miles south of Sault Sainte Marie, at the Canadian border. The area first belonged to the Chippewa Indians, who used it only as a place to send their exiles. In the 1870s lumbering was the main activity. Then the town's druggist, experimenting with local lime, discovered he could make the newly discovered Portland cement. The residents of Alpena found themselves sitting on one of the largest limestone deposits in the United States. The availability of all the cement ingredients and the excellent transportation system supplied by the Great Lakes ensured Alpena's future. Today it is an attractive town

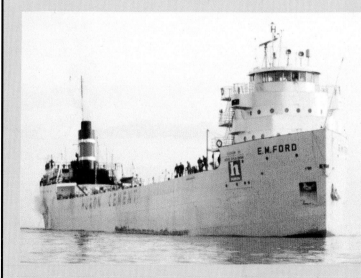

The *E. M. Ford* is probably the oldest cargo vessel of her size, still in its original configuration, operating anywhere in the world.

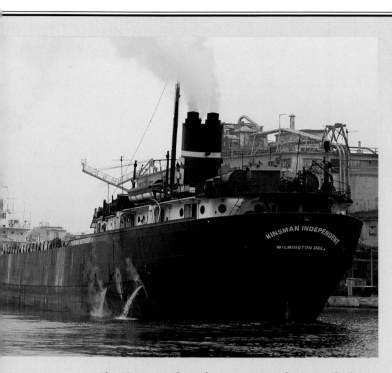

The *Kinsman Independent* steams into the Huron facility to load cement.

The *Kinsman Independent* and the *Crapo* puff side by side at Huron's Alpena plant. These ships are among the very few coal-fired steamships still working, the survivors of a vanishing species that once sailed all the world's oceans.

whose main employer, Huron Cement, still relies on those local resources. Besides being interested in the welfare of the community, Huron is proud of its fleet of old steamships. Excellently maintained, they in turn serve the company well.

On that particular summer day, Huron Cement's coal burner, the *S. T. Crapo* (built 1927; 4,769 gross tons), was loading cement for delivery to the company's Saginaw distribution terminal when the coal-burning *Kinsman Independent* came steaming in to load 14,000 tons of cement for Huron's facility at Superior, Wisconsin. The *Independent* (7,490 gross tons) was built in 1923 by American Shipbuilding Company of Lorain, Ohio, and is part of the Kinsman Lines fleet belonging to George Steinbrenner, owner of the New York Yankees baseball team.

While these two coal burners were puffing away in the harbor, Huron's *E. M. Ford* was just outside in a lay-up slip. Built in 1898 by Cleveland Shipbuilding Company, she is the oldest operational large freighter left in the Great Lakes and probably in the world that is still in her original configuration. At 4,575 gross tons, she is a quadruple-expansion steamer. The original 1898 engine remains, although the *Ford* was converted to oil from coal in 1975.

The following day the *George A. Sloan* also steamed into Huron's terminal to discharge 13,000 tons of petroleum coke for the company's power plant. The *Sloan*, built in 1943, is owned by United States Steel (see Chapter 16).

Together these four ships constitute a sizable portion of the fifteen steam-powered cargo vessels left in the United States and Canada. The *Crapo* and the *Independent*, the only coal burners still operating there, are very likely the only large coal-burning cargo vessels of their age left in the world. Those of us who care about old ships certainly hope that at least one of these vessels will be preserved when her services are terminated. Perhaps this cement-producing town will someday have a floating museum, a permanent Alpena connection.

A side street in the little city of Alpena, located on the shores of Lake Huron.

Alpena's Fieldstone House, located on majestic, tree-lined State Street, was hand built in the early 1890s.

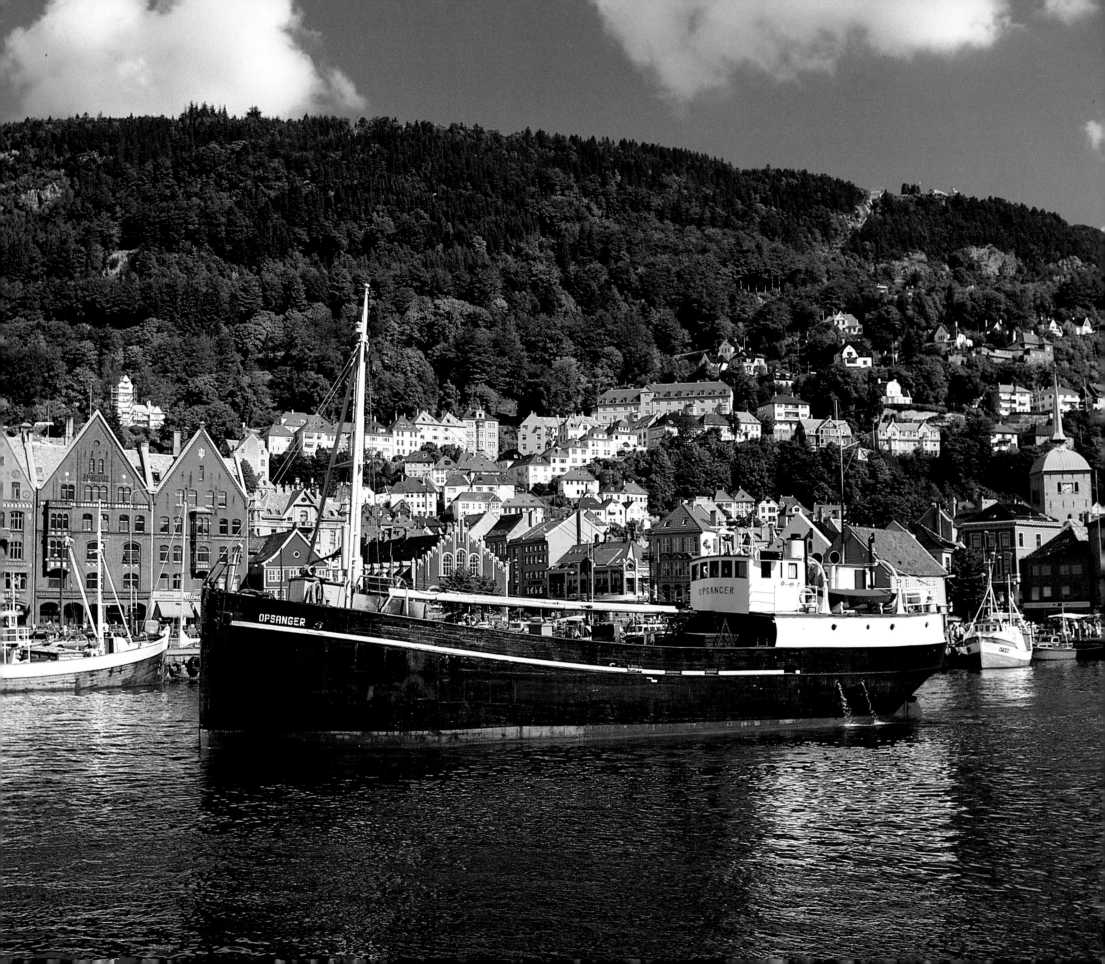

BERGSETH AND OPSANGER

Journeys in the Norwegian Fjords

*L*ittle blond Andoss is exploring. He has toddled across the galley and is balanced belly down over the door combing that leads to the poop deck. He is trying to get one chubby leg over the raised threshold and has his eye on a white life ring attached to the stern rail. Twenty steps farther and he will be at or under the rail and perhaps into the icy waters of Norway's Osterfjord. Six-year-old Hanna silently watches her baby brother, curious to see if he will be able to get over the threshold and cause some mischief. In an emergency Hanna will certainly come to his rescue, but that crucial point has not quite been reached. Eva, the children's mother, is busy cooking *panne kake* (Norwegian crêpes) and talking to the visitors. For the moment she has lost track of eighteen-month-old Andoss.

Eva Bernes is a vibrant, robust young woman. This is fortunate, because besides being a mother, her duties include being second mate, cook, line handler, helmsman, deck swabber, and ship's painter. She studied design at the university in Bergen, and for a year after graduation she made window displays in some of Bergen's department stores. Then she married Ove and

her life changed completely. Instead of living in the fashionable world of the cosmopolitan single woman, she found herself working as a sailor on a small cargo vessel and residing in a tiny, isolated village on the Osterfjord.

Now that Eva has two small children to take care of, she does not always sail on the *Bergseth*, particularly in the winter, when the whole ship may be covered with ice. Then Ove takes another crewman and Eva is alone with the children. Is it difficult for her? "No," she says. "In my little village is my mother-in-law and my sister-in-law and the whole family. They are very, very warm people. Everybody is very close so you don't feel you are standing outside. You are always together."

"About the children, do they understand the hazards around the ship?"

"Hanna does," Eva replies. "Since she was ten months, when she was quite young she understands very much of what we have told her. She is careful, but Andoss..." She pauses and looks around for the baby. Seeing him on his way

The *Bergseth* sailing through the Osterfjord
to deliver a load of sand.

out the door, Eva dashes over, scoops him up, and plunks him down in a safe place next to her. She gently admonishes Hanna for not retrieving her baby brother. Shy Hanna is mortified and buries her head in her mother's lap.

The *Bergseth* carries sand used for road construction and cement making. The sand is taken from a quarry at the end of the Osterfjord to nearby fjords or to Bergen itself. The journeys are short, generally less than a day's sailing in each direction. Sometimes a longer trip, up or down the coast, might take a week. Except for two months in the middle of winter when she is laid up for maintenance, the *Bergseth* is almost always on the move. She makes about 120 trips a year.

Built to be a lighthouse tender for the government, the *Bergseth* originally had sleeping accommodations for perhaps a dozen men in her fo'c'sle. She serviced Norway's lighthouses until 1962, when she was sold to a private party and converted into a cargo carrier. A pilothouse that had once been on a fishing boat was added, as was a chart room removed from some other small vessel. Ove, who has owned her for five years, added automatic hatchcovers in 1983.

Andoss has been deposited with his father in the wheelhouse. Ove pilots the *Bergseth* while he cradles little babbling Andoss and tells about himself and his work. "I was twenty years when I started sailing. I was sailing with Mr. Bergseth, who was owner of this boat then. He wanted to sell it to buy a bigger one, so I took a loan from the bank and bought it. At that time the loan was about ten percent [interest]. Now it would be more than fifteen percent. So maybe now it would not be possible for me to buy this ship. You can't afford to buy a new boat to carry sand, and to carry things more profitable than sand you need a much more expensive, specially built ship."

Ove continues talking about the changing business conditions for coastal shipping in Norway. "The boats are getting bigger with more specialized equipment, and many of the smaller boats are not going anymore because they can't compete against the bigger ones. You don't earn enough money on a little boat. The number of crew is about the same. I can go with three [including himself] on this boat for a cargo of three hundred tons, and maybe I would need only four or five on a much larger boat and it carries maybe two or three times as much as we do."

The future does not look promising. Will Ove continue with the *Bergseth*, or would he like to be in another kind of business? He replies, "When you have started with a work, you have to continue. I think so. It is difficult to start on another thing in the middle of your life."

Still, Ove is intelligent and he looks as if he would take advantage of any good opportunity that presented itself. Also he likes his work, and business must not be too bad. The previous winter he and Eva were able to take a vacation to Disneyworld in Florida.

Supper is ready. Ove and Andoss go down for their dinner of *panne kake* and Eva and Hanna do their spell at the wheel as the *Bergseth* makes its way between the towering mountains turning gold in the evening sun.

In the Veafjord on the Opsanger

Like the *Bergseth*, the *Opsanger* is a sand carrier. Built in 1917, she is largely in her original condition, except for her V-12 G. M. diesel. The hull is double-planked three-inch Swedish elm on steel frames. Her deck and pilothouse are of Swedish elm as well. The wood is highly valued for marine use in the Scandinavian countries because it can be bolted directly to steel without rusting the metal. The *Opsanger* is smaller than the *Bergseth* but can carry about fifty tons more sand. Like the other vessel, she is family-owned and -operated.

Mons and Jan Vik are cousins, both in

The *Bergseth* underway in the Osterfjord near Bergen, Norway.

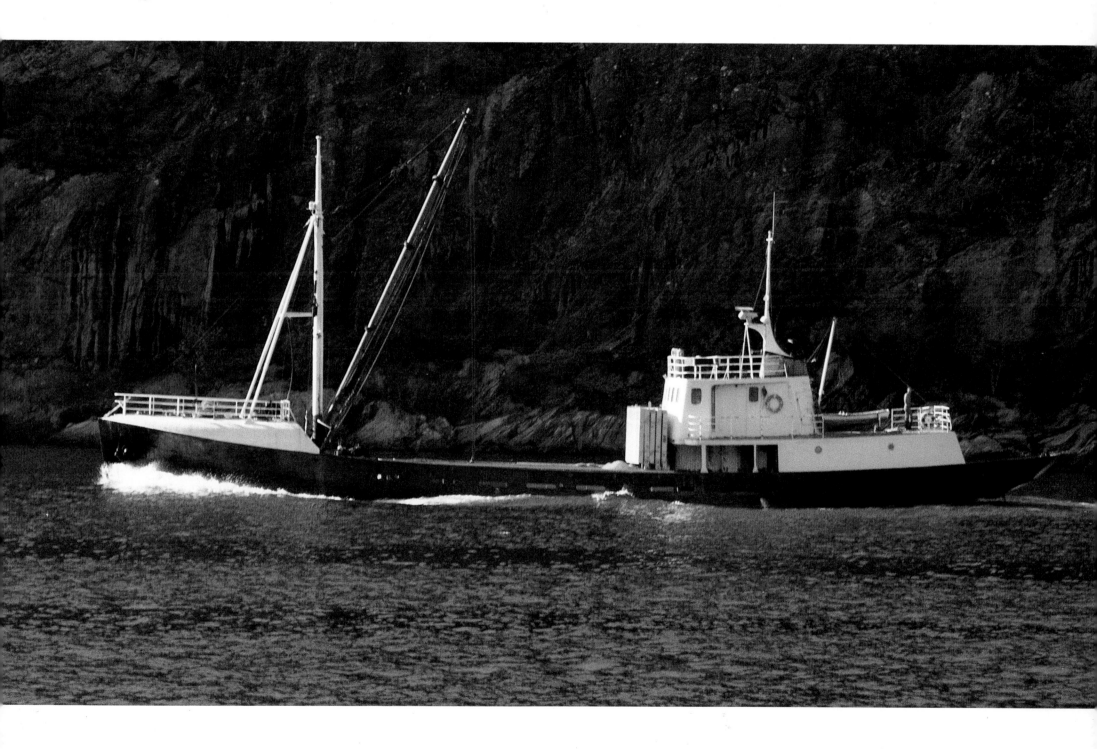

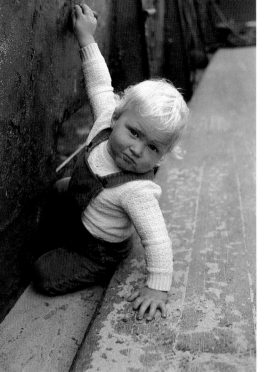

Eighteen-month-old Andoss has spent much of his life on the *Bergseth* and is right at home exploring her decks and cabins.

The Bernes family aboard the *Bergseth*. The man on the right is Eva's brother.

Cousins, Mons and Jan Vik, enjoy a *smörrebrod* lunch while Henning takes the helm of the *Opsanger*.

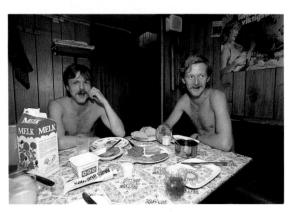

their early thirties, and together they sail the *Opsanger*. Mons is the engineer and owner, along with his father. Jan is the captain. They have just delivered a cargo of sand to a place near Bergen and are returning home. They sail in one of the most spectacular areas in the world. Today is a beautiful August day, and the mountains rising straight up from the fjord are covered with conifers and meadows of young summer grass. The fjords are alive in a thousand shades of green and blue. There is joy in the air.

Both Jan and Mons, along with most of their compatriots, are taking advantage of the weather. The uniform of the day consists of shorts and and tennis shoes. Their crewman, Henning, who previously sailed on Norwegian navy torpedo boats, is similarly attired. Henning doubles as ship's cook. Mons says that Henning's specialty is strong beef. Today, however, there is a simple *smörrebrod:* Danish salami, Jarlsberg cheese, pickled herring, onions, and good Norwegian rye bread and butter. Henning takes the helm while Mons and Jan eat. Then the two cousins return to the wheelhouse. One handles the ship while the other lies out in the sun in an old plastic deck chair. This is tough sailing.

Though operating a coastal vessel here is bliss in the summer, it is just the opposite in the winter—and a Norwegian winter lasts half a year. Winter work is demanding and can be dangerous. In sub-zero weather, spray taken on board turns to ice. If ice or snow builds up on a ship, particularly if she is on ballast, she can turn turtle from the tons of extra weight above her waterline. Ice must be broken with an axe and the decks constantly shoveled. Often visibility is nonexistent, and navigating by radar in the narrow, winding fjords is difficult at best. Radar reception during heavy snowstorms may be very poor.

Offshore the situation can be equally bad. Strong winds and heavy seas are common in the

North Sea during the winter, and hatchcovers must be made very secure. Seawater in an empty hold can be pumped out, but if a ship is loaded with sand and the hatchcover is breached, the cargo will absorb the water until the additional weight may sink the vessel. The Viks do not normally operate the *Opsanger* during January and February. Nevertheless, if there is sufficient cargo to warrant a trip, the extra revenue is difficult to turn down.

It is early evening by the time the *Opsanger* reaches her home port, a quaint village ten miles from Stamnes. The summer sun is still high in the heavens as the *Opsanger* is secured and the two cousins pile into a decrepit old Opel and head for home. Home is Vik and Vik is extraordinary.

After a few miles on the main road skirting the fjord, the Opel turns off onto a narrow lane and begins to climb. Traversing a series of winding switchbacks, climbing higher and higher up a mountainside, it finally reaches a verdant little valley lying between two ridges. The whole Osterfjord seems to lie a thousand feet straight down. Beyond, mountaintops spread from horizon to horizon.

This valley, nestled in a crook of the mountain, is lush with meadows and stands of pine. Scattered around the valley are twelve houses, all belonging to the family Vik. Besides Nils (Mons's father) and Johannes (Jan's father), there are two other senior Vik brothers, as well as eight sons and daughters and all their families. Each family lives in its own traditional steep-roofed cottage, and each has its own vegetable garden. The valley Vik is awe-inspiring in its beauty and tranquility.

The first Vik in Vik was grandfather Nils, who bought the valley at an auction in 1860. He cut timber for the local people and had a small farm. Two of his sons, Mons's and Jan's fathers, started with a small boat and progressed to larger, more capable vessels. They carried fish, sand, timber, and almost anything else that needed transporting, for in those days there were few roads along the fjords. Jan and Mons sailed with their fathers from the time they were children. Mons attended a school for marine engineers and Jan a special school for coastal captains. Each of the men has a small son, and while they both say that it is up to the children themselves, most likely another generation of Viks will be raising families in the little village and sailing tramps through Norway's fjords.

Dawn on the Veafjord.

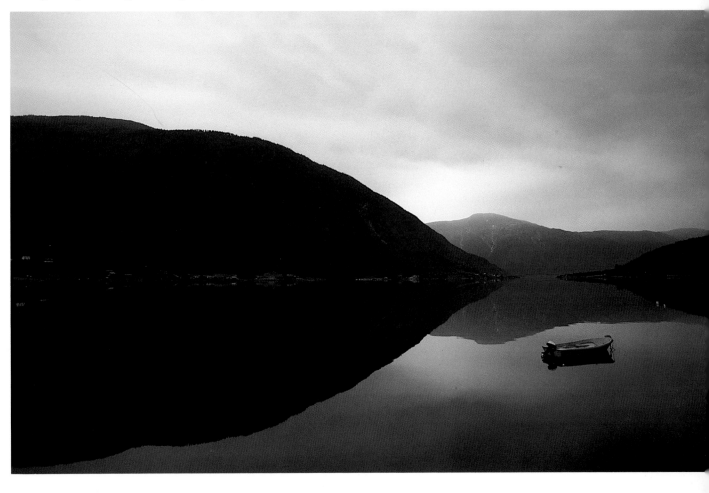

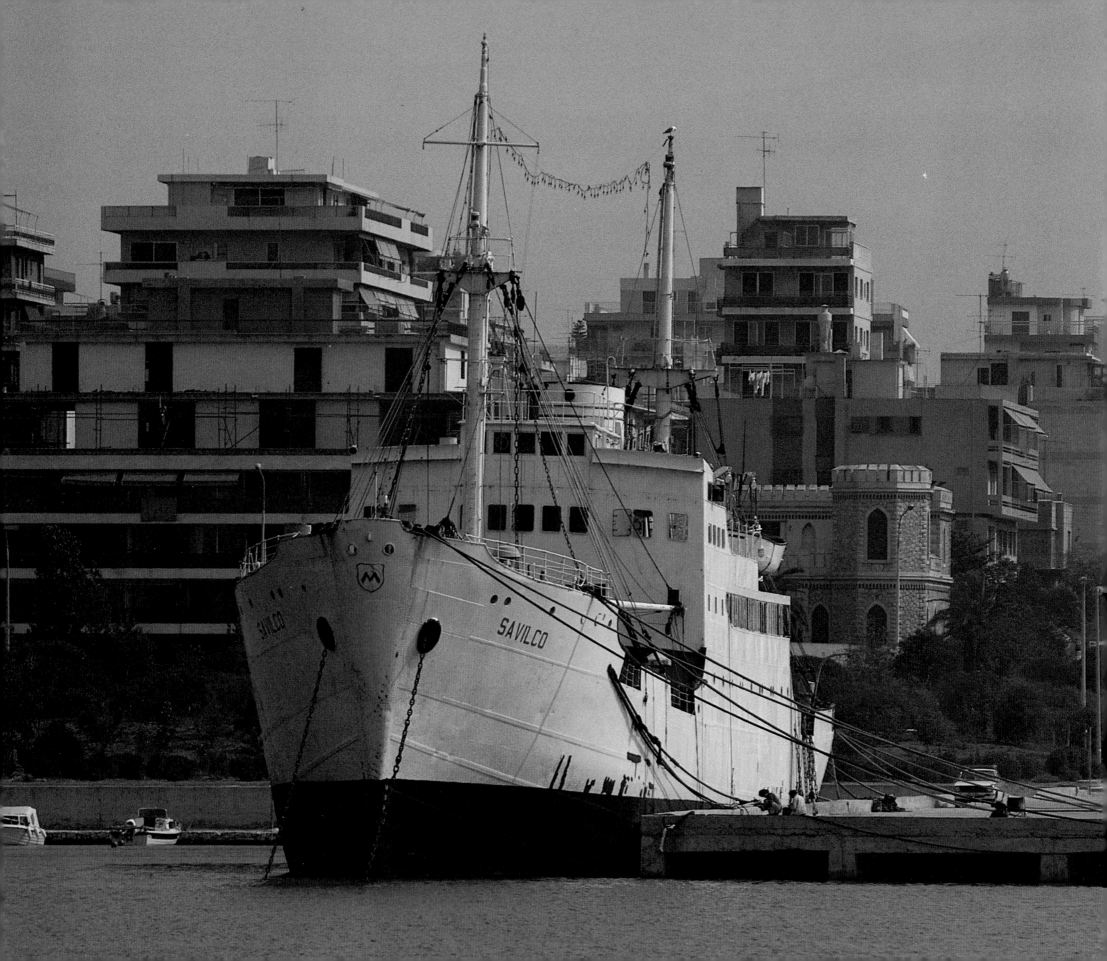

SAVILCO

Torpedoed!

As German panzers began their May 1940 blitzkrieg of Holland and Belgium, the *S. S. Wickenburgh* sailed from Rotterdam with a general cargo and twelve frightened passengers who hoped to escape the onslaught. She was on her scheduled run, bound for Curaçao and other Dutch islands in the Caribbean. The *Wickenburgh* passed the Hook, off Rotterdam, then headed south along the Dutch coast, but she did not get very far. Without warning, a German torpedo hit her amidships and exploded near her engine room.

A lovely ship she was. Only two years old, she had been built in Lübeck, Germany, for the W. H. Müller Company, her Dutch owners. Larger than a coaster, but smaller than most transoceanic freighters, the *Wickenburgh* was a shelter-deck vessel designed especially for the Caribbean trade. She had a large refrigerated hold forward and luxurious public rooms for her twelve passengers. She also had extra-thick hull plating to guard against North Sea ice, but it did not protect her from torpedoes.

The *Wickenburgh* was sailing alone that morning. Convoys had not yet been established, and certainly not in Holland. Extra watches had been posted, but no one saw anything. The U-boat must have been stationed just off the Dutch coast for the express purpose of picking off such fat chickens as the *Wickenburgh* and, defenseless, she was an easy target indeed: a perfect gleaming white silhouette against the low Dutch headlands. The submarine commander no doubt figured that one torpedo would be sufficient. He was right.

Imagine you are an engineer working in the ship's boiler room, a space perhaps seventy feet long, thirty feet wide, and fifty feet high. You work below the waterline; four very steep ladders are the only means of reaching the deck. The engine room is cramped with the enormous boiler, a triple-expansion steam engine, and dozens of auxiliary engines, condensers, generators, pumps, and other heavy machinery. All around you are pipes conducting live steam, and if one breaks, it can scald you to death in less than a minute. Except for a small skylight, all the light is derived from the electric generating system. The explosive power of a torpedo is so great that a

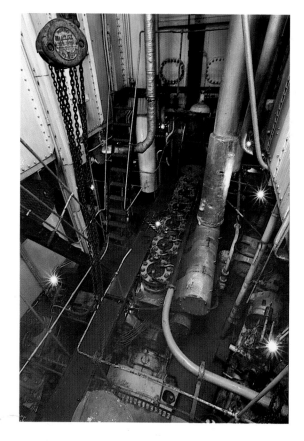

The five-cylinder M.A.N. diesel is kept immaculate by the engineering students.

The *Savilco* lies in a small harbor south of the main Greek port of Piraeus. She poses an interesting contrast to the neighboring waterfront apartment buildings that line the shore.

Emmanuel Marcozanis explains the operation of *Pythagoras*, the maritime academy he founded, to visitors.

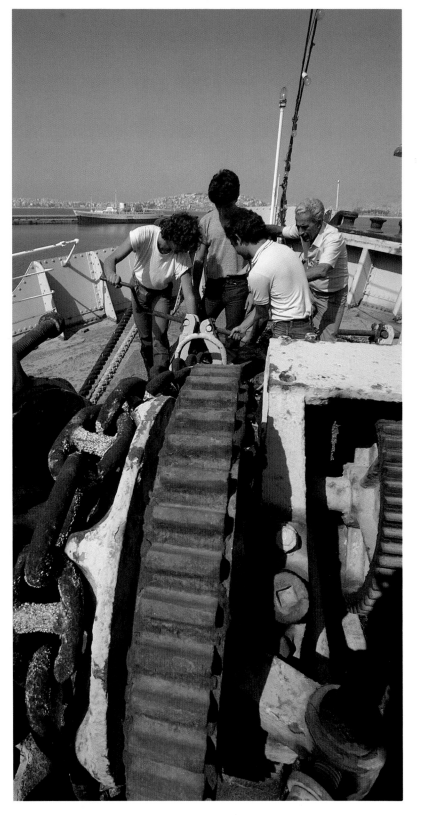

Students learn how to operate an electric anchor windlass. The corrosion on it testifies to its lack of use.

Winch operation and cargo handling are important aspects of deck training. The *Savilco* provides an excellent stage for "hands-on" learning. Here the students are shown how to rig and position derricks in preparation for loading or discharging cargo.

resulting fire will certainly ignite the bunker oil from ruptured fuel lines, creating an instant inferno. You now begin to understand why it takes brave men to work in a ship's engine room during wartime.

When the torpedo hit the *Wickenburgh*, there were probably four men in the engine room. The explosion and its aftermath must have seemed like the end of the world: hull and deck plates torn asunder, boiler and steam lines ruptured, the hideous roar of great volumes of live steam escaping and the screams of scalded men, the ship suddenly listing heavily as thousands of gallons of seawater invaded her. It is hard to imagine more terrifying circumstances. To those trapped in the dark, disoriented and not knowing which ladders must have collapsed, the situation must have seemed a hopeless one.

Somehow all the men below dragged themselves out. Finding ladders that had not been torn from their stanchions, the injured, aided by the more fortunate—and perhaps by some of the deck crew—climbed to safety. Once the crew and passengers gathered on deck, lifeboats were launched and everyone left the ship before she went down.

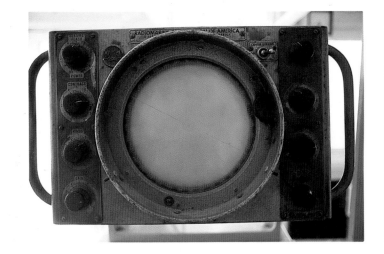

This RCA radar (model CR103), one of the first commercial radars, was used on many World War II Liberty ships.

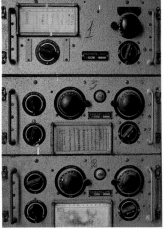

The *Savilco*'s Radio Holland radio telephone is believed to have come out of a U.S. Army Dakota (DC-3). It, like most of the ship's radio and navigation equipment, was scavenged from any available source immediately following the war.

The ship's radio room looks like a communications museum. However, almost all the equipment still is in operating order. On the desk are two receivers and to the right of them a Radio Holland transmitter. To the left of the desk are transmitter components, each operating different frequency ranges.

That no one was killed on the *Wickenburgh* is some sort of miracle, but it can probably be attributed to two factors. First, her boiler was most assuredly not superheated (a superheated boiler pumps steam through at very high pressure). If it had been, a secondary explosion would have occurred when the boiler ruptured that likely would have killed everyone in the engine room. Second, it seems probable that the German submarine captain did not realize how shallow the *Wickenburgh*'s draft was and he set his torpedo to run too deep. Thus, the torpedo probably hit at engine-room-deck level or even below it, somewhere on the keel. The impact, therefore, was not concentrated in the engine room.

The *Wickenburgh*'s survivors reached the Dutch coast, where an uncertain fate awaited them. The ship went to the bottom of the English Channel, to be joined later by many other vessels, both Allied and German.

After the war many shipping companies brought old Liberty and Victory ships, freighters that had been built in American and Canadian yards to move the vast quantities of material necessary to supply the war effort. These vessels,

however, were poorly suited for much of the intra-European shipping that was again developing. European shipyards were still in shambles, as were the steel mills and most of the industrial plants required to produce all the specialized machinery that goes into a new ship. W. H. Müller, the *Wickenburgh*'s owner of record—even though she was still at the bottom of the English Channel—needed a smallish vessel in their Europe–North Africa service. So why not raise the *Wickenburgh*? Why not indeed. After all, she was practically new, having been in service for only two years before she was torpedoed, and if she could be salvaged, it would save a great deal of both time and money.

The *Wickenburgh* was in shallow water not far from Rotterdam. Divers using air hoses pumped compressed air into many of her tanks and other relatively airtight spaces. With enormous barge-mounted cranes she was raised, the water was pumped out of her, and a temporary patch was welded onto her torn hull. She was then towed to Rotterdam. But that was the simple part.

When the *Wickenburgh* was brought into the Niehuis & van den Berg shipyard in Rotter-

dam for repairs, everyone's fears were confirmed. After more than eight years on the bottom, her giant steam engine, and all her electronics and auxiliary engines, were corroded beyond redemption. Certain pumps and other machinery could be reconditioned, but her whole power system had to be replaced. And replaced with what? No new marine diesels of a size large enough to power the *Wickenburgh* were yet available, nor was any of the equipment necessary for navigation or communications.

Both the shipyard and the Müller Company searched Europe for replacements, at first with no success. Then someone heard of an almost new German diesel engine that might be available. Engineers checked the specifications and decided that it certainly would work in the *Wickenburgh*. After an inspection the Müller Company snapped it up. It was a 1,450-horsepower, five-cylinder M.A.N. diesel from a boat that had never sailed—a German submarine.

Even with the engine in place the search had barely begun. Fortunately some types of new equipment were again being produced. Two new dynamos were ordered, as well as electric motors to power all the winches and the windlasses.

The master's cabin shows the fine quality of paneling and joinery that were common on prewar-built cargo vessels.

New Seimens electric steering and an RCA radar were purchased, but radio equipment was unavailable.

The problems were solved by the time-honored method of scavenging. What has to be the original Telefunken radio direction finder was purchased from a Liberty ship ready to be scrapped. A radio telegraph was acquired from the same source. From somewhere else came an old U.S. Navy compass. The crowning glory was the Radio Holland radio telephone that was taken out of a C-47 Dakota (Douglas DC-3). Finally in 1953, looking like a mechanical and electronic Noah's ark, the *Wickenburgh* sailed again.

During the next eleven years the *Wickenburgh* traded between Holland, England, France, and North Africa, with her main ports of call in Morocco. In 1964 she was sold to a Greek merchant by the name of Livas. He reversed the spelling of his name and rechristened her *Savilco*. Her new owner put her to work as a tramp, carrying logs from Archangel, Russia, to Greece, and later from Romania to Tripoli, Lebanon. For a while she also carried general cargoes between Italy, Spain, and Algeria. Mr. Livas, a minister in the Greek government, apparently was a better politician than he was a shipping magnate, for his company went bankrupt and a Greek bank took ownership of the vessel. For eight years the *Savilco* lay in Piraeus rusting. Her present owner, Iacovos Emmanuel Marcozanis, bought her in 1971 for the bargain price of $65,000, and for the second time the phoenix rose from her own ashes.

Marcozanis is one of an astonishing number of Greek success stories. In true Horatio Alger fashion he started from humble origins, his father being a woodworker in Piraeus. Born in 1919, Marcozanis worked his way through technical school, studying mechanical engineering and architecture. In 1945 he started teaching at a technical school in Piraeus and three years later

founded his own "technical institute" with a grand total of four students. In the next thirty years Pythagoras Maritime and Technical Schools, named after the Greek philosopher and mathematician, grew to be the largest private technical academy in Greece. It has had as many as 3,500 students enrolled and more than 200 professors and instructors. It presently occupies five large buildings in Piraeus and one in Athens. The curriculum ranges from auto mechanics and electrical repair to mechanical engineering and architecture, but more than half of its courses and students are involved in either merchant-marine-officer or engineer training. In fact more than 60 percent of the engineering officers on Greek flag vessels have graduated from Pythagoras.

At sixty-four, Marcozanis is a wealthy man who dabbles in both real estate and the Byzantine world of Greek politics. When he bought the *Savilco*, she was in a sorry state of neglect. It took eight months for her refit, which included among other things the installation of a new propeller and shaft, an engine overhaul, the replacement of most of the cargo rigging, and some new derricks.

In 1972 the *Savilco* went to sea again. Her master, Captain Antonios Hatzifotis, an easygoing, rotund Greek who had also been *Savilco*'s captain under her previous owner, describes her last years as a tramp.

"In that time [1972–80] we sailed *Savilco* over all Mediterranean. In Saloniki we loaded two thousand tons of fertilizer for Trabzon on Black Sea. Then to Costanza and we loaded logs for Lebanon. *Savilco* is very good for logs. She las large holds forward and winches are high up [the winch platforms forward are elevated above the deck] so can carry large deck cargo. We had many logs on deck, up maybe three meters, fastened by chains, and off Dardanelles we come to storm of 8 Beaufort [winds of forty-five to fifty-five miles per hour], and we think maybe we have trouble. But *Savilco* is good stability. Is no problem for heavy seas. She has good hull design and thick plates. We have no trouble."

Captain Hatzifotis is on the bridge showing his old ship to visitors. He runs a hand over the ancient Radio Holland radio telephone. A visitor asks if it still operates. Captain Hatzifotis nods vigorously. "Sure, if you maintain her, she will operate. These are simple things. You can

The seafood restaurants that line the little fishing harbor of Mikrolimano light up the evening sky.

The sun rises over the Greek coast looking south from Piraeus.

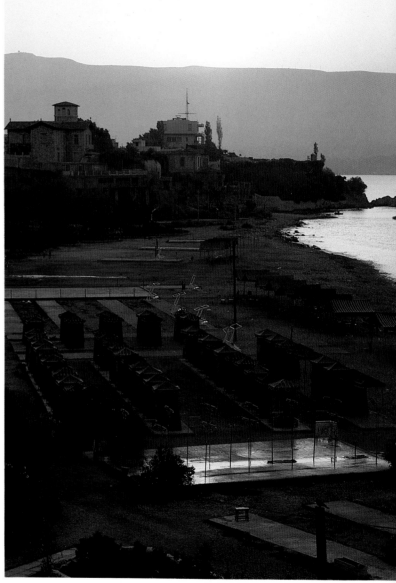

find the damage easily, but is hard to get parts—sometimes we have to make." He points to the transmitter on the bulkhead behind the bridge. "This one, in Lebanon, the what-you-call-it, the tube is bad, and we cannot find new one because is so old. So second mate, he was very good with such things and he take tube apart and make new inside and I watch him and now we can do these things. Is no problem."

The problem is, Captain Hatzifotis no longer has a command. The first eight years the *Savilco* sailed for Marcozanis, she traveled mostly from European ports to North Africa carrying logs and cement. Then he decided to use her as a floating training ship, taking cadets to sea so they could learn firsthand how to operate a merchant vessel. For one reason or another the Greek authorities refused to issue Marcozanis the necessary permits to sail with cadets. So the *Savilco* now sits in Piraeus. Some of the public rooms have been converted to classrooms, and students are being trained on board in the fundamentals of cargo handling, seamanship, navigation, and engineering. But the training does not have the same impact as it would have on a sailing freighter.

The *Savilco* is an ideal floating classroom-merchant ship. Her machinery is well maintained by the students under the watchful eyes of their instructors. She could easily accommodate two dozen cadets at a time in the old passenger cabins. But until the Greek government relents and issues the necessary permits, the *Savilco* will go nowhere.

Antonios Hatzifotis hopes he will again have the opportunity to command the *Savilco*. With the worldwide recession eliminating the need for much of Greece's merchant fleet, he has not been able to find a master's berth, or probably one even as a mate on another vessel. He looks wistfully out to sea. What is one to do? He can do nothing. So sometimes Hatzifotis wanders over to the *Savilco*, putters around his old ship for a while, gazes longingly at the ocean, then trudges home again.

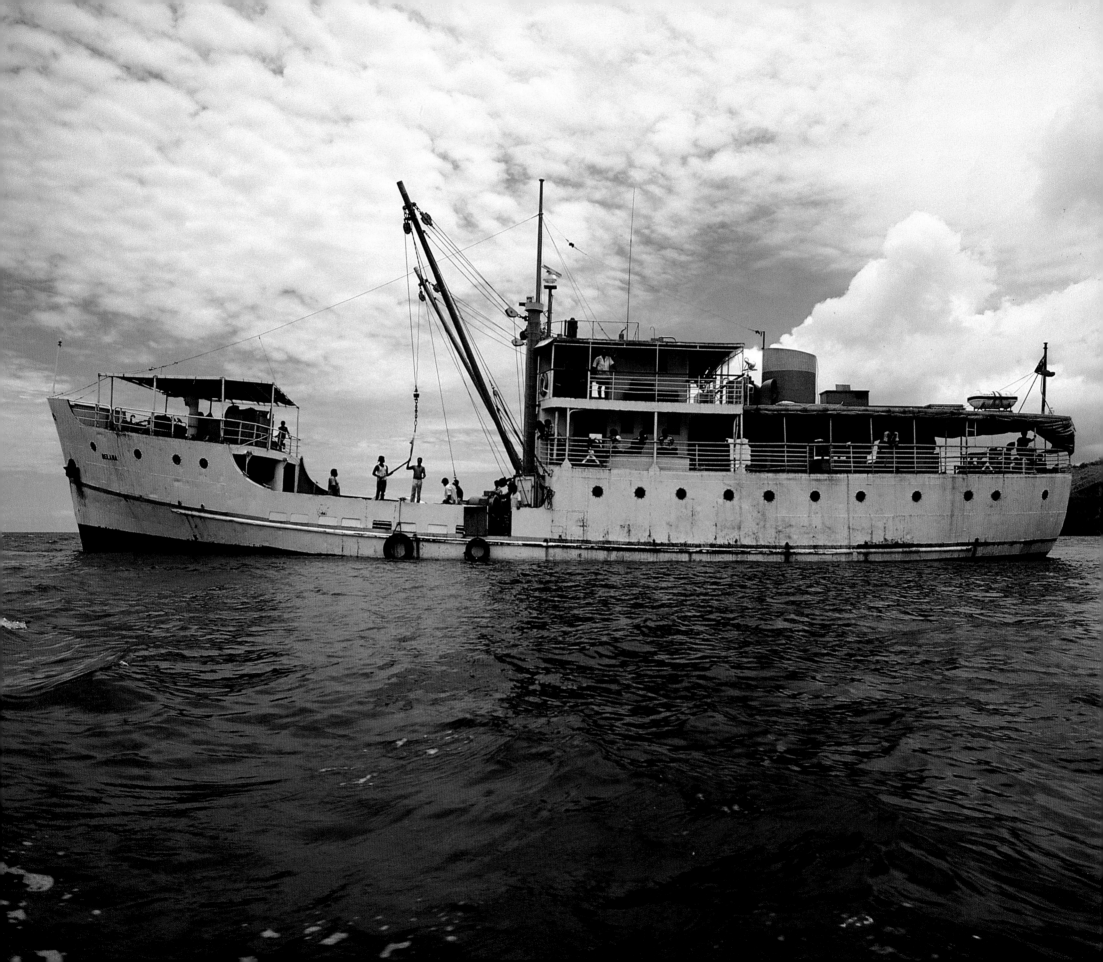

BELAMA

Passage to Kadavu

A Fiji war drum is beating above my head. Wearily, I drop down from the upper bunk to the deck, put on some clothes, and investigate the sound. The sun has not come up yet and the air is cold. Fijians, rolled up in their sleeping mats, some covered with towels, litter the deck like woolly-headed cocoons. The little *Belama* can carry twelve cabin passengers and ninety deck passengers. Each sleeping-deck passenger is allotted a space two feet by eight feet, each sitting-deck passenger a space four feet by one and a half feet. Every inch of the deck is filled, but it is not clear by how many "sitters" and how many "sleepers." The two categories are jumbled together in a multicolored, amorphous mass. It takes some fancy footwork to cross the expanse of deck without stepping on a sleeping Fijian.

The thumping noise gets louder. Forward, under the bridge, five men sit around a fellow who is pounding in what looks like an old-fashioned wooden butter churn. A big, handsome young Fijian good-naturedly beckons me to join them. His name is Jess. He and his friends have been in Suva and are returning to their village, which lies on the far side of the island we

are now approaching. Jess's buddy is crushing roots to make kava, the seminarcotic beverage that is the national drink of the Fiji Islands. The men have been drinking it all night and their eyes are glazed. I am immediately offered a cup. It is six o'clock and I would much rather have a cup of coffee, but so as not to offend them I take a sip. It tastes like dirty dishwater and numbs my tongue. The custom is to down the whole bowl. I tell them, thanks, but I never drink kava before breakfast. We start talking about their island and in five minutes the seven of us are like long-lost brothers. It is not the kava. It is the Fijians. They are the friendliest people on earth.

The *Belama* approaches Vunisea, the first stop and only real town on the island of Kadavu (pronounced Kahn-*dah*-voo). Lying south of the main island of Viti Levu, on which the city of Suva is located, Kadavu is a sparsely populated forty-mile stretch of mountains, shaped like the foot of "the boot" that forms southern Italy. The only flat spot on the island is here at the northeastern

The funnel of the *Belama* registers a vivid contrast to the brilliant Fijian sky.

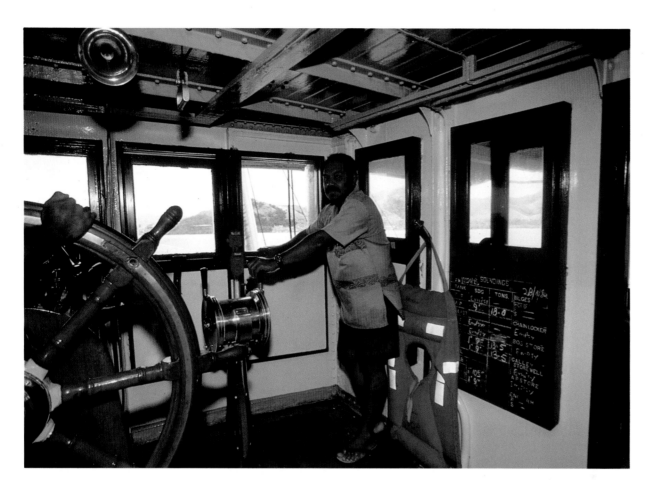

Captain Sammy in the wheelhouse.

end. Vunisea boasts not only the island's only airfield and wharf, but also its only two miles of road—running from the airfield to the wharf. Houses, some small stores, and a few dilapidated public-works buildings are spotted helter-skelter amid bougainvillea, palms, and giant ferns. Tethered cows and goats munch lazily alongside the coral road. Building materials go off the *Belama* and not much comes on. In an hour she is away again, heading west to the island's other villages.

Jess and his friends are still drinking kava. Jess lived for eight years in Suva, second largest city, after Papeete, in the South Pacific, working as a bookbinder in the government printing office. I ask him what differences exist between city and village life. With a frown he says, "Well, living in Suva, it is a worrying life. You know every movement of life has to concern money. You have to have it for everything. In Kadavu you don't have to bother about it—money is not part of life. In the Fijian [village] life the only thing that is important is you have to look after everyone related to you. I mean, if you have food or something they need, you give it to them or loan it to them. The tradition with Fiji life is, for example, if there is a family who's lost their husband and maybe the mother and the grandmother are there and there is no one to look after them, we in the village look after that family. You go fishing and give them some fish. You go to the bush, you bring them some food. It's not a fact of helping each other, it's part of life."

We have been sailing about a mile out, paralleling the spiny green mountains that range down the island. Now the *Belama* pulls in close to a small village called Richmond. Slings of plywood are lowered into the workboats that come alongside. One workboat heads in to the beach loaded high with plywood and bags of cement, topped off by a new Yamaha outboard still in its crate. All these supplies are for the new Methodist school under construction. The workboat

A Fijian crewman steers the *Belama* alongside the dock at Vunisea.

Ratu Arthur Tuigalo Soqo Soqo, chief of Bukulevu, returns to Kadavu after taking care of village business in Suva.

A crewman shifts the position of the derrick to load kerosene cans from the dock.

ferries back new passengers, who bring with them burlap bags of kava root.

A kindly old gentleman with a beautiful carved, knob-headed cane sits serenely on board the *Belama*, enjoying the goings-on around him. His name, he says, is Ratu Arthur Tuigalo Soqo Soqo, and he is an island chief. "Ratu," Arthur says, "means royalty, Tuigalo means king of Malo—a local area—and Soqo Soqo, inherited from my father, means collecting the people of the local villages and bringing them together."

Ratu Arthur is a joy. He speaks with an old-school British accent, and his whole demeanor, everything about him, sparkles with gaiety. "I was also a teacher. Yes," he says with a laugh, "two hats I wear. I started teaching primary school here in Richmond, then was an agricultural officer, then a forestry officer—that until I retired in 1960. Also, I have my job as chief. My district here, Bukulevu; we have eleven villages. Also, now, there are four schools in the district. Everyone gets at least a primary education. The chief 'business,' yes, that is passed down from generation to generation—at least four generations in my case."

I ask Ratu Arthur, who has lived in Australia and has seen some of the world, whether life in the villages has changed since he was a boy. "I don't think there is very much change there, not many changes," he answers, "except, you know, when the children go out, they come back with different ideas and so forth. I find everything is all right. Whereas in the old days the chief administrator was running everything for the people, now they do more, make more of the decisions themselves. There are meetings, usually every Monday in the villages, maybe men in the morning and for women in the afternoon,

A workboat approaches the *Belama* with a load of passengers. Mount Washington, named for U.S. President George Washington, is prominent in the background.

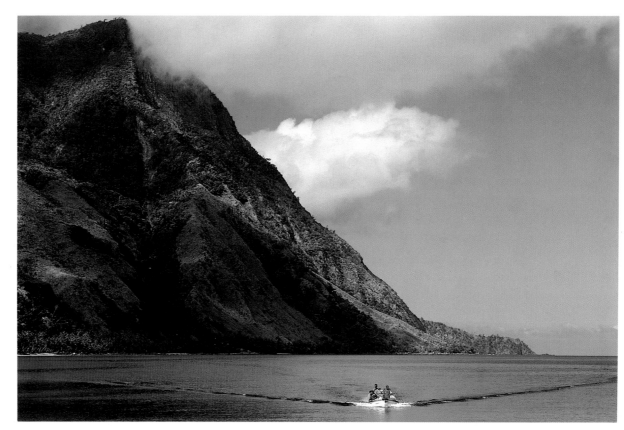

A crewman loads cans of kerosene in Vunisea for delivery to the more remote villages on Kadavu.

and they assign work for all the individuals now. [All the land is communally owned.] In the olden days maybe the people didn't do so much work, but now maybe they work harder. Otherwise they can't send their children to school."

I ask him why that is. Ratu Arthur says, "Well, it costs one hundred and ten dollars a year to send a child to school past the primary years, and they all want to do that. They want their children to be educated and also there is status associated with that, so I think the people work a little harder than before, but really, there are not many changes in these country villages."

As the *Belama* makes her way around the island, she stops at one bay after another, usually anchoring in deep water outside a coral reef. These reefs, constantly battered with waves, mother the calm turquoise lagoons inside them. Clouds shift across the mountains, coming and going. The rich greens of the mountains, the lagoons' brilliant blues, and the deep aqua sea create a fantasy of color. Slowly but steadily the ship progresses down Kadavu's north coast. The workboats shuttle back and forth to isolated villages, carrying building materials, drums of gasoline, and miscellaneous cargo, as well as passengers returning home. New passengers come on board bringing their crops, usually kava root, tapioca, or sweet potatoes, to sell in Suva. This world provides a placid sense of continuity. Life here was the same yesterday; it certainly will be the same tomorrow.

The *Belama* accommodates a large number of passengers relative to her length. She was built in Hong Kong for the British high commissioner, or governor general, of the Solomon Islands when they were still a British colony. The commissioner made his inspection tours on her. After five years she was sold to the Gilbert and Ellis Islands, where she was used for roughly the same purpose before those islands were formed into the Republic of Tarawa. Then the Wongs

bought her. The Wong Shipping Company also operates the 450-ton freighter *Tovata*, and the *Evelyn*, which is a forty-foot auxiliary cutter used to transport copra and supplies to and from Fiji's smallest outer islands.

There are supposed to be one hundred villages on Kadavu, and by the second day it seems like the *Belama* has stopped at half of them. It takes an indescribably long time to load the workboats, bring them through the reefs, unload and reload them, then return and discharge their small cargoes into the *Belama*. The Wong Company is fighting an uphill battle to stay in business. The cargoes are too small to justify the time it takes to load and discharge them. While passenger revenue helps, it still does not compensate for the low productivity of the ship.

Patrick Wong, a bright young man, who with his father, Wong Si Sing, operates a company, describes their plight. "Fiji is a funny, sort of circular place. All the islands radiate out from Suva. Most of the smaller islands are within one hundred to two hundred miles of the main port, so that is less than twelve to eighteen hours' steaming time away. The islands could be divided into three categories. There are the main ones like Vanua and Ovalau, which have most of the population and freight. They have roads around them and recently a company bought some old ferries and now they drive everything to and from those islands. Then there are some islands which have a fair amount of cargo but don't have roads, and there are some new tugs and barges now operating to these islands. Our company hasn't been able to compete with these new developments. So we are left with the small islands that have no roads and just with the crumbs [of cargo] to pick up. Crumbs are not sufficient."

Si Sing, the genial elder Wong, was born in Fiji, ran a plantation, then bought a small wooden coastal trader. He continued buying and

A sling of wood, part of the materials for a new Methodist school, is lowered into the workboat for delivery to the village of Richmond.

A boisterous group of passengers plays cards on the deck just aft of the funnel.

selling small vessels, eventually working his way up to steel freighters. A third ship, the *Isakoola*, crashed and was lost on a reef off the main island. Now the senior Wong is in a quandary. He figures it would cost at least half a million dollars to buy a modern vessel, be it a small ferry or tug and barges, to meet his competition. However, since the Fiji government does not regulate or assign shipping routes to individual companies, the cargoes on the more lucrative routes would still be split and it might be difficult or impossible to amortize the investment. The solution would seem to be for the government to regulate both routes and freight rates, thus protecting both the shipping companies and the public. So far this has not happened.

The new passengers on the *Belama* have settled in. A wild card game aft of the funnel has been going on all morning. Men drink kava, laugh, and slap their cards down on the deck. Women have their own space. In their bright *sulus*, or sarongs, they are busy weaving mats with colorful fringes, which they will sell when they get to Suva. The women giggle and talk with each other while they work. Small children nestle in their laps. One boy seems out of place. He does not laugh or join in the groups of other young men on the ship, but instead stays by himself, looking wistfully at the others. We begin talking. Estuva (not his real name), a quiet sixteen-year-old, is returning to his village from Suva. He would like to stay in Suva and go to school or find a job, but there is little work available and he is needed at home. He has been staying with his cousins in the city, going to some wonderful cinemas, and having other exciting adventures.

Jess has been telling me that while the young people like the excitement of Suva, life is easier for them in the villages. I ask Estuva if the work he does in the village is easier than it would be in Suva. There is not a second's hesitation in his voice. "No," he says. "We have to go to the for-

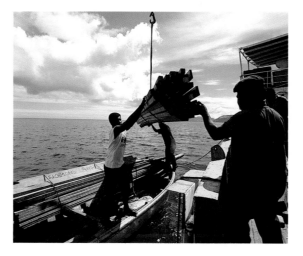

est to pick some yams to sell in the market. We always have to work in the garden—turning the soil, planting the crops, putting the manure, and harvesting the crops. It's really hard."

"And you don't like that sort of work?" I ask.

"No, I'm very lazy. I can't do this job," Estuva replies without embarrassment. "I dislike doing this job."

Changing the subject, I ask him what life is like in the village. His answer surprises me. "It's okay, but last week my father was killed."

"Was killed? How?" I ask.

"He was dead from cancer. The doctor couldn't take it out, and after about two days he died."

"Well why did you say he was killed?" I ask. "Cancer is a disease, a sickness."

"No, it's not really a sickness," Estuva explains. "Some people in my village puts this in his head."

"Why? Why would they do that?"

"Because of our house—."

I interrupt him. "Because of your house? You live in a nice house and that's why they wanted to kill him?"

"Yeah. Jealous. In the village people must be jealous if you live in a nice house with nice furniture."

I am still wondering if this boy is putting me on. I ask, "So these people made bad thoughts about your father and he got cancer? How did they do that?"

Estuva is completely serious. "They find a decomposed head of a dead man and they pour kava inside that head and talk to that head—that empty head, they talk to that, you know—talk to the devil through that head. Put a curse on that man. And after a while the devil will be alive and go around and search for that man. That's why my father had cancer."

"That's horrible," I answer. "Does your mother believe that this is how your father died? How many people in the village do this?"

"Yeah, we believe it. Maybe a group of people do this—four or five people. These are people that cannot read, you know, cannot really develop their houses and they are jealous with other people. In our village there is always bad people who are jealous about us."

"So, Estuva, what will happen to these people who did this to your father?"

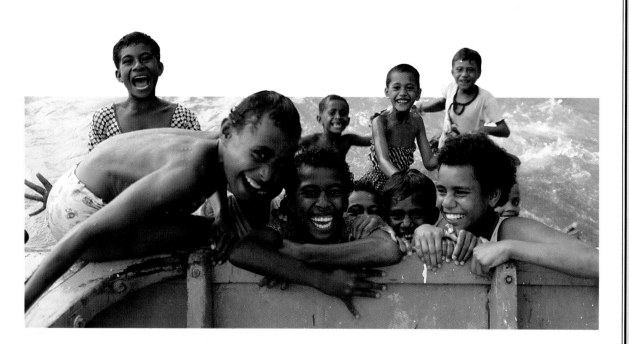

Estuva shrugs. "Maybe God will punish them. Maybe they will get caught by somebody else and they will have a curse put on them."

Poor Estuva doesn't want to talk anymore. He goes up to the bow and sits by himself. He doesn't want to stay on the ship, but he doesn't want to go home to his village either.

The *Belama* now begins to head into large Levuka Bay. Surf is breaking all around us as we pass through a small opening and drop anchor in the calm water. Three villages front the bay. One of these, Levuka, is Jess's home. Judy and I accompany Jess and the kava drinkers in the workboat to their village. Children wait in the shallow water to greet us, and when they see Judy with her camera, they go crazy with joy. A Western woman seldom comes here—and especially not one with a camera. We are treated like visiting royalty. All the elders come out to meet us. Jess proudly takes us for a tour through his village and introduces us to his family and friends.

Levuka is poor, with small concrete-block or thatched houses scattered over a hillside. Pigs and goats are penned or tethered at random. Chickens poke through the tall grass. A

As the workboat approaches a remote village on Kadavu, the children swim out to welcome it.

whitewashed masonry church stands by the water. It would be considered modest in a city, but here it looks impressive. We are taken to the village meeting house, a lovely traditional thatched structure that was built by the people and is the pride of the community. Here we meet with an elderly white-haired lady, the chief of the village. Everyone is friendly and we receive invitations to tea at various houses. Jess asks if we would like to spend the night at Levuka. Sadly we reply that we must go with the ship, now preparing to depart for its return to Suva. All the villagers come to wave us off.

A few stops farther on is the village where Estuva lives. I go down to the workboat to say good-bye to him, but he doesn't appear. Halfway back to Suva, I see him sitting by himself in front of the hatch. Estuva does not want to talk anymore. I sit with him awhile. Late that night when the *Belama* arrives in Suva I look for him again to say good-bye and to offer him some encouragement. But he is nowhere to be seen.

On the Reef

A tiny animal is responsible for the sinking of more ships and boats in the Pacific and southern Indian Ocean than all the typhoons, waterspouts, and storms put together. This little creature, the coral polyp, has a hollow, cylindrical body. One end of the body is attached to other polyps; the other end is a mouth surrounded by tentacles armed with stinging cells used to capture the minute organisms on which the animal feeds. The polyp secretes a hard calcareous substance that becomes its residence. This skeleton is known as coral. The polyps thrive in warm, shallow seawater, where they build enormous colonies, sometimes in the form of reefs, that extend for hundreds of miles along a coastline, and other times as individual mushrooms, or coral heads, dotting a great expanse of shallow

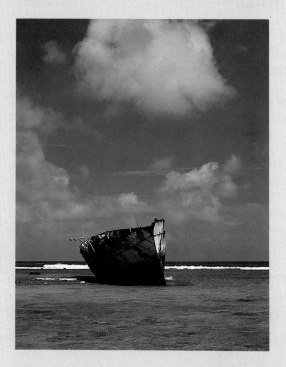

National Geographic's barque *Yankee* has found her final resting place on the reef off Rarotonga, where she was lost in a storm.

The *Belama* negotiates a small entrance to a bay on the northwest side of Kadavu Island, Fiji. One slight error at the helm may cause her destruction, yet this is a passage she makes at least twice a month.

This American-owned ketch was lost at night on a reef off Aitutaki, Cook Islands, due to a navigational error. Fortunately her passengers were able to walk ashore.

The *Mataora* sails through the narrow passage blasted through the reef outside Rarotonga's postage-stamp-size harbor.

ocean. Coral reefs range from twenty yards to several miles across and vary in shape according to species. They may resemble shrubs, flowers, mushrooms, fans, or brains. Piles of dead or wave-broken polyps form small islands called atolls. The atolls are usually less than a quarter of a mile wide and often enclose a large saltwater lagoon.

Although the reefs cause the shipwrecks, storms or navigational errors often are contributing factors. Many accidents happen at night when the only warning is an unexpected booming of the surf where there should be no surf. Usually when the mariner hears the crashing of the waves, it is too late to change course. Suddenly the ship or boat lurches wildly as it hits all

the little polyps. If there is a heavy sea, the vessel is commonly thrown on its beam-ends. There is a grinding roar as the bottom is torn out, followed by water cascading in as if shot from a hydrant. The end is near.

A severe storm in an area of heavy shipping concentration like the Fiji Islands may put a dozen or more vessels on the reefs in one or two days. So in an average year in the Pacific Ocean the owners of more than one hundred ships will likely find that their pride and joys or their livelihoods have been lost to the coral reefs. The numerous hulks dotting the reefs of the Pacific give mute testimony to the fact that many of those vessels that crash on the reefs will never sail again.

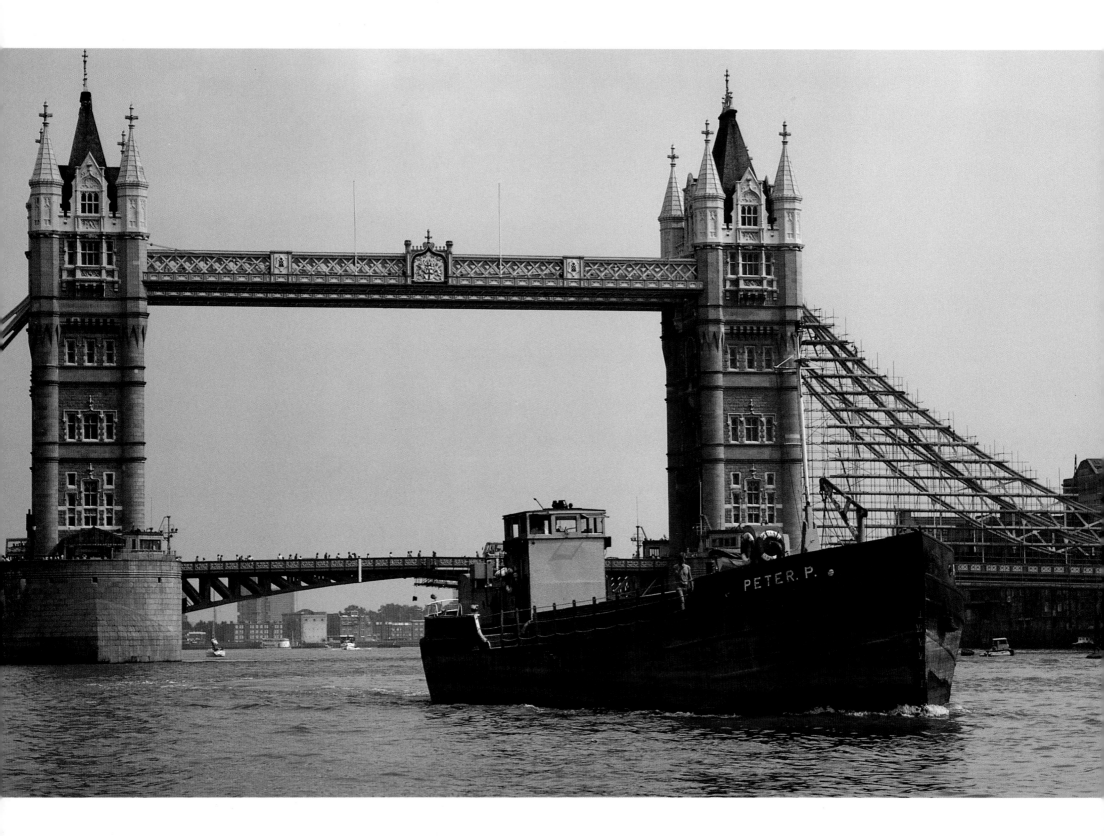

PETER P

Landing the Troops at Gallipoli

The *Peter P* and her sisters, if they could but speak, would have some exciting tales to tell. Though they were not built until 1915 and 1916, their story begins in 1914 on the western and Russian fronts. The carnage in the trenches was already so great, with hundreds of thousands of men dead on each side, that this military catastrophe would soon be known as "the war to end all wars." Britain, France, and Russia were desperate. How could they divide the kaiser's might and prevent Turkey, Germany's newest ally, from committing its troops to the battles raging in the north? The obvious solution was to strike at Turkey and what was left of her empire. This would require not only armies but naval forces as well.

Winston Churchill, in one of his first steps as first lord of the admiralty, persuaded the legendary Admiral Fisher, former first sea lord and father of the modern British battle fleet, to come out of retirement and work as his assistant. Fisher had a farseeing and imaginative mind. He realized that Great Britain's navy, powerful as it was on the high seas, had almost no amphibious capability. In the Mediterranean, particularly, the British would need to be able to land large numbers of troops and their supplies under fire. At that time there were no shallow-draft vessels designed for shore bombardment and only modified fishing smacks and whaleboats to land troops and equipment.

To answer the need for close fire support, Admiral Fisher borrowed from the American concept of the monitors, a heavily armored, shallow draft warship. The British monitors he designed were unwieldy flat-bottomed ships of 6,000 tons that used American-manufactured fourteen-inch guns. Fisher then devised what would become known as "the black beetles," the first modern landing craft. There were 250 of the black-painted, X-class landing barges. Built in 1915, X-1 through X-200 measured 105 feet by 21 feet by 1 foot and (most) were powered by sixty-horsepower diesels. X-201 through X-225, also powered, were constructed in 1916 and were 93 feet long. In addition, there were twenty-five (DX-1 through DX-25) engineless dummies. All the

The *Peter P* approaches two of the emergency flood gates designed to prevent flooding of the Thames.

On her way up the Thames, the *Peter P* has just passed under London's Tower Bridge.

51

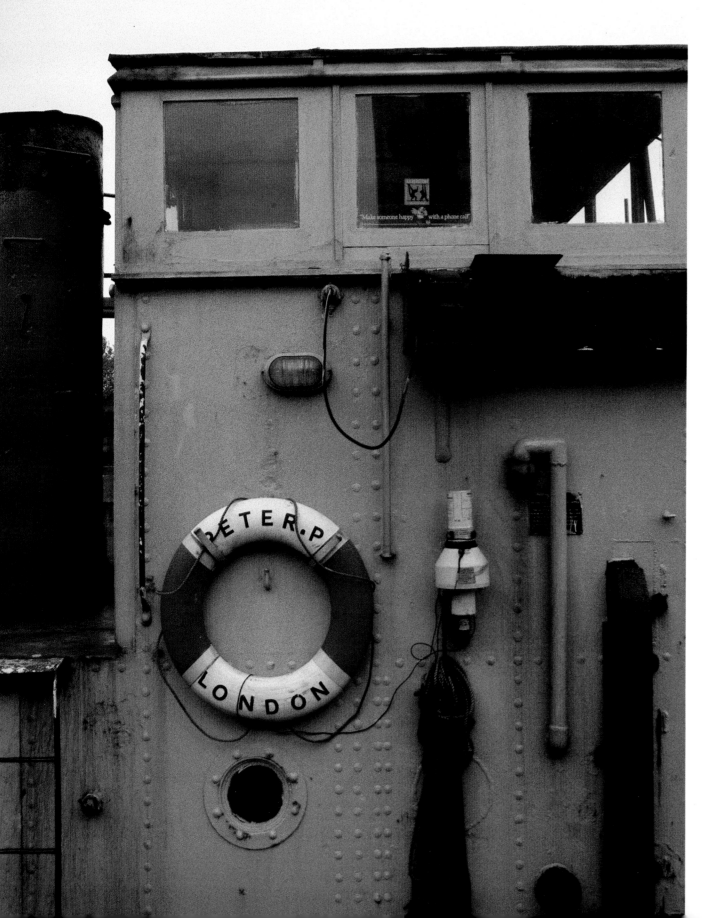

Derek, the young mate of the *Peter P*, has time to relax in the wheelhouse as the ship heads downriver.

Brian Whiting, captain of the *Peter P*, pours himself a spot of tea.

lighters, as they are called in England, had forty-five-degree slopes to their steel hulls forward to allow them to beach. They all had lowerable bow ramps and were armor-plated to protect against machine-gun fire and shrapnel. The larger beetles could carry 500 soldiers or forty horses.

In April 1915 the first modern amphibious landing took place at the southern tip of the Gallipoli Peninsula, 160 miles southwest of Constantinople. It was a gigantic undertaking for its time. Nearly 75,000 men,* 1,600 horses, donkeys, and mules, 300 vehicles, and supplies, including not only food and ammunition but also water and even hay, were landed to face furious Turkish machine-gun and artillery fire. More than seventy black beetles played a part. These, because they were armored and because they could discharge animals and bulky equipment as well as small artillery pieces, saw the most action. Many of the beetles probably should have been nicknamed "sitting ducks," for Turkish troops on the cliffs surrounding the beaches mowed down the Allied soldiers even before the landing crafts' bow ramps could be lowered.

The attack on Turkey was supposed to open up a southern front that would unite with the Russians to the north and act as a pincer to trap the Central Powers between Turkey and the western trenches. Of course this did not happen. The Allies advanced only a few miles. In the first four months of the invasion, there were 57,000 Allied casualties and about the same number of Turkish ones. The X-crafts were used more and more to ferry the dead and wounded to the ships. In the end they evacuated the remaining troops from Gallipoli.

Though at Gallipoli the X-class boats were important in a losing cause, a thousand miles

south they were important in a winning one. Turkey still controlled Palestine and a substantial part of the Arabian Peninsula. The English hoped that an Arab rebellion against the Turks would help them defeat her while most English forces remained concentrated in Europe. Lt. Col. T. E. Lawrence, called "Aurans" by his Arab irregulars but better known to the rest of the world as "Lawrence of Arabia," was successful in uniting the Arabs against their Turkish occupiers, who held the important ports on the Red Sea and what is now Israel, Jordan, and Syria.

Lawrence and the Arab Legion, in their camel-borne attacks on the Turkish railway and on the Turkish Red Sea strongholds of Wajh and Aqaba, relied solely on ammunition, machine guns, and other supplies brought to them by ship. Once captured, these ports had to be defended from counterattack, and here again the British navy played an important role. There is little documentation of exactly where the X-lighters went and what they carried, but they operated up and down the Red Sea and from Alexandria to Haifa on the Mediterranean. Probably they brought ashore some of the Rolls Royce armored cars that, aside from their camels, were the Arab Legion's most prized possessions. The X-lighters, revolutionary for their time and long since forgotten, played an important part in the war in the Mediterranean. After the war they were sold to private companies, to be recalled to duty twenty years later.

J. J. Prior Transport Limited began in 1870 when John James Prior, an Essex "farmer's boy" who worked for sixpence a week taking a farmer's produce to London, somehow managed to buy his own horse and cart. On one of his trips he met Maisie, who owned her own grocer's shop. Once he and Maisie were married, J. J. set up his transport business in London's East End. He was a member of the Worshipful Company of Carmen, a wonderfully named association

J. J. Prior, founder of J. J. Prior Transport Limited, was a self-made man who started as a "farmer's boy." Well-to-do in his later years, he poses with his spaniel before going bird hunting.

*Of the total, 30,000 were Australian and New Zealand troops, 17,000 were British troops, and 16,000 were French troops; 10,000 were royal naval forces.

whose members were allowed to park their horses and carts on City of London streets. J. J. prospered to the point that he was even able to buy the farm he had worked on as a boy, and its two hundred horses.

Four generations of Priors developed the transport business further, first buying and using Thames River barges—sailing scows—to haul all types of goods and commodities not just up the Thames but along the coast. Later Prior Transport diversified into the sand and gravel business, carrying these materials from their Colchester quarry on the River Colme up the Thames to London. This is now the company's major involvement. The business is presently run by two Prior brothers, Colin and Peter, and their two sons, Stephen and Mark. It still operates three of the old X-lighters and over the years has owned eleven of them at one time or another.

The *Peter P*, formerly the *X-57*, may have been at Gallipoli, but it is not certain. Originally, it seems, she was powered by a two-stroke, 130-horsepower Swedish Scandia two-cylinder gasoline engine. After World War I, she was operated by various British companies until the admiralty took her and three other X-lighters owned by the Prior company at the beginning of World War II. In May 1940 the German Panzer divisions trapped 350,000 British and French soldiers at Dunkirk, setting off the greatest naval evacuation in history. Britain pressed into service everything that would float to cross the English Channel and rescue the troops. Again the X-lighters proved their worth, and since they could go right up on the beach, they carried to safety many of the wounded. The *T.I.C.*, a hospital lighter that was owned by the Prior company, was sunk at Dunkirk. Another Prior company X-lighter, the *A.H.P.*, then called the *Sherfield*, was also at Dunkirk. In a letter dated 1 June 1940, written to the Prior family, her master said, "I proceeded from Sheerness to Dunkirk for evacuation of

This X-lighter carries parts for an airplane from the British fleet anchored off Gallipoli.

Lt. Col. T. E. Lawrence became a living legend and captivated the spirit of much of the Western world. Lawrence and the Arab Legion were supplied by the *Peter P* or her sisters.

troops. On arrival at Dunkirk we were bombed and machine gunned by German planes, causing severe shaking to our boat. Our red ensign was shot away by gunfire, wheelhouse windows smashed, also glasses in skylight cracked. Six blankets were used and lost for the wounded. Signed, Master of M.V. *Sherfield.*"

After Dunkirk the Prior X-lighters served various naval functions. The X-57 *(Peter P)* was used as a water vessel to supply elements of the fleet anchored off the Scottish coast. The *Shawford* acted as a mooring vessel for barrage balloons on the Thames. The balloons prevented German bombers from flying at low level right up the river to London, and the *Shawford*, while on station, was sunk by the German aircraft against which she was defending.

Besides the *Peter P* the Prior company currently owns the *Sidney P* and the *Colin P*, two of the last five or six X-lighters in existence. All three vessels have been extensively modified over the years. They have been decked over to prevent the sea from blowing into the holds; pilothouses and accommodations for three-man crews have been added; and of course they have been repowered with new diesels. Still, they are the same vessels that valiantly served Britain in two wars and they still plod up and down the river. If you are in London walking along the Thames, you may see one. If you do, give her a wave.

Prior Transport Limited moved with the times. Here is the company's first fleet of motorized lorries. The Thornycroft trucks probably were built in 1913 or 1914. Note their solid rubber tires.

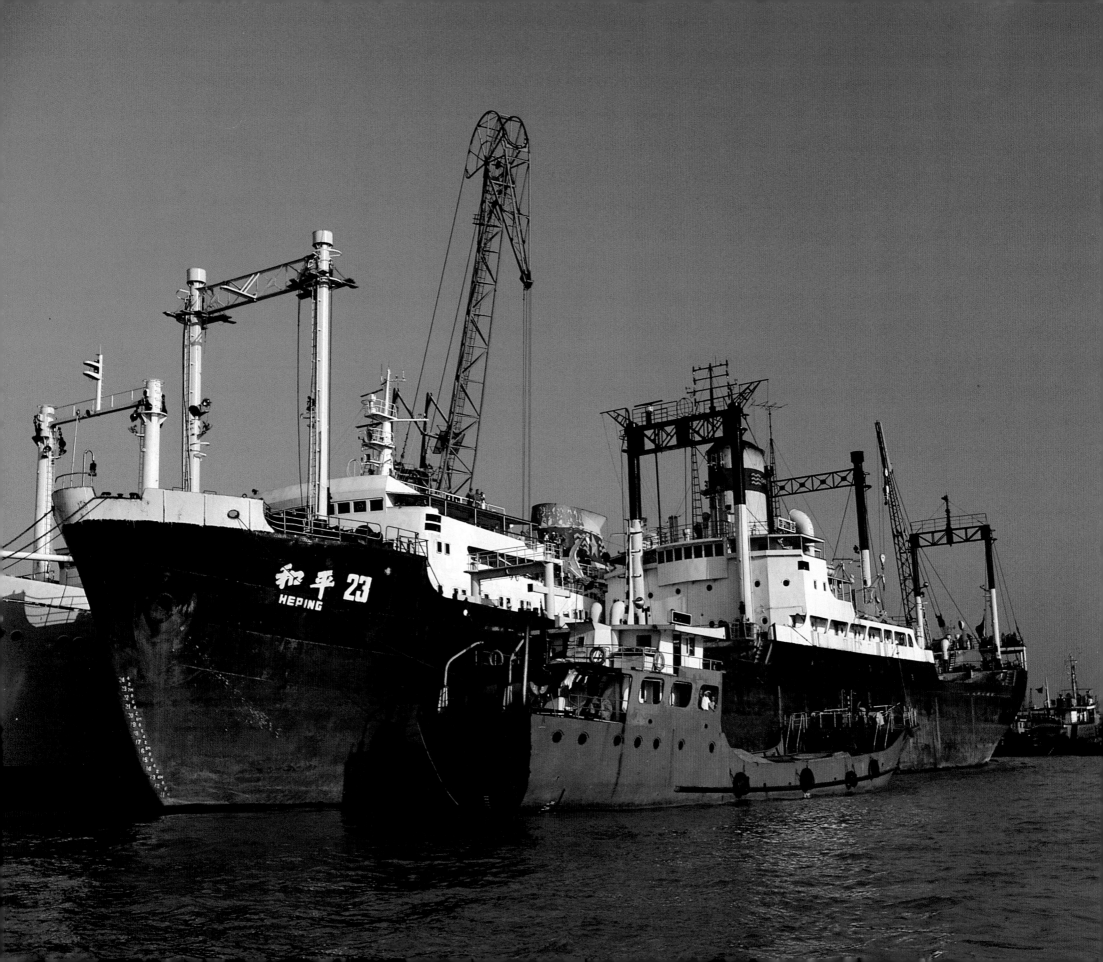

HE PING 23

Tramping around China

Shanghai is the New York City of China. It is one of the country's greatest population centers, its most important commercial center, and its largest port. Located at the mouth of the Yangtze, third longest river in the world, Shanghai is the heart that pumps the commerce to and from all of central China. With its wide avenues and monumental government buildings, offices, and hotels erected by the European powers before World War II, Shanghai is also one of China's most imposing cities. The crush of its 10 million inhabitants absolutely overwhelms Western sensibilities. Trying to escape the city's masses of people is like trying to dodge the drops in a rainstorm. Yet the Chinese are friendly, polite, and also very curious about Westerners. When a Caucasian stops on a Shanghai street, a large crowd often will gather to view and to introduce the alien spectacle to their children, always with warm humor.

From the Bund, Shanghai's main artery fronting the city's center, the *He Ping 23* was visible at the Shanghai Shipyard on the Huang Pu River. Undergoing an engine overhaul and refit, she seemed like a permanent fixture, tied along-

side a modern coastal passenger vessel. The *He Ping*'s derricks and anchors had been removed and her decks were littered with rusting winches, anchor chain, and other gear being replaced or renovated. Her triple-expansion steam engine was dismantled; she exemplified the disheveled state of any vessel undergoing major yard repair. The *He Ping 23*, or "*Peace 23*," belongs to a class of seven coal burners built in Poland from 1955 through 1957 for the Chinese. She had already been modified to burn oil and was now undergoing her last overhaul.

Captain Zhou (pronounced Joe) was on board supervising the refit. In his blue coveralls and with his boyish mop of hair he looked more like a young shipyard worker than a senior captain. Zhou grew up in a town in the far north of China. In 1949 as a young boy in middle school he watched Chiang Kai-shek's forces surrender to the People's Liberation Army. Two uncles were seamen and their stories prompted him to seek a job as a sailor. At fourteen he shipped out on an ex-Liberty that had been purchased by China Merchants S. S. Co. and then confiscated by the new government. Zhou entered China's Maritime Institute for officer training, served the cus-

Zhou Zuang Zhang, captain of the *He Ping*, supervising his ship's refit, stops for a cup of tea.

The *He Ping* lies between a passenger vessel and a coaster, all undergoing repairs at Shanghai Shipyard.

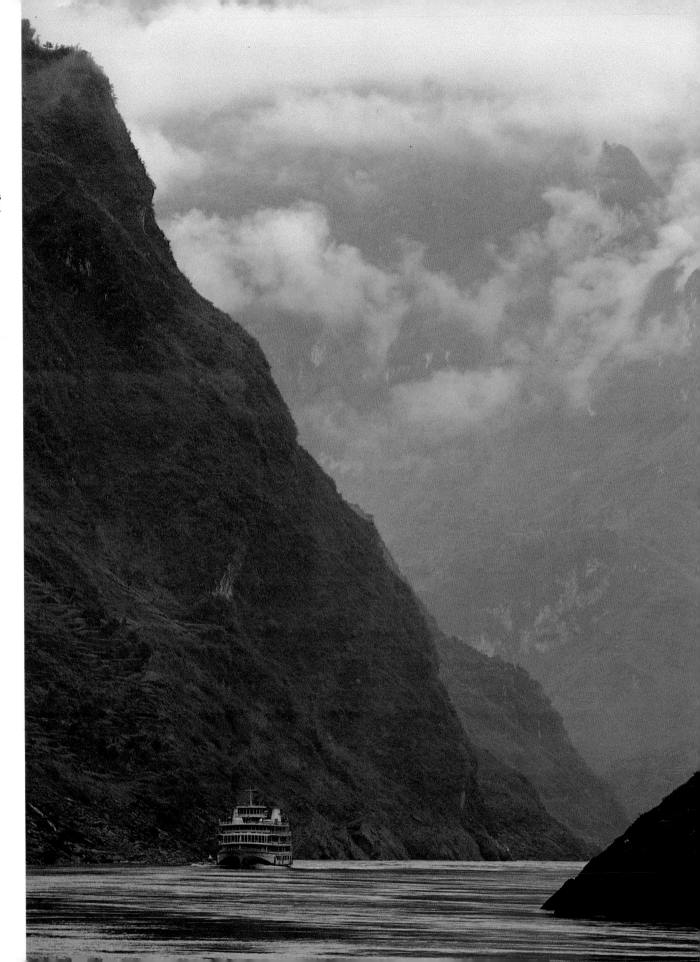

Passenger ferries transport people and goods through the scenic gorges of the Yangtze River.

A number of steam-powered vessels still operate in China. These freighters are in Shanghai harbor.

tomary postgraduate probationary year as a seaman, then became an officer. He has sailed over much of the world, though since becoming captain of the *He Ping* most of his trips have been to Japan with cargoes of grains and canned foods, returning with chemicals and machinery. While the *He Ping* is probably not his most cherished command, Captain Zhou and his crew are fortunate that their usually short voyages allow them to spend more time with their families.

The *He Ping* is operated by the Coastal Transportation Bureau, one of three government companies that control most of the shipping in China. At anchor along the twenty-mile stretch of the Huang Pu that constitutes the Port of Shanghai are many other bureau ships awaiting berths. Unfortunately there simply are not enough dock facilities to accommodate the crush of cargo vessels waiting to load or discharge. A Coastal Bureau official estimated that if tomorrow China could double all its coastal port facilities, the increase would still be insufficient to handle the country's present waterborne trade. The bureau, with more than 500 ships under its command, is responsible for the water transport of goods and people among all the

major ports along China's 8,700 miles of coastline. The larger, more modern vessels of the China Ocean Shipping Company (COSCO), China's international flag carrier, lie alongside the Coastal Bureau ships in Shanghai harbor. COSCO operates 530 cargo vessels, which have a total capacity of more than 10 million deadweight tons and sail to virtually every port in the world.

Since China's highway system is so underdeveloped and its railroads so overtaxed, waterborne transportation is more important there than in almost any other major country. More than 44 percent of all the cargo moved within China is carried by ship or barge, compared to 49 percent by rail and only 3 percent by highway transport; pipelines carry 4 percent and aircraft 0.1 percent (1982 figures). While there are scheduled shipping services within China, most cargo is carried on a tramp basis, with ships allocated as needed to move the nation's goods and commodities.

China's rivers are a vital part of her transportation system, and the mighty Yangtze, known as the Chang Jiang, is the largest in the country. It stretches east for nearly 4,000 miles from the Tanggula Mountains in Tibet to its

mouth near Shanghai. The upper reaches of the Yangtze are impassable for everything but sampans, and these must be pulled upstream by peasants on the banks heaving at the ends of long towing lines. Farther downstream, traffic moves primarily by tug and barge, though large passenger vessels sail to Chongqing (formerly Chungking), 1,500 miles from Shanghai.

Chongqing is an industrial city of 6 million people. It is built on mountainsides, and the Yangtze, which flows through its center, has an average yearly rise and fall of ninety feet between the dry and wet seasons. For this reason there can be no stationary docks; everything must rise and fall with the river. This tremendous variance in river depth causes unimaginable problems. Trams are used to load and unload cargo, and staircases have been built into the banks at Chongqing and all the nearby cities and large villages. Farther east the Yangtze rushes through a spectacular series of gorges. For 120 miles there is some of the most incredible scenery in the world, with vertical mountainsides arching up thousands of feet directly above the torrent. During the rainy season currents here reach fifteen or twenty miles an hour, and all traffic is dis-

Passengers await the ferryboat in Fen Jie on the Yangtze. Because of tremendous flooding during the rainy season, many Yangtze towns are built more than one hundred feet above the river.

Trams transport passengers to and from ferryboats ninety feet below the city of Chongqing.

continued until the river drops. At any season the tug-barge combinations and the passenger vessels have all they can do to maintain control and avoid collisions.

Tramp operations by larger vessels of up to 10,000 tons begin at Wuhan, 675 miles from Shanghai. This stretch of river has been tamed by dams upstream and runs through fertile farmland. Here the Yangtze is a different river altogether from the raging torrent to the west. Most of the traffic is barges operated by the Inland Waterway Transportation Bureau, which moves over 50 million tons of cargo a year.

Steam has played an important part in China's rail and maritime transportation sys-

Suzhou Creek, which empties into Shanghai harbor, is a major inland artery for the transport of goods by tugboat and barge. Here a tugboat tows a raft of logs.

An oar-powered sampan on the upper Yangtze.

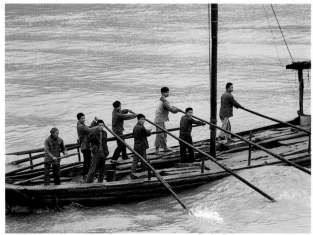

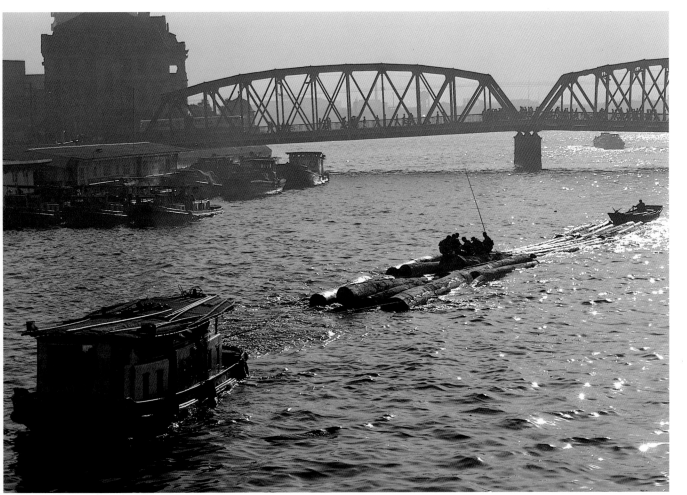

tems. Because of its enormous coal fields the central government decided in the 1950s to develop coal-fired motive power. The steam buff can still see steam locomotives puffing all over the country. A sizable number of steam-engined vessels presently operate too, though these are rapidly being phased out. After the revolution in 1949 the new government bought or confiscated many old Liberties and Victories, as well as ordered cargo vessels ranging in size from 2,500-ton coasters to 10,000-ton oceangoing freighters. These latter vessels, almost all with triple-expansion engines, were purchased from the Soviet Union, East Germany, and Poland. Only seven or eight of the larger freighters remain in service, operating as Coastal Bureau tramps. An un-known number of steam coasters (probably ten or twenty) still are being used by provincial administrations or communes in eastern China to carry their particular goods or farm commodities. Almost all the coal burners have recently been modified to burn oil, and like the *He Ping 23*, which is due for retirement in two or three years, the remaining steamers too will soon be a memory.

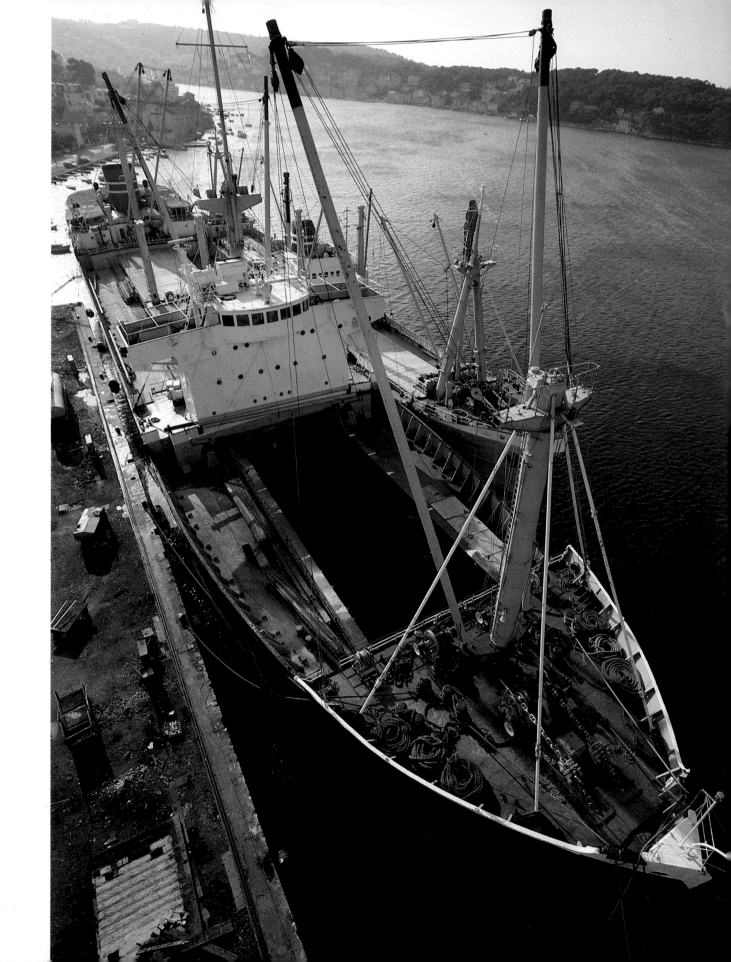

BUGA

The Oldest Giant

At the northern tip of Cres a green-and-beige Yugoslavian bus bumps its way off the little ferry and is immediately greeted with a series of steep, winding switchbacks. Grinding up the mountainside, a trail of cars in its wake, the bus finally reaches the spine that runs the length of the island. To each side the mountain falls off abruptly into the blue Adriatic. The views are gorgeous. The feeling is of an island fortress that could, and maybe did, hold off an army of Saracens.

Cres and Losinj lie atop a chain of islands that appear to have been splashed off the Yugoslavian coast. For most of the year, these two outer islands of the chain, which are perhaps forty miles southeast of Trieste and the Italian border, are forgotten by tourists and Yugoslav mainlanders alike.

The bus rambles down the island's single road, passing an occasional farm with a few sheep or a small grove of olives. Everywhere the soil is poor and so rocky as to provide only the most marginal sustenance for those who must live off it. The sloping hillsides, where they can be farmed, are divided by walls of piled rock that look centuries old. The farmhouses, too, are of

rock, and the few sheep must nibble around a never-ending supply of rocks yet unpiled.

With a screech of brakes the bus shudders to a stop to allow another bus to pass on its way to the ferry. The road is very narrow. Fortunately there is little traffic. Occasionally a man or woman stands solemnly at the roadside—in the midst of nowhere. The bus stops and the solitary pedestrian, once aboard, changes like a chameleon. There are broad smiles and greetings to everyone, then a burst of rapid-fire banter as the new passenger catches up with the island gossip. The few daily buses serve not only to provide transport, but also to act as the social centers for the inhabitants of the scattered communities and farmhouses strung out over the two islands' sixty-mile length.

Half an hour later the bus swings into Cres, a quaint waterside village built entirely of stone. Its old fishermen sit in the afternoon sun talking and watching the action with some amusement as a few passengers disembark and a few more board, to head south. An older woman with a suitcase searches plaintively for one of the two small hotels, which look like old houses and, in any place larger than Cres, would be impos-

The *Buga* undergoes maintenance at her company's shipyard on the Yugoslavian island of Losinj. (*opposite and right*)

The *Buga*'s bridge wings and derricks bespeak the strength of the vessel that has worked continually for over fifty-five years. She is an anomaly in an age when new vessels are constructed to be written off in fifteen or twenty years.

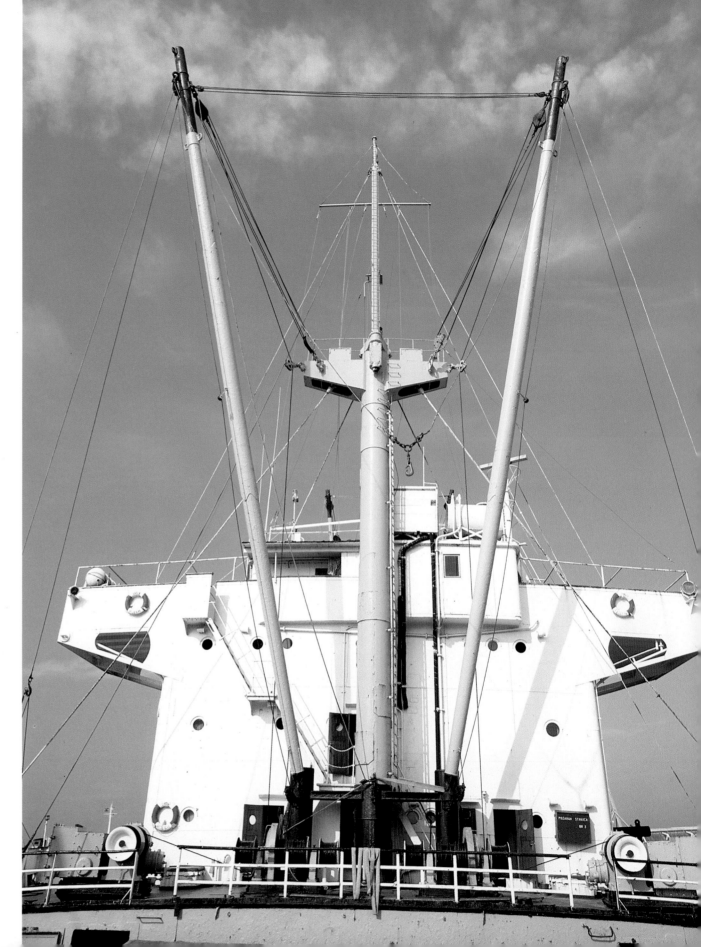

sible to find. Without warning, the driver closes the bus doors and begins backing and filling in order to turn his vehicle around in the postage-stamp square. There is little room for miscalculation; a brake failure and both bus and passengers will go head first into the bay.

Farther south is a short causeway that connects the smaller island of Losinj to its northern neighbor. Losinj is a narrow sliver, hardly more than a few miles across at its widest point. It is a small garden with groves of pines and cypresses, even some large palms and lush vegetation, which seem out of place this far north in the Adriatic. At last, reaching its final destination, Mali Losinj, the bus heaves to a stop on the village's cobblestone promenade, which faces a serene bay. It is here, in Mali Losinj, the most unlikely of all places, that Losinjska Plovidba, Yugoslavia's fourth-largest shipping company, is located. Yet the visitor sees almost nothing of it.

Losinjska Plovidba has thirty-two ships. Among them are some of the most modern ro-ro ships in the world. A ro-ro is a vessel with ramps that enable cargo to be driven on or off the ship. Losinjska Plovidba operates scheduled cargo service from Italy and Yugoslavia to some North Af-

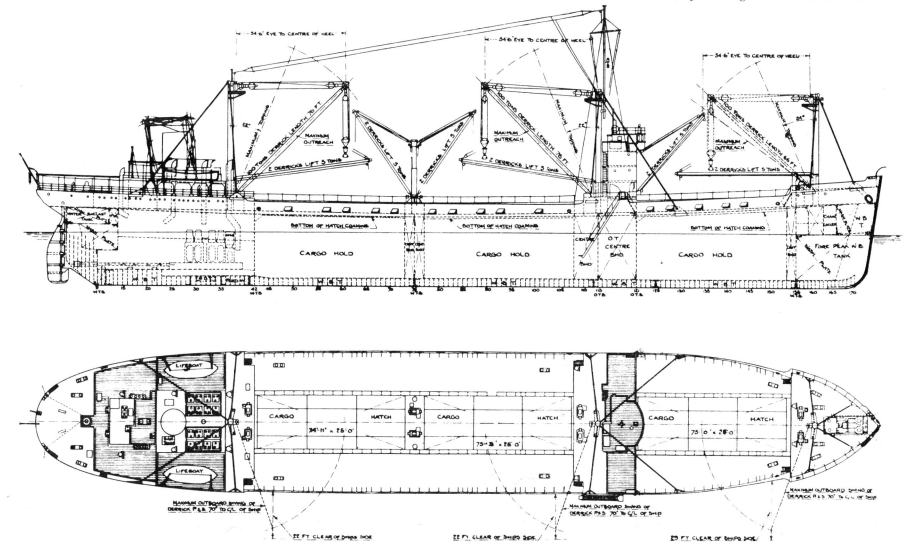

One of the company's original vessels, this lugger was built of wood by a local boatyard and carried goods and produce between the island and the mainland. She was long ago scrapped.

rican countries that have poor cargo-handling facilities. The ro-ros carry containers and general cargo on trailers, as well as many vehicles. Besides these newer vessels, the company operates a fleet of conventional freighters, some on scheduled lines and others as tramps. The company also has a tourist branch with two tourist camps, a 250-boat marina and restaurant, and a travel agency. Then there is the shipyard, which, with its 6,000-ton-capacity floating drydock, can repair most standard-size cargo and passenger vessels.

Julijano Sokolic looks as though he could be a pretty tough customer. He was a boy during World War II when his countrymen were fighting the invading Italians. The suffering is like a ghost with which he must continue to deal. You can see it in his eyes. Sokolic, solid but wiry, is in his late forties now. He is the director of Losinjska Plovidba's shipyard, which is located just outside the village, and sits on the board of directors of the parent company.

Losinjska Plovidba was started after the war with almost nothing. Sokolic, who has worked for the company since its inception, says, "In the postwar days, our shipping company in the circumstances of a centralized economy was not allotted any ships, so we had to begin with some wooden boats and others that were sunken and that we could raise and repair ourselves. These were very hard days of uncertainty when the people who were embarking on these tasks used to live from hand to mouth. Our navigation company started only with eleven small boats [nine wood and two steel] of average one hundred tons. [The total for the fleet was 1,230 deadweight tons.] Then most of these little vessels were already twenty or thirty years old."

In 1960 the company began constructing its first ship, a 955-gross-ton freighter, in the Mali Losinj shipyard. But growth remained slow. Yugoslavia was still recovering from the war, and

The ship's wheel, an original fixture, looks as though it might have been made for a fishing boat. Much of the brightwork throughout the ship is original.

The officers' saloon sports paneling and joinery that is now found only on a few modern passenger liners.

there was little money available for financing the construction of new vessels.

Stjepan Kutlesa, the grandfatherly chief of the company's tramp fleet, relates, "As it sometimes happens in the life of an artist or an opera singer, perhaps she is taken ill—and then another [fate?] steps in to help her career. This somehow happened to a vessel of ours: it was collided by a Japanese ship in the north Adriatic and as it was a total loss, the money, at our request, was remitted to us from Westminster Bank of London. This relationship opened a confidence for their financing our purchase of British secondhand tonnage through a shipping broker in London."

From that point on, the fleet was built in an amazingly short time through the acquisition of secondhand ships, using the older ships already owned by the company as collateral for the purchase of newer vessels. Losinjska Plovidba originated scheduled liner services from Yugoslavia to Greece, Turkey, and North Africa. It also began constructing a ro-ro ship in its yard and ordered two more built at other yards. Within twenty years the company developed from virtually zero to its present position as one of the Mediterranean's most prominent carriers.

During a conversation with Losinjska Plovidba personnel, my eyes were riveted on what was one of the most extraordinary vessels left in the world. The *Buga*, all 10,446 deadweight tons of her, was moored alongside the shipyard dock. She had been built in England in 1926, and here she was looking almost exactly as she had on the day she was launched into the Tyne. She was, in 1982, the largest freighter of her age still afloat in Europe.

Standing next to the *Buga*, one is immediately struck by her enormous cantilevered bridge wings. They look like a muscle builder's flexed biceps. Indeed, everything seems massive on the *Buga*. Her No. 2 and No. 3 hatches are each sev-enty-five feet long; her No. 1 is only slightly smaller. She is powered by two large M.A.N. four-cylinder diesels each producing 1,750 horsepower. Even with her 3,500 horsepower, however, she is very much underpowered. When she is loaded, her maximum speed is a meager nine knots.

The ship is named after a warrior princess. In the seventh century many Croatian tribes living in what is now the Russian Carpathians invaded lands lying along the Adriatic. Among these tribes was one ruled by a family of five brothers and two sisters. One of the sisters, Buga, had a reputation as a strong and fierce warrior and led her own army to victories over many of the indigenous tribes then occupying what is now Yugoslavia. Buga was not forgotten; her namesake is seen today sailing the Mediterranean.

The *Buga* was built as a heavy-lift vessel by Armstrong Whitworth at Newcastle for New Zealand Carriers Ltd, a Hong Kong-registered firm. She was used during the twenties and thirties to carry locomotives, railroad cars, factory boilers, and similar heavy cargoes from the United Kingdom to Asia, Australia, and New Zealand. Her return cargoes would likely have been jarrah and karri timber from Australia and pine from New Zealand, as well as mahogany, teak, and other hardwoods from the Malay Peninsula. She also would have carried tin and rubber from Southeast Asia back to Britain. The *New Zealand Venture*, as she was originally known, was well equipped to carry heavy cargoes with one-hundred-ton-capacity derricks on No. 2 and No. 3 hatches. She also had four five-ton derricks on all three hatches, which allowed two gangs of stevedores to work the hatches simultaneously for normal-size cargoes.

In 1950 the *Buga* was rebuilt: her original triple-expansion steam engine was replaced by the M.A.N. diesels, and her heavy-lift derricks were removed, as were all the winches, to be

The *Buga*'s crew eats well. Here roast chicken is being prepared for lunch on one of the ship's old oil-burning ranges.

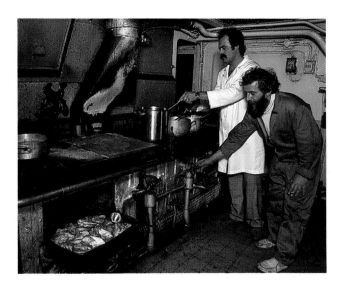

The crew's mess is not fancy, but the sailors are more interested in what they are eating than where they are eating it.

replaced with Clark-Chapman electrics. Some plates on her hull were changed and her stack was modified from the tall, narrow steamer shape to the present short, elliptical design.

Even though she has suffered a fire that apparently was centered in the mess steward's cabin and that resulted in the installation of some mediocre replacement paneling, she still retains much of her original grandeur. The officers' salon and mess, as well as the wheelhouse, are beautifully paneled in mahogany and teak. The joinery is of a caliber that simply does not exist on modern ships, and, fortunately, many of her lovely features, such as the fireplace in the officers' mess, have not been removed or destroyed.

Losinjska Plovidba operates the *Buga* as a tramp. Over the last few years she has been used mostly to carry scrap iron from the Russian Black Sea port of Novorossijsk to Yugoslavia. With her huge hatches and no tween decks, the *Buga* is admirably suited for this work. But her future does not look bright.

Magasic Mate, a large, easygoing man with a bushy moustache, is the master on the *Buga*. While he appreciates her beauty and uniqueness, he has other matters to worry about, namely, how to control his vessel.

"The *Buga*," he says, "has a rudder that is too small for the size of the ship and gives little control, especially when she is on ballast. Maybe a large rudder could not be put on because her old steering mechanism [electric] could not operate a larger rudder.

"In May 1982 we had a terrible problem. We were sailing down the Bosporus on ballast. As sometimes is the situation in the Bosporus, there was a heavy current, also a strong crosswind. The ship would not answer the helm and we are going straight for the bank. I reversed, full, the port engine—and still nothing. I blasted a warning on the whistle to prepare the crew for colli-

sion. Then, just before she is ready to hit the bank, she begins to come around. After that I had to use both engines to control her until we could get out of there. We were looking like a drunken auto driver."

Aside from the poor steering and the ship's slow speed, the *Buga* has other drawbacks as well. Since the vessel was originally built to accommodate a much larger crew, each seaman now has his own cabin. However, there has been little upgrading of the sanitary facilities, and they are a subject of crew complaint. Also the galley still has equipment that dates back to the 1920s and makes cooking for a large crew much more difficult than it should be. These problems, coupled with a disastrous recession in Europe and an overabundance of ships relative to cargoes, do not portend well for the future of the fifty-six-year-old *Buga*.

Though the outlook for the *Buga* is not good, the future for the firm that owns her is much better. As a company belonging to the state in socialist Yugoslavia, Losinjska Plovidba has the responsibility not only to make a profit for the state, but also to provide employment and a good standard of living for the local people.

Cres and Losinj together have a population of 10,000 and about 3,000 of these are working people. Losinjska Plovidba employs nearly 1,000 people in its shipping company, 200 work in its shipyard, and another 200 people earn their living in its various tourist businesses. Thus, the company, through its subsidiaries, is employer to more than 40 percent of the working population of the two islands. Were it not for the employment offered by Losinjska Plovidba, there would be tremendous poverty on the two barren islands. Before the growth of the company, many of the local people were only one step from starvation. Now, through the company's credit union, many employees have been able to finance the construction of their own homes.

The village of Cres probably looked about the same a hundred years ago. The state-owned shipping company provides employment for most of the inhabitants.

In a small country town on a summer evening, old men sit under a palm tree and reminisce.

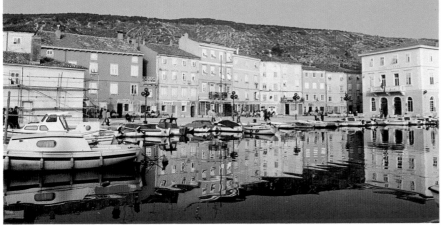

Luxuries like television, refrigerators, and, to a lesser extent, automobiles are commonplace. The standard of living seems to compare favorably with that in many parts of Western Europe.

There are great differences in how business and industry operate in various communist countries. In the Soviet Union, for example, most companies have little discretion in what and how much they produce, the amount of capital equipment to be purchased, and generally the whole direction the business is to take. The central planning offices make most of the major decisions. In Yugoslavia, however, this is not the case. The directors of each company have a great deal of both autonomy and latitude in decision making that will affect their company's production and growth. Direct external financing from western banks is permitted, and to a large extent the directors run the company.

Directors in Yugoslavian companies are normally chosen from the senior employees. There is much less employee movement from one company to another than there is in the West, and supervisors usually promote someone from within rather than search outside the company. If there is a position that cannot be filled

from inside the company, the firm may, of course, offer the job to a specialist from another part of Yugoslavia. Julijano Sokolic is frank to admit that political considerations are important, too. Some of the seats on the company's board must be filled by local Communist party leaders. However, it is not the case that someone must be a Communist party member to be promoted within the company.

The company executives are very aware of their social responsibilities. During my visit Sokolic held a meeting with the shipyard employees at which he had to tell them that because of poor business conditions, Losinjska Plovidba would have to reduce labor costs. It was up to the workers whether this would be accomplished by laying off some employees or by salary reductions for all the employees. It was not a happy meeting, but in the end the employees decided that everyone in the company would undergo salary reductions (the percentage was not decided) large enough to help bring operating expenses in line with revenues.

At the time of my visit, Losinjska Plovidba's shipping company was breaking even. The shipyard was most assuredly losing money (as was

almost every shipyard in the world that was not engaged in building or repairing military vessels), and the tourist group within the company was making good revenues. All told, in a horrible economy, Losinjska Plovidba was doing as well as most Western companies, and a good deal better than some. Part of the credit for the company's success should go to the government's policy of granting autonomy to local management, but most of the credit must be given to Losinjska Plovidba's employees themselves.

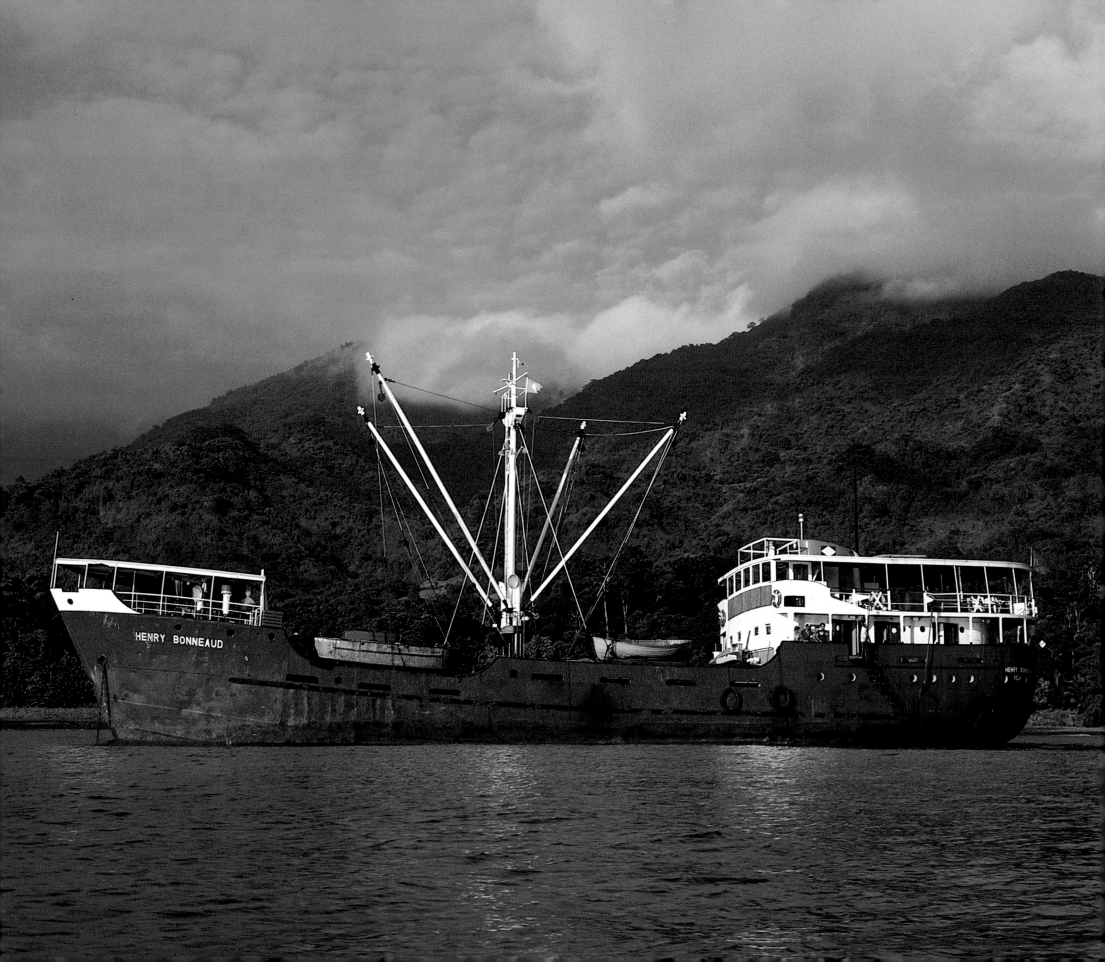

HENRY BONNEAUD

Life on a South Pacific Copra Trader

Santo, Espíritu Santo Island, Vanuatu— 2045 hours. The *Henry Bonneaud* casts her lines and heads off into the darkness of Santo harbor, taking a northeasterly course to avoid two small reefs opposite the timber company dock. The captain then rings "full ahead" and the *Henry* thumps her way north, the lights of the town passing to port. After an hour there are no more lights on shore except for an occasional flickering kerosene lantern.

0525 hours. Dawn is breaking. The *Henry* rolls in a chop at the mouth of Big Bay. She passes Cape Queros, the steep, jungle-covered headland guarding the bay's eastern approaches. Lianas and creepers envelop the cape's trees like camouflage netting, and the whole green entanglement slopes 200 feet above the water. Great cumulonimbus have already formed over the jungle. They float in a stately procession to the east. Looking north, there is nothing but the empty Coral Sea.

The decks of the *Henry* are deserted. No one is up except Roger, the captain, at the helm. Crazy, the new little mutt-puppy, is wedged between the freezer and the ventilator. The pussycat investigates, then backs off and goes down the ladder to the main deck. A slight breeze rustles the awning over the boat deck. Even at six o'clock the air feels like molasses. The *Henry* is on the northeast side of Big Bay. The bay is shaped like the hollow formed by an extended forefinger and thumb, with Cape Queros lying at the thumb's tip and the end of the island, seventy miles northwest, represented by the point of the forefinger. In the early light the end of the bay had been shrouded, but now jagged mountains appear fifteen or twenty miles to the south.

Big Bay, at the north end of Espíritu Santo, is not an easy place to reach. First you must get to Port Vila, the capital of the new island republic of Vanuatu.* A couple of flights a week come from Australia (1,400 miles west) and from Fiji (700 miles east). From Port Vila you take a small plane 250 miles north to the sleepy town of Luganville, or Santo, as the locals call it. Then your problems begin, because there are no roads to Big Bay.

*Before independence in 1980, the islands, then known as the New Hebrides, were a protectorate jointly administered by the British and the French.

The *Henry Bonneaud* lies off the coast awaiting cargo.

The *Henry* and her few competitors are the only connections that some of the isolated villages of Vanuatu have with the twentieth century.

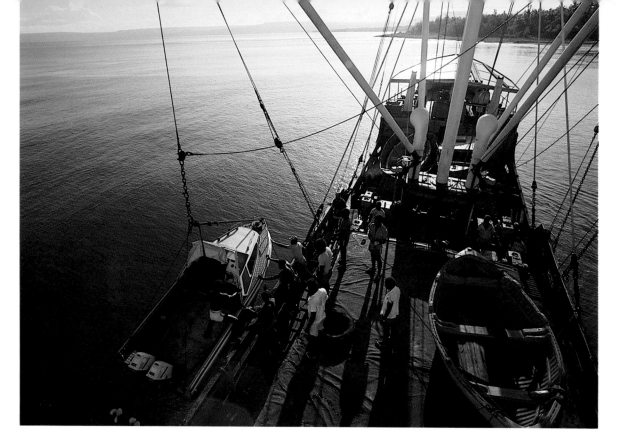

Leong's boat is lowered into the water. This is the first
time she has been used to scout ahead of the ship, buying
up copra before a competitor can reach the villages.

There is a single four-wheel-drive track that
serpentines through the jungle, but more than
likely you will find it has been washed out by one
of the frequent torrential downpours. In any
event, that track stops at the southeast corner of
the bay. Farther west lie only malaria-infested,
jungle-covered mountains, many of which have
never been charted or even explored.

The *Henry* cruises at half speed, waiting
for enough light to begin working. She will buy
copra (dried coconut) at the isolated villages
scattered around the rim of the bay. She also has
a general store on board from which villagers can
purchase staples with the money they will
receive for their copra. The *Henry* and the few
other trading vessels are the native people's only
link with the outside world. In the interior of this
and some of the other islands the people are not
far removed from the Stone Age. The villagers on
the coast, by comparison, are fairly sophisticated
because of more frequent contact with Europe-
ans and with their urban countrymen.

The pilothouse looks almost barren,
equipped only with a wheel, engine telegraph,
and compass. The *Henry* has no radar, no loran,
not even a Fathometer. Fortunately Roger, the

captain, and Matthew, the second captain,
appear capable. They are ni-Vanuatu, or island
natives. Both come from the northern islands
and have sailed the local waters since they were
children. I ask the middle-aged Roger how he
navigates through the reef-strewn waters with-
out even a Fathometer. He is shy and seems to
have difficulty coming up with an answer. Per-
haps he has never been asked the question
before. Finally, he stammers, "I just measure with
my eyes, measure the distance to the reef. I can
read the hills and the current, whether it is push-
ing us down or not, and I watch these things
carefully all the night." He makes it sound simple
but it is not.

0700 hours. Two native crewmen struggle
to crank the heavy flywheel on one of the single-
cylinder winch motors. So far it has not started.
They take turns cranking, their enormous mus-
cles bulging and their faces dripping with sweat,
but the motor refuses to catch. Between the
winches are the *Henry*'s two hatches, on top of
which sit two workboats, one steel and the other
wooden. There is also an aluminum speedboat
and a large lapstrake dinghy. The crew have
shifted their attention to the second of the four

winch motors. A few minutes of cranking and it
starts unevenly, an oily cloud of smoke envelop-
ing the foredeck.

We are now halfway up the bay. Another
trading vessel is anchored at the head of the bay.
It looks like the *Kismet*. That is not good news for
the *Henry*. Manwah Leong is stocky, toughened
by hard work and the weather. He stands by the
rail, binoculars to his eyes, looking over the com-
petition. One of three partners who own the
Henry, Manwah is a Vanuatan whose parents
emigrated from China at the beginning of World
War II. His partners, Puichee and Jackson Lo, are
brothers whose parents also fled the Japanese
invasion of China, eventually settled in Santo,
and now own many of the town's stores and
shops. Puichee Lo is not on board the *Henry*. He
is a scholarly accountant who prefers to stay on
shore and handle the financial end of the busi-
ness. Jackson Lo, twenty-four, is just out of col-
lege and is learning the ropes. He runs the trad-
ing store on the ship. The three partners
attended the same university in Australia, then
returned to Santo to carry on the business tradi-
tions of their families. It is Manwah, however,
who is the natural leader and who makes most of

the decisions regarding the vessel and the copra purchasing. He is the ramrod of the group.

All the winches finally are clattering away. The *Henry* slows as she nears the head of the bay. Mountains, rugged and covered with dense foliage, stand directly before the bow. Palm groves interspersed with jungle rim the beach and are separated from the mountains by lush green hills. Except for the few people working around the other trading vessel, there is no sign of man.

The *Kismet* is loading copra. She belongs to Burns Philip (B. P.), a huge Australian trading company that is the General Motors of the South Pacific. It could probably buy the whole country of Vanuatu. In fact, Burns Philip does buy and sell almost every article and commodity produced or consumed in the country. Manwah says that with his speedboat he could, if he wished, run ahead of the *Kismet* and purchase all the copra, thereby shutting B. P. out of business for the whole bay. I ask him if that would be wise. He shrugs and answers that he has decided not to do it because it would not be fair. Besides, he says, many of the villages save their copra for him because his reputation is good in the area. Most of the traders, when they buy copra, deduct four kilos for the weight of the bag itself and he only subtracts two kilos.

0745 hours. Jackson Lo and his assistant start stocking the shelves of the store, taking everything out of the cases that fill the tiny room. The cartons contain canned milk, Ovaltine, mosquito spray, lanterns, canned beef, canned mackerel, cigarettes, flashlight batteries, mosquito coils, chewing gum, flour, sugar, crackers, tampons, cotton swabs, writing tablets, chicken curry, and even a few soccer balls. Looking at all the canned food, particularly the mackerel, I reflect on the cultural changes that encourage a people living near waters teaming with fish to eat it canned.

Manwah's aluminum boat is lowered into

the water. It is filled with cases of cabin biscuits, cheese twistees, and two-minute noodles, along with some shovels. The boat's two forty-horse-power outboards come to life, and Manwah heads into shore to find out whether there is copra for sale and in which direction the *Kismet* is working so we can skip ahead of her. The spray thrown up by the speeding boat feels cool and refreshing.

The food and shovels are dropped off at one of the villages in payment for copra already purchased. Then we travel another mile down the coast toward a signal fire and beckoning villagers on the beach. Manwah pulls in, successfully negotiates with the local men for their copra, and leaves a scale on which it will be weighed. Then he heads back to the *Henry* to get a workboat. Judy and I elect to stay on the beach and watch the proceedings.

The village, set back 200 yards from the water, appears empty. All of its thirty-five inhabitants are attending the copra weighing. Eight thatched laplap huts encircling an open cookshed make up the settlement. The huts are well spaced, and some palm trees have been left standing around them to provide shade. The little community covers an area of perhaps two acres and except for the water side is enclosed by walls of dense foliage. Everything is tidy. Even the dirt around each hut shows signs of broom marks where it has been swept clean.

Next to the beach sits a bamboo shed in which the villagers store their copra. A few bags have yet to be filled, and two men shovel copra into them while others tamp the partially filled bags with bamboo packing sticks. Another older man, whose skin is as black as night and whose muscles stand out like ropes, sews the burlap bags closed with a wooden needle. The coconut shells have been split into small pieces with a machete, then put over a fire to dry. This is called smoked copra and, because it is dirty, fetches a

Manwah Leong is the ramrod who keeps the whole copra-trading operation together. He is respected by crew and villagers alike.

A sailor watches uneasily as a sling loaded with bags of copra is raised above him. He is in a most dangerous position. If the sling comes apart he has only a second or two to leap aside before being crushed by a ton of copra.

A crewman secures the sling to its cargo.

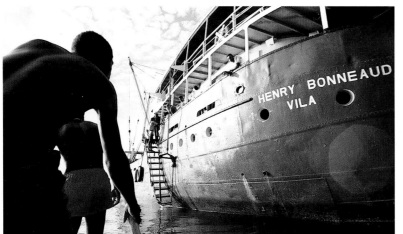

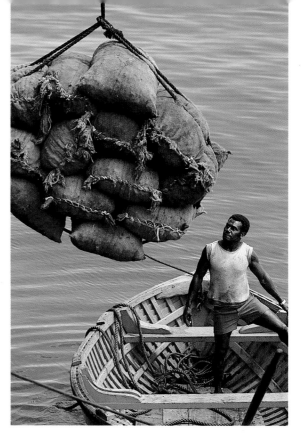

lower price than air-dried copra. It also stinks and yet, oddly enough, it is used as a base for perfume and soap, as well as for cooking oil and suntan oil.

Nearby the village women sit with their children in the shade of a big fig tree. Each of the women appears to have one and in some cases two small babies. Flies swarm over everyone. Nobody seems to mind. One woman while talking softly to her small child, cuts a slice of sugarcane for it. The people are shy, but very friendly. A smile invariably brings a big smile in response. Besides their native language, some of the villagers speak Pidgin English, but it is often very difficult to understand. After a few attempts to communicate, I let myself be lulled by the beauty around me. A flight of dazzling red and green lorakeets arcs through the trees, squawking and chirping as they go. The beach is all black volcanic sand, and small waves drop on it with soothing regularity. The day is very hot and the ocean feels luscious; I let it swirl around my knees. Judy and I have been told not to swim off a black volcanic beach because the dorsal surfaces of large sharks blend in too well to be seen. We will heed this advice.

Manwah's assistant supervises the weighing of the bags of copra. The scale is mounted on a bamboo pole held between the shoulders of two villagers. As someone calls out the weight of each bag, the assistant records it and the owner's name in a little notebook. The workboat arrives towing the dinghy, which it casts loose thirty feet from the beach. The ni-Vanuatu troop out in a line through the surf with bags of copra on their shoulders. Each bag weighs as much as 170 pounds, yet the powerful villagers handle them as if they were feather pillows. Some of the *Kismet*'s crew come by in their workboat and swing in to see if they can buy any of the copra. It is too late; the *Henry* has bought it all. The villagers point to another place up the coast where they think the people might have copra to sell. *Kismet*'s workboat heads back to its ship. As it passes the *Henry*'s boat, the two ni-Vanuatu crews yell and laugh at each other, good-natured jibing that seems to indicate a friendly rivalry between the two ships.

1000 hours. Crazy, the puppy, has had his breakfast and is sound asleep again behind the freezer. A married fall is rigged using the two forward derricks and a sling put around half of the

workboat's twenty bags of copra. The sling rises over the side, and the copra is dumped unceremoniously in the *Henry*'s forward hold. Roger has been on the walkie-talkie to Manwah who is up the coast. He has copra from three more villages lined up, so he tells Roger to haul anchor as soon as the *Henry* is finished loading at her present location. The ship's store is packed with villagers trying to decide what to buy. Jackson is behind the counter filling orders as fast as he can.

1145 hours. Manwah has returned. He is trying to get the villagers off the ship so that it can be moved up the coast. "Passengers, let's go!" he yells. "Everybody ashore that's going ashore." Nobody appears. Ten minutes later one boatload of villagers is taken ashore. More people line up at the ladder with their purchases. One man has a bag of flour and a box of .22 caliber shells. Another has two beers, and a third admires a new plastic comb.

I ask Manwah how many villages he has visited in his speedboat and how much copra they had to sell. He answers, "Three. I only stop at the main ones and we work our way back. The main village, they have over one hundred bags,

maybe eight tons. The other ones less."

"So you got ahead of the *Kismet* and bought up all the copra?" He nods. "I thought you said you weren't going to do that."

"That's what I told you when I left so that's what I thought," Manwah answers, "but with *Kismet* here, well...that's business."

An hour later we see one of the *Kismet*'s workboats going up the coast. Obviously it did not take the *Kismet* long to figure out Manwah's game and to realize that two could play. I ask him if he is worried; he certainly does not seem to be.

"No," Manwah says, "because they don't have any European on board so they work Far East time. When half past five comes, they stop doing copra. They just stop working. We work till there is no more cargo to load. I just pay the crew overtime. At Malacoola we worked till midnight—well after midnight, because the crew, they are very satisfied if I pay them overtime. So *Kismet* can't compete well."

Manwah seems sure that with his and Jackson's supervision, their good reputation, and B. P.'s much higher overhead, his little David will always have an edge over B. P.'s Goliath. Hope he's right.

I wonder what the native people do with all the money they receive, which is certainly more than they need to buy food. Jackson says that they must pay a fifteen-dollar-a-year head tax to the government and that some of them are starting to buy wire and implements for cattle raising. They also buy clothes. When they have village parties at Christmas and on Independence Day, they invite other villages and purchase a great amount of food, beer, and wine. They usually roast a pig for these celebrations, which go on for two or three days.

1330 hours. The *Henry* drops anchor in front of a large village eight miles west of where we had been. Judy and I accompany Manwah and some of the crew on the speedboat to the

beach. There is a great expanse of grass in front of the village, which is built around an impressive corrugated steel building. Manwah explains that it's the village church, built by prisoners.

We walk through the village, surrounded by curious ni-Vanuatu. It is hot and mostly silent here. Jungle-covered mountains loom in front of us. "Prisoners," I ask, "whose prisoners?"

"They were headhunters from up in the mountains," Manwah says, "and they were killing people. The police caught them and brought them down."

"Who did that?" I ask. "Was it the British or the French?"

"The French, yeah, back in the sixties. The headhunters were coming down and killing people for their heads. Just cut them off with knives."

"Were they eating people?"

"No, just killing them. See, they believe in voodoo and witchcraft and things like that and they were doing some witchcraft. If a man believes in this and he wants to kill you, no matter if a whole crowd of villagers try to stop him, he will just walk through and come and kill you, like that. The local people believe this too. They believe that people turn into shock [zombies] and come and eat other people for revenge and things like this."

While Manwah is talking, I am listening to a sound coming from the mountains. It seems like distant drumming, but it must be my imagination. A little chill runs down my spine in this too quiet village. I wonder how I would taste.

We find the village chief, who accompanies us back to the beach. The launch arrives, pulling two workboats close to shore. The waves are good-sized here, so the villagers are having difficulty loading the copra. When the first boat is half full, a big wave comes in and knocks the boat and the people around it askew. Loading stops. The men put their bags of copra down on the beach, sit on them, and wait for the waves to

subside. The only sounds are the roar of the surf, birds twittering, and cicadas humming. But it is so hot that it seems as if you can hear the heat too. I feel like pancake syrup, like I am melting into the sand.

1500 hours. Back on the *Henry* the crew have begun unloading the workboats. The steel workboat is stacked high, a veritable mountain of bags. Ten or twelve bags are taken in each sling, raised above the rail, and dumped into the hold. The winch motors clatter. A second and a third sling are loaded, and the empty steel workboat heads back to the beach. A sling comes over the side from the wooden workboat. It prematurely comes apart. Copra bags are bouncing in every direction. The three crew members on top of the hatch leap out of the way, then kick the bags into the hold.

Dan and Joan Sheperd, two adventurous, middle-aged New Zealanders, stand in the shade of the bridge overhang watching the loading. Dan is the chief engineer, the one that keeps the *Henry* running. When Manwah and the Lo brothers bought the *Henry* for $120,000, they thought they had a steal. However, with almost no previous experience on ships, they did not realize what a wreck they had purchased. The Sheperds had been sailing for two years around the Pacific in their self-built thirty-five-foot steel sloop. They sailed into Santo about the time the three partners realized their predicament and were becoming desperate. Since Dan had owned a marine engineering firm for fifteen years in New Zealand, he was thoroughly familiar with a ship's mechanical and electrical systems. A deal was struck and Dan undertook the herculean task of putting the *Henry* back in operating condition.

He laughs. "When I came on board all the heads were off, three were cracked, there were cracks in the block, one piston was out, the pumps and the timing gear were all disassembled, as was an auxiliary engine—and all the

pieces were mixed together. It was a bloody mess."

"What did you do to get her running?" I ask.

"First we took stock of what we needed. Then we had new heads and the other parts airfreighted in from Germany. I pinned the block, cleaned everything, and put it all back together. We had her running again in a month."

"That was quick work."

"We wanted to be on our sailboat and cruising again," he says, smiling.

Dan and Joan are cruising all right, but not on their sailboat. Manwah and the Lo brothers realized that they would need someone with Dan's talents to keep the *Henry* together. Such a person is not easy to find in Vanuatu. So they offered Dan an unheard of salary for those islands, and three months later he and Joan are still on the *Henry*. Joan has adopted Crazy and is slowly edging her way into taking over in the galley. She wants to do it gradually so the present cook does not become offended and quit. Her presence in the galley would be a service equal to Dan's work on the engine.

Manwah and Jackson are busy counting out the money for the large amount of copra they have purchased. In the cash box there are stacks of 1,000-vatu notes.* The tally sheets are computed and the men are paid in cash. In some cases the women also get money. Small village children look on. As each name is called out, a man steps into the small store to get his earnings. Patrick, Samson, James, Mele, they all approach eagerly and stare at the pile of 1,000-vatu notes. Manwah calls out to one fellow, "Thomas George, you, Tom, come." Tom comes in to get his money, gets 15,870 vatu for eight bags. Jackson calls, "Nonnay, stop," which means "Nonnay, come here." The villagers who come in

* A 1,000-Vatu note equals ten U.S. dollars.

to collect their money range in age from early teens to perhaps early sixties. Generally they have made anywhere from $80 to $300.

When the men have finished collecting the money, the women come into the store to ask the price of a bag of rice or of a length of printed cotton dress material. There's a large box filled with different kinds and colors of fabric. Manwah takes out a selection and places it before a prospective buyer. She is a heavy-set lady in her middle forties. The woman selects a blue floral pattern. She's quite pleased with her purchase. A young girl in a Vanuatu T-shirt buys a Casio plastic wristwatch with a red band. Another pretty young girl walks away with some chocolate biscuits. A boy who has been standing patiently also gets a package of chocolate biscuits and runs outside as fast as he can to start eating them. Two flashlights go over the counter, complete with batteries. The small children look wide-eyed at everything going on around them. Now half the counter is taken by little children. Webster's chocolate cream biscuits seem to be the best seller, followed by flashlights. The ladies are giggling and laughing. They are simple, naive, and honest people, certainly unsophisticated. "You gottem one round biscuits, you gottem one, one no more?" a woman asks. A mother with a number of children buys two brightly colored towels and a pile of gum. Most of the small children put out their 10-vatu pieces and get a little package of Wrigley's. Jackson is trying to push soup. The lady who bought the dress material asks, "How much some soup?" He tells her and she digs into her plastic bag for the money. For 100 vatu she gets packages of chicken-flavored soup mix. A young boy comes in and buys a pair of rubber go-aheads the size of waterskis. Jackson's still trying to push the soup mix. There's a dispute about the amount of money received for a copra sale. Raymond, a rough-looking guy with a chain around his neck, comes in, asks, "How much me

gottem?" Manwah replies, "Seventeen thousand six hundred." Raymond says, "Me gottem only six thousand, no more." Manwah goes over his receipts again, recalculating the amount paid for the number of bags delivered. I miss the outcome in the din.

The customers come in groups, delineated by age and sex. After the women leave, the next group is young men in their teens. Jackson sells one good-size young fellow an orange towel for 200 vatu, about two dollars. The young men want cotton shirts, and things slow down because in the jumbled store it's difficult to find sizes. One shopper gets a pair of black swimming trunks, holds them up against himself, seems undecided whether they'll fit or not. He asks, "What em size?" The answer is "eighty, eighty." A pair gets flung down from the top shelf with the call "seventy, seventy." Black swimming trunks go for 900 vatu a pair; three pairs are taken. Jackson says that soap is a bestseller, but I've only seen two bars go out. Just then two more bars go over the counter. A middle-aged man buys a mosquito coil, a flashlight, and a Cowboy cigar, which does not look like it's on the high end of the cigar range. The crowd begins to thin out. Jackson wipes the sweat off his brow and plunks himself down on a case of canned mackerel.

1640 hours. The *Henry Bonneaud* weighs anchor to sail a few miles to a small village at the northwest end of the bay. This will be her last stop of the day. At 1715 both workboats are shuttling to and from the beach. Jackson is still busy in the store. A ni-Vanuatu couple has just bought a bottle of Gilbey's gin and a gallon jug of Hamilton's vintage claret. Jackson asks why they are buying the liquor. The man answers, "My cousin's brother. Time him cut em face hair." A universal rite of passage, it seems. The first shave is as good as any reason for a celebration. The couple walk off, gently cradling their booze.

1825 hours. Loading is about completed.

Manwah returns in the speedboat. He has six nouamba, large green tropical pigeons, which he has shot in the forest. Good. We will have something other than curry for dinner tonight.

The next morning there is no sign of the *Kismet*. It has headed down the west side of the island hoping to buy up all the copra before the *Henry* arrives. That is all right with Manwah. He has decided to sail east to the islands of Aoba and Maewo. A small outboard is found to take Judy and me to the village at the southeast corner of the bay, where it has been arranged that a Land Rover will meet us. We don't know it yet, but our ride will not be able to make it and we will have to trek out through the jungle with our equipment.

Two hours later, we land on a deserted beach in front of a small village. We turn to get a last look at the *Henry*. She is just a dot now, hull down on the horizon, heading east.

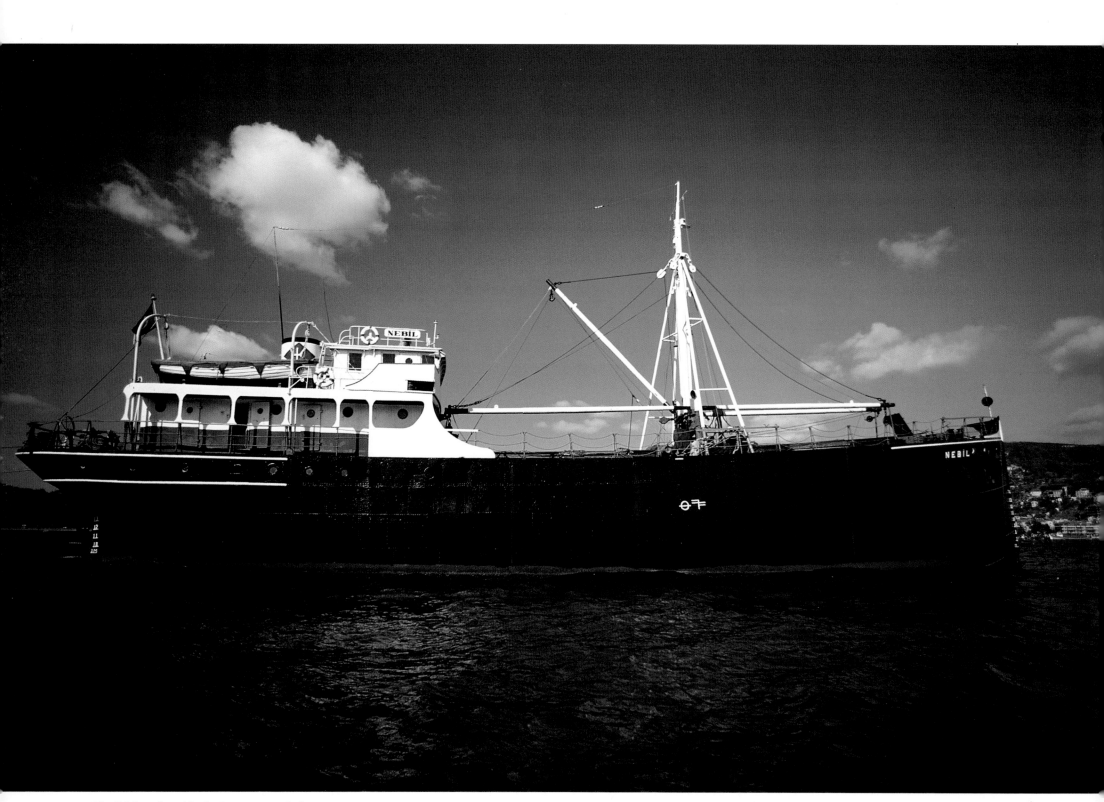

The *Nebil*, anchored in the Bosporus, awaits her next cargo.

NEBIL

The Bugatti of Old Freighters

The *Nebil* is the Bugatti, the vintage Ferrari of freighters. Not in terms of speed, certainly, for her flat-out racing maximum is only a hair over ten knots. It is her lines that make her a floating classic. With her plumb bow, beautifully proportioned house set well aft, and her old-fashioned counter stern, she looks as though she has been rescued from a 1914 time capsule.

Her interior smacks of Grandma Svenson's parlor. A. B. Lodose Varf., her Swedish builders, had no thought of making a grandiose statement, for the *Nebil* was designed as a coastal carrier to haul timber and general cargo along the shores of her native country and only occasionally to venture as far afield as Denmark or Finland. Much of what remains of her original woodwork is planked pine. The combination mess and saloon sports a simple but handsome sideboard as well as mess table and bench, and is heated by an old oil-burning stove.

The *Nebil*'s original wheelhouse was built open to the elements (see old photo). This is difficult to understand in frigid Sweden, but it is a common feature of many coasters designed early in the century. The open wheelhouse design was

used in the first oceangoing steamships of the 1800s, but by the time the *Nebil* was built, almost all the larger vessels had fully enclosed pilothouses. The *Nebil* was modified, probably in the twenties the first time and again in 1959, when a new wheelhouse was installed following the design of the previous one. Her entire hull and all her frames are original, however, as is her chain-driven steering gear.

Huseyin Avni Kalkavanlar, the *Nebil*'s Turkish owner, is a happy man who dearly loves his old ship. He has certainly taken good care of her. When Kalkavanlar bought her in 1959, he installed a two-stroke Crossley diesel that had been used in a World War II British minesweeper and two other coasters prior to finding a home in the *Nebil*. The Crossley has long been out of production, so obtaining replacement parts is difficult. Curiously, however, some items such as valves and valve covers are being fabricated in Turkey. This would indicate that there are a fair number of old Crossleys still in use in the country.

The *Nebil* carries coal, salt, and timber from Black Sea ports to Izmet and Izmir. She also carries huge twenty-five-ton marble blocks from

The auxiliary steering apparatus on the stern is a perfect example of functional art. It, like the rest of the ship, has been well maintained and is fully operational.

A most simple structure, the wheelhouse, while an addition, fits the vessel so well that it looks like a part of the ship's original design.

The saloon could be a dining room in a Victorian country cottage. It would not be surprising to see a grandmother serving coffee on the crocheted tablecloth.

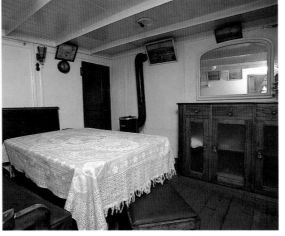

Marmara Island. These blocks usually measure 4 meters by 2.5 meters by 1.5 meters and require extra-heavy loading gear. When the *Nebil* was modified in 1959, Kalkavanlar installed a heavier mast and new Lister diesel winch motors for this purpose. Still, even with having doubled the six-ton-capacity derricks, loading the marble remains a risky proposition.

The fact that the *Nebil* was originally powered by a steam engine and, as has been said, was built for carrying timber is about all that is known of her early history. She first came to Turkey in 1952, purchased by the Cerrahohullari Company, a large owner of bulk carriers. Kalkavanlar is her third Turkish owner, and it is likely that he and his son will keep her as long as she can still sail. It is good that the *Nebil* is owned by someone who appreciates her, because she is a rare antique. She is also one of the prettiest old ships left in the world.

The table in the mess is large enough to accommodate most of the *Nebil*'s crew. The planking on both walls and ceiling is at least fifty years old.

The Elephant's Graveyard of Old Ships

In 1983, with a worldwide recession drastically reducing trade in and between almost every country, the ship-scrapping business is a good one. Vessels by the hundreds lie dormant, hollow and unmanned, silently awaiting their destruction. Sometimes they are lined up at anchor in neat rows. In other places they float in a random jumble, or lean on each other like old drunks. When a ship's turn comes, her guts are ripped out; everything of value is stripped from her. Then with cutting torches she is split into pieces small enough to be loaded onto another ship, or smaller if they must be transported to the smelter by truck or rail.

The old ships are the first to go. They are the least efficient and usually the most expensive to operate. The litany of their disadvantages is endless: hull shapes that do not cleave the water cleanly and therefore take tons of extra fuel per day to move; cargo-handling gear that is 50 percent slower than modern cranes; hatchcovers that must be laid plank by plank over the hatch beams. In the case of the latter, four men must put in two or three hours of labor

A jumble of coasters await their end. All high-value objects have already been removed from these ships, but because of the yard's backlog, the ships appear to have been forgotten.

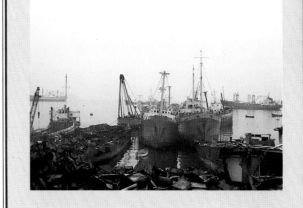

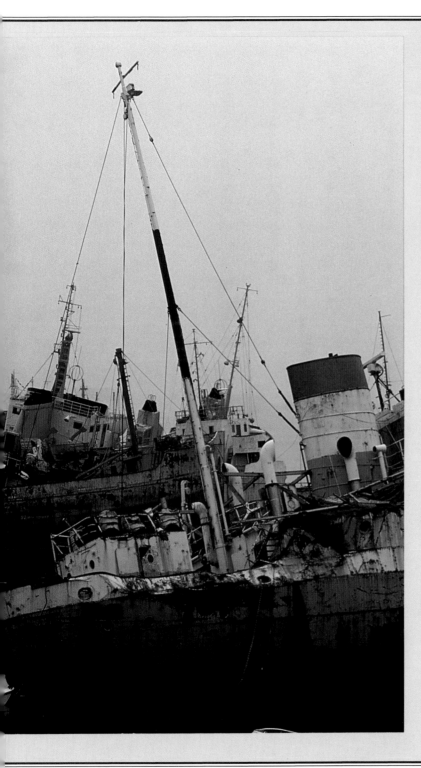

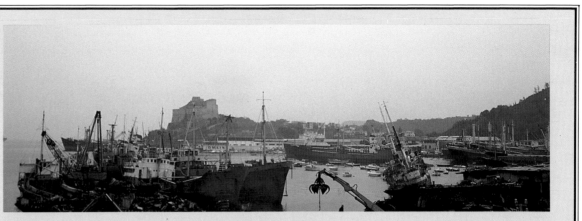

This breaking yard is in Pozzuoli, just north of Naples, Italy. Old ships of all sizes lie anchored before being scrapped; an ancient fortress stands guard over them.

The yard loads cut-up steel sections onto barges. Tugs then tow the barges to a smelter where the steel is melted down for reuse.

for each hatch that is to be used. On a modern vessel, the whole mechanized operation is performed for four hatches in only thirty minutes, all accomplished by one man pushing buttons. Then there is the scarcity of replacement parts. Try to find a No. 8 piston for a 1949 Buckeye Marine Diesel when the Buckeye Machinery Company has been out of business for twenty-five years.

Some of the old vessels were poorly designed. They have nook-and-cranny cargo spaces that are slow and difficult to fill, or because stress coefficients could not be precisely calculated, framing and other structural members are much larger than they need to be, thus considerably reducing the ship's cargo space and deadweight capacity. And always there is the great bugaboo of old machinery: steering gear, winches, anchor windlasses, engines, and cooling and electrical systems that continually break down despite constant inspection and maintenance.

It is also harder to find and keep a good crew on old ships. Seamen's quarters are usually cramped and have poor lighting. There is never air conditioning in the south and usually inadequate cabin heating in the north. Galley facilities and plumbing are antiquated and, to say the least, unhygienic. It takes a sailor with a strong stomach to use the head on many an old ship.

In most developed countries the modern seaman is reluctant to submit to poor living conditions for any length of time, and in many countries he is not permitted to. The old vessels violate volumes of health and safety (and sometimes pollution) regulations, and to bring such a ship up to code often costs far more than it is worth.

Then consider insurance. The premiums to cover the hull and machinery of an old vessel are usually 50 to 100 percent higher than they would be for a modern one. Sometimes insurance simply can't be purchased or is so prohibitively expensive that the owners can't afford it. Even the insurance for the *cargo* carried on a prewar ship is at least half again as expensive as it would be on a newer vessel. Thus most shippers of high-value cargo will not even consider using an old ship. In many parts of the world neither the vessels nor their cargoes are insured, and each voyage takes on the aspect of a game of roulette—often with an owner's entire life savings at stake with each turn of the propeller.

It is no wonder that in hard times the old vessels come into the bays that front the breakers' yards, sometimes towed, sometimes under their own power, but all with the quiet aspect of their terminal voyage. The final roar of the anchor chain through the hawsepipe is heard. Then after the last crewman departs, there is silence again as the laid-up vessel floats in eerie solitude awaiting her turn under the torch.

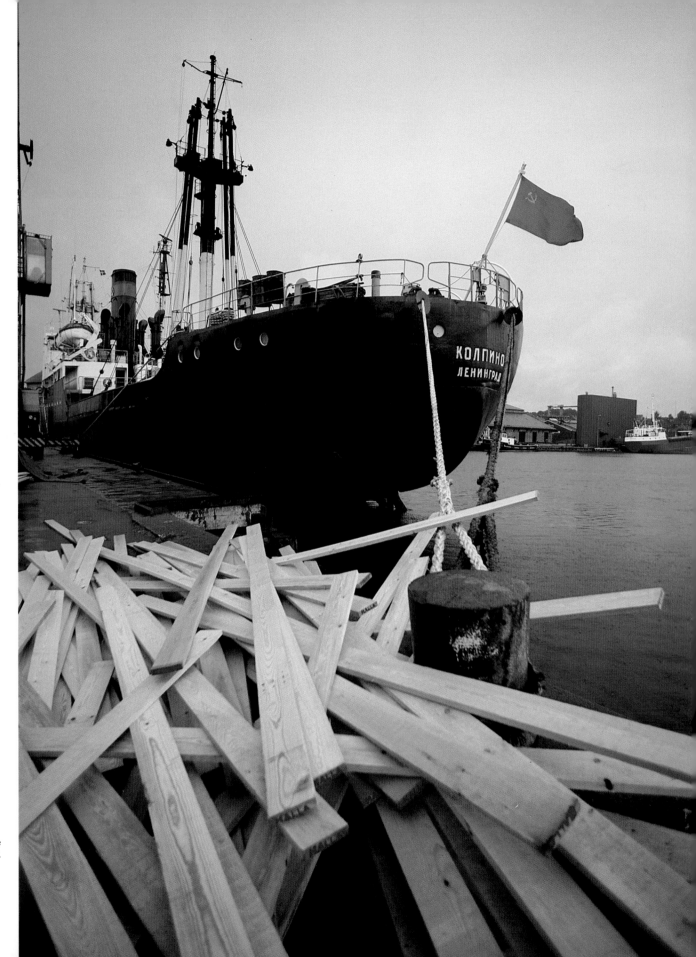

Dunnage, used to brace the cargoes in the
Kolpino's holds, is removed upon discharging.

KOLPINO

Oldest Steamer in Russia's Baltic Fleet

It had been a busy week. Judy and I had completed work on the Danish islands of Aerø and Funen before arriving at Horsens to do a story on a small coastal freighter. That work was now finished as well. It was Friday evening and we were still in Horsens, an industrial city on the east coast of Jutland. What do you do in Horsens on a Friday night?

A sailor we had interviewed on the Danish coaster invited us to meet him for a drink at a seaman's bar on the waterfront. When we arrived, the place was filled with Scandinavian seamen celebrating their evening in port. The atmosphere resembled a Friday night in a college pub. Laughter was raucous. It was early evening, but some of the patrons were already on their way to Saturday morning hangovers. Dice cups banged on the bar, accompanying a female singer blasting out a Danish pop tune on the jukebox. We squeezed through the crowd and spotted our acquaintance at a window table.

Soren (not his true name) must have been drinking for some time, judging from the number of empty glasses in front of him. He was morose. His wife had divorced him for unspecified reasons a year before. Sailing was a living but held

no particular interest or fascination for him. Soren alternated between telling us his troubles in broken English and ordering us a steady procession of aquavits and a horrible black anise-based concoction aptly named "North Sea crude." The fiery aquavit, a sort of caraway-flavored vodka, was burning a hole in my stomach. We urged our friend to come and have some dinner, but he wasn't ready yet. During the third retelling of the sorrows of Soren, my gaze wandered to a vessel lying on the outskirts of the harbor. It was a steamship and a black cloud of smoke billowed from its stack.

I asked Soren the nationality of the freighter, and he replied it was Russian. I suggested that we visit it and see if we could get on board. Soren said most emphatically that it was not possible, that the Russians wouldn't let any strangers on board. I persisted. After all, we had absolutely nothing to lose by trying. Soren answered that there was no point. He said the Russians didn't even permit Danes to visit their ships, and they certainly were not going to allow us, Americans, on board.

He was right. It was the summer of 1984, and relations between the Soviet Union and the

The officers' saloon could be on a ship built in the 1930s. A watchful Lenin insures that no diner forgets where he is.

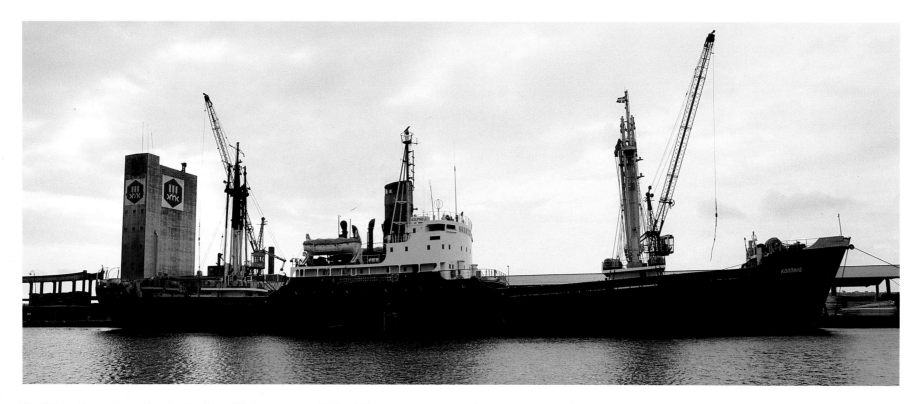

The *Kolpino* lies under sodden Danish skies while her cargo of plywood is unloaded by dockside cranes.

United States were worse than at any time since the Cold War of the fifties. In fact, relations between the two countries were so bad that I had not even sought permission from authorities in the USSR to do stories on any Soviet Russian ships. Still, the opportunity was sitting right there in front of us, and it was too good to pass up. I told Soren that with or without him Judy and I were going to try to get on the Russian ship. Reluctantly he agreed to come along.

The three of us set out on foot. When we arrived at the bottom of the *Kolpino*'s accommodation ladder, Soren spoke Danish to the sailor on watch. A Russian officer approached and the spiel was repeated, again in Danish. Then Soren turned to us and with a conspiratorial smile said, "It's good. I told them you are Swedish journalists."

Judy and I were astonished. Neither of us spoke a word of Swedish, and since the officer Soren had been talking to spoke Danish, *he could certainly speak some Swedish.* The officer invited us on board. The three of us stumbled up the ladder and were met by third mate Igor Vinogradov. With the help of the aquavit and in Judy's case the "North Sea crude," we did a fair

job of imitating Soren's broken English. That, together with a sprinkling of *das* and *nyets*, seemed to allay suspicions. Fortunately the officer did not test our Swedish.

Vinogradov appeared to enjoy showing us his ship and gave us a quick tour of the bridge and engine room. A handsome, affable young man, he was well educated and spoke good English—certainly better than what we were pretending to speak. He seemed happy with his work as navigator and even posed for a photograph, "plotting a course" on his chart table.

The *Kolpino* was an interesting vessel. While she was quite modern by "old tramp" standards, she possessed a vintage Old World atmosphere, particularly below deck. Also, she was one of the very few steamships still operating in Europe and was the oldest freighter in Russia's Baltic fleet: definitely a candidate for the book.

I told Vinogradov about the work we were doing and asked if we might return the next day to do a story on the *Kolpino*. With a shrug he said, "Why not? But first you must ask the captain and he is not now on board. You come back

A crewman repaints one of the lifeboat davits.

The quarters of first officer Sergey Bobicol has a cramped but homey feel. The curtain at left conceals the officer's bunk.

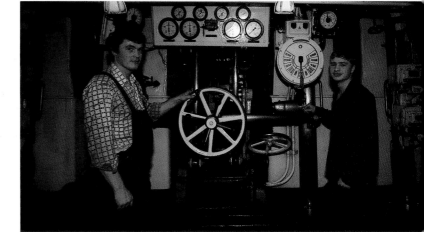

Motorman Iury Poljakov (left) and cadet Peter Suspizin pose in front of the engine-room telegraph and throttle.

tomorrow and you can ask him." Then, as an afterthought, he added, "You have some papers? We must have some papers to show the captain."

I told him that I didn't have any papers with me.

"No problem, no problem," he replied. "Just card of business is okay." His voice trailed off in a manner that indicated rising suspicion.

Time to pay the piper. There was a long moment of silence. I handed Vinogradov my business card. He looked at my name and profession, the address in Washington State, and the block letters at the bottom: USA. He raised his eyebrows and his mouth showed a hint of a smile that seemed to say, Caught you, you son of a bitch! Vinogradov would have done well in Hollywood. In fact, all he did say was, "You come back tomorrow morning."

There was one chance in a hundred that we would be permitted to do the story, but at nine the next morning Judy and I were at the bottom of the *Kolpino*'s ladder. The captain was still not on board. A seaman took us to the quarters of first officer Sergey Bobicol. Officer Bobicol was a stern-looking man in his early forties. I think he had steel teeth. It seemed likely that he

was the ship's *pompolit*, or political commissar. He studied our references carefully, then said, "Okay, let's go. Where you want to see?"

Normally it takes a minimum of four hours to do a story on a ship. In some cases we would spend two or three days interviewing the crew and photographing life on board a vessel. It was clear from officer Bobicol's manner, however, that today we might have thirty minutes. I told him we wanted to see the bridge, engine room, mess, and galley. With Judy shooting as fast as her motor drive would advance the film, we raced behind the fast-striding first officer.

The bridge appeared to be fairly standard for a vessel built in the late fifties. The radar and navigation aids looked as if they were original equipment. The *Kolpino*'s engine room was more interesting, with its oil-fired boilers and quadruple-expansion steam engine.

All the public areas gleamed with polished wood and brass fixtures. The officers' saloon had cut-glass lamps, fine wood paneling, and a middle-aged Lenin peering down from the wall. Both the saloon and the officers' quarters were similar to what one would find on Western European cargo vessels built in the thirties. The

Third mate and navigator Igor Vinogradov works at the chart table.

decor was warm and certainly more appealing than the austere steel-and-plastic interiors of many contemporary freighters. Everything was shipshape and looked well cared for.

The *Kolpino* usually sailed from Leningrad to ports in Western Europe. This voyage she was discharging 750 cubic meters of plywood in Horsens and another 1,680 cubic meters in Antwerp. Then she would load sheet steel in Bremen, West Germany, for her return to Leningrad. Loading and discharging cargoes were no longer accomplished by the vessel's derricks and steam winches. More efficient dockside gear now performed these tasks. The *Kolpino*, according to her officers, would soon be scrapped.

Unfortunately I was not able to develop any interesting interviews with members of the crew. Not only was there a lack of time, but with officer Bobicol's hovering presence, no one wanted to volunteer much information about himself or life on board the *Kolpino*. Still, it was a welcome surprise to be allowed to see and record for posterity even a smattering of one of Russia's oldest working cargo vessels.

Life on a Communist Ship

Stack insignia, Soviet merchant fleet.

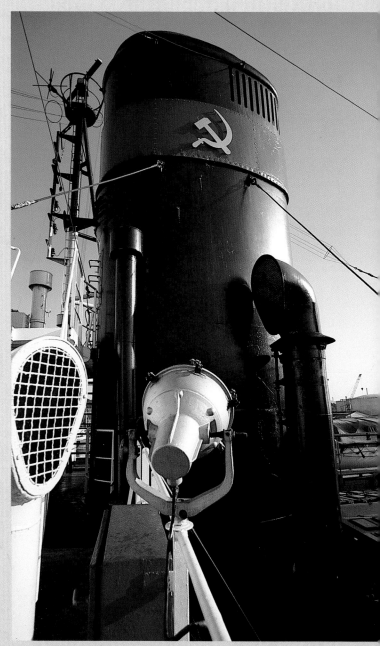

It would be interesting to pluck Karl Marx from his grave, place him on a modern communist ship, and then observe his reactions. One hundred years after Marx prophesied that a classless society would result following implementation of his political and social theories, that society has not come to pass at sea—at least not on Soviet ships. While in some respects a ship at sea does not lend itself to democratic operation any more than, say, an airliner can be flown by vote of the passengers, there remain areas where crew members may influence their working and living situations.

The crews, however, of many communist ships, particularly Soviet vessels, live not only under a totalitarian or military-style command structure, but under a social one as well. Interestingly enough, it is on Yugoslavian vessels, representing a country whose economic structure in many respects only borders on communism, that Karl Marx might feel the most at home. In theory Yugoslavia's "self-management socialism" is a doctrine that permits everyone involved in an enterprise, in this case the crew as well as the officers, a part in deciding how it will be managed. The reality is not as perfect as the theory. Still, Yugoslavian sailors may vote on their work schedules or on other aspects of ship management that affect their lives. According to Western translators and observers living on Soviet factory fishing ships, there is no Russian counterpart to the Yugoslavian democratic method. Nor does it seem to exist on Chinese ships, though Chinese officers are subject to criticism from their crews, and the crews from their officers.

The Chinese claim that there are no class distinctions on their vessels. Yet on Chinese ships, as well as Soviet and Yugoslavian ships, the officers live in the best quarters and eat in separate, more luxurious dining saloons. More social mixing of officers and crews takes place on Chinese vessels than on Eastern European ones. Even on some Western European, Ameri-

Stack insignia, China Ocean Shipping Company, the flag carrier of the People's Republic of China.

Wang Yong Shang is political commissar on the Chinese Coastal Navigation Bureau's *He Ping 23*.

Sergey Bobicol, first mate and political commissar on the Soviet Union's *Kolpino*, stands on the bridge.

Stack insignia, Losinjska Plovidba, a Yugoslavian state shipping company.

The political commissar is responsible for crew education, morale, and discipline. He provides the crew with the party interpretation of world and national events and explains new government policy and regulations. He also delivers party propaganda. Discipline and productivity are effected through individual conferences with seamen and by crew meetings in which group or peer pressure is utilized.

Lu Shu Ling, political commissar on the *San Jiang Kou*, a Chinese freighter, provided responses to two hypothetical situations with which he might be confronted at sea. A young seaman, homesick for his girlfriend and family, is not performing his duties and wishes to return to his village. Comrade Lu tells him, "You are like a part of a machine. If your part fails, the whole machine does not work effectively. The collective need [of our country] is more important than the needs or desires of the individual. Therefore, you must do your work and the time will pass quickly [until your holiday]."*

In the second scenario, a seaman continually gets into fights with other crew members; the seaman blames the rest of the crew for picking on him and says that he is only defending himself. Comrade Lu responds, "Our ship is a working unit. Everyone on the ship must unite. If you fight, then the loyalty of the crew will be split into several groups. According to reports of the others, the facts are different [from what you have stated]. [The crew testifies that the seaman instigates the fights.] In China the eyes of the masses are the most clear. Fighting is against the law.† If you continue fighting, you will be locked in your room until you confess your sins."

can, Canadian, and Australian ships there is considerably more social interchange between officers and crew than exists on most Russian vessels. At meals, for instance, the lower-ranking Russian officers seldom start a conversation, but react upon invitation when conversation is initiated by the captain or political commissar.

Perhaps the greatest difference between life on Western and life on communist ships is the presence of the "extra officer," or political commissar, who sails on every large Russian or Chinese vessel. On Soviet ships he is the first officer and is called the *pompolit*. The Chinese equivalent does not have a mate ranking, but is known simply as the political commissar. Both the Russian and Chinese extra officers have rank and authority equal to the captain's even though these men usually have only a political background and seldom know anything about operating a vessel. Because the Chinese and Russian seagoing commissars, like their counterparts in factories or large companies, are chosen by the Communist party, they have tremendous power and influence aboard ship. No one, not even the captain, likes to run afoul of the commissar.

Although occupations in China and the Soviet Union are assigned by the state, most Russian and Chinese seamen feel fortunate to work on ships, particularly those visiting foreign ports. For Russian seamen the food and wages are usually better at sea, and sailors of both nations enjoy opportunities to see the world and to buy Western consumer goods. In the final analysis, however, the quality of life for communist seamen largely depends, as it does for Western seamen, on the type of officers under whom they work. If the captain, mates, engineers, and political commissar are of high caliber and are concerned with the well-being of the crew, the average sailor will have a good life at sea.

*Chinese seamen have eighty-two days' leave and holidays per year.
†Comrade Lu and two other commissars emphatically stated that fighting between crew members is very rare on Chinese ships.

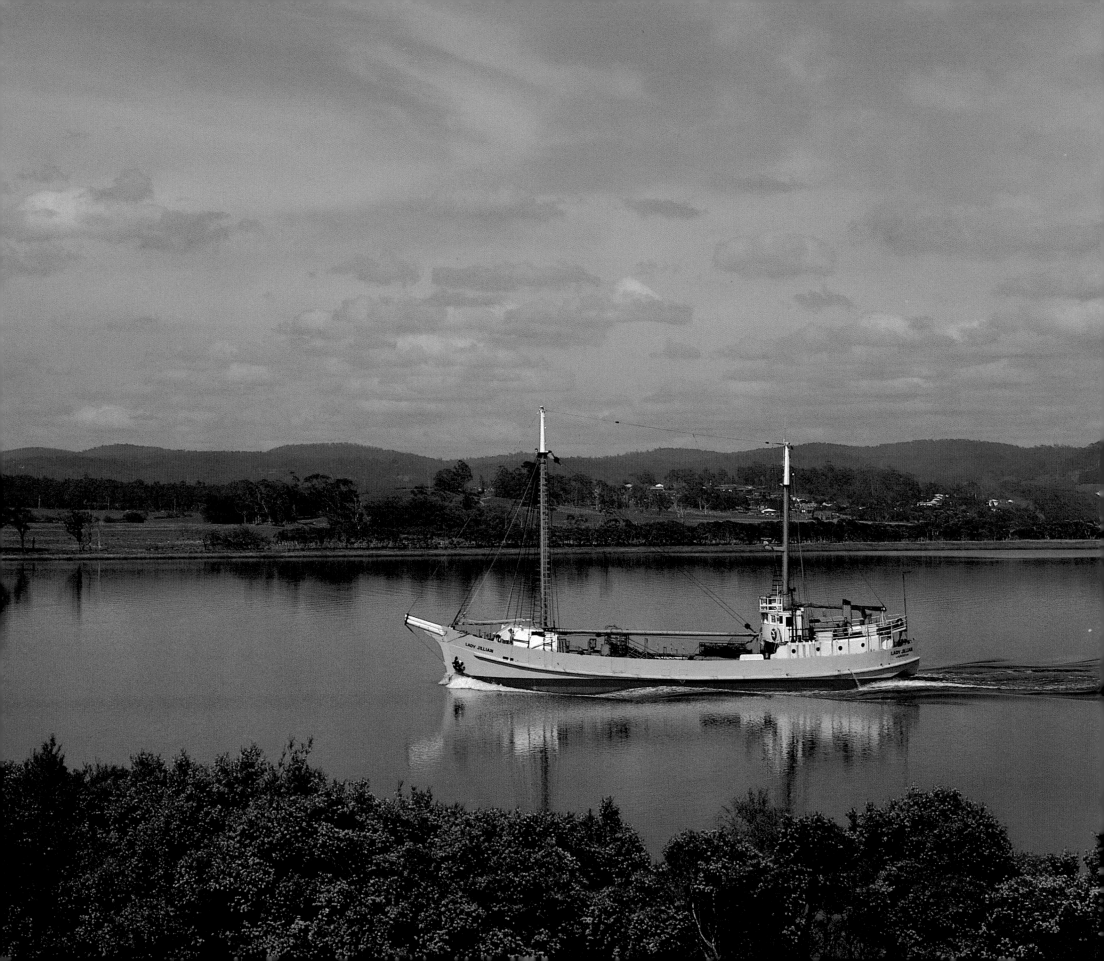

Chapter Thirteen

LADY JILLIAN

Carrying Cattle to Tasmania

They were a tough-looking bunch: Springhead, Max, Shortfinger Sprocket Jr., Jass, and Sprocket Sr. As the ketch-rigged *Lady Jillian* slid alongside the wharf at Launceston, Tasmania, her crew looked as though they were ready to jump from her rigging with cutlasses. A moustached and tattooed Springhead guided the bridging chute into place as Alf Ess, the engineer, lowered it with the cargo winch. The crew positioned themselves along the chute, which ran from the *Jillian*'s hold, across her deck, to the livestock pens on shore. All the men were armed with electric cattle prods.

A series of bellows rang out from below deck. A full-grown cow, the first of 208 Herefords stumbled up the chute from the hold. Wide-eyed and petrified with fear, she stopped midway up the chute. Immediately the cattle following her piled up, bellowing and trying to lift their heads into the air. A crewman stuck an electric prod into the lead cow's flank. The shock sent the haggard animal bolting forward. Each succeeding cow received a shock that propelled it after the first Hereford. Within thirty minutes the ship was cleared of animals. The crew hosed the deck

and hold with live steam, and the *Jillian* was ready to load again. A small but very valuable cargo was to be put on for the fifteen-hour return trip to Flinders Island: five prize-winning Santa Gertrudis bulls.

Late in the afternoon the loading of the five Santa Gertrudises began. The huge chocolate-brown bulls, however, wanted absolutely no part of the *Lady Jillian*. With saliva foaming, they balked at every turn in the chute until the cattle prods shocked them into moving forward. One of the bulls, confused and bewildered, tried to go over the top of the chute and and succeeded only in tangling his foreleg between the rails. Stuck, the one-and-a-half-ton animal thrashed wildly in an attempt to free himself. It was a delicate moment. Jass Cheema, the closest crewman, had to react both correctly and immediately. A wrong move would cause the bull to break his trapped leg. Jass poked the prod once at the bull's neck and the shock provoked exactly the right reaction. The bull backed away and in

This Santa Gertrudis bull balks while being loaded for the trip to Flinders Island.

The *Lady Jillian* makes her way up the River Tamar toward Launceston.

89

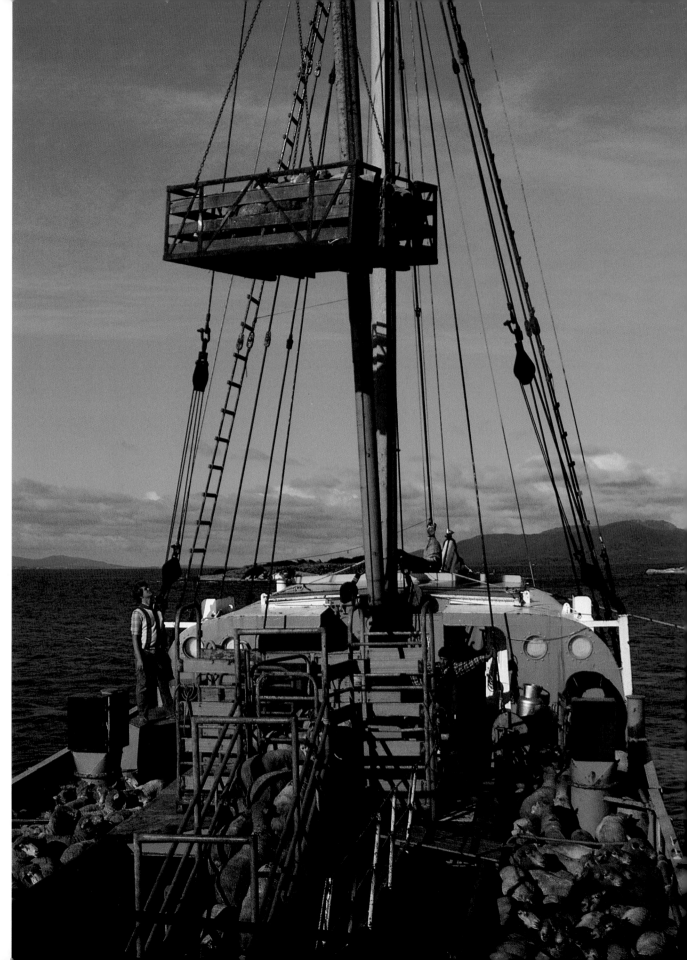

Once the sheep have filled all available deck space,
a portable pen is loaded onto the hatchcover.

so doing freed himself. The men knew their work and they did it with a minimum of force.

Loading was completed without further incident, and, her Caterpillar 353 purring, the *Jillian* nosed out into the River Tamar, heading for Bass Strait and Flinders. The *Jillian*'s regular route takes her into the roaring forties, that area of ocean between 40° and 50° south latitude known by sailors the world over for its fearsome winds and mountainous seas. Bisected by the fortieth parallel, Flinders is the largest of a wind-swept collection of islands and rocks forming the Furneaux Island Group. Lying in Bass Strait off the southeast coast of Australia, the islands are 200 miles from Melbourne and 120 miles north of Launceston. To the east there is nothing but wind and waves for 1,000 miles until you hit New Zealand.

Low-lying, with rolling hills and empty white-sand beaches, Flinders is home to 150,000 sheep, 20,000 cattle, and 1,100 tough, self-reliant, friendly people. There are not many millionaires on Flinders. Aside from sheep and cattle raising, the island's economy is dependent on a little fishing and the odd tourist. Period. The island abounds with wildlife. Cute piglike wombats, badger-looking Tasmanian devils (the only marsupial carnivore), some red-necked walla-bies, and a few small Tasmanian pademelons, together with possums, the Cape Barron goose, and the burrowing muttonbird (short-tailed shearwater) all live there. Unfortunately, the is-landers view their animal neighbors as pests who compete for food with the livestock, instead of as the potential tourist gold mine they are. The wal-labies are used by the local fisherman for lobster bait, and the other animals are shot as a matter of course.

Isolation has been the islanders' main problem. Traditionally they have depended on small shipping companies both to transport their livestock to market and to supply them with everything they need from the outside world. Too often the shipowners were not reliable or moved on to more lucrative markets. So in 1969 a group of island farmers and the local storeowner formed the Flinders-Strait Shipping Company to provide a transportation service for their community and the surrounding islands. Besides the *Lady Jillian*, the company runs the 350-ton general cargo carrier *Katika* and the tiny *Flinders Triad*, which is used as a backup vessel.

The Flinders-Strait Company and its ships have served the islands well. In 1983 the *Lady Jillian* and the *Katika* carried 7,571 cattle, 62,247 sheep, and 6,623 bales of wool, plus 8 pigs, 3 dogs, and 19 horses. They also brought to Flinders everything the people needed, from cornflakes to motor cars. This commerce was accomplished at a rate of a vessel call every other day. The company has helped Flinders so much that the islanders started their own airline and now operate three de Havilland Herons and two Piper Navajos between Melbourne, Flinders, and Launceston.

Teenage brothers Max and Niel (Shortfinger Sprocket Jr.) Pickett were enjoying their dinner of lamb chops (what else?), string beans, and mashed potatoes. Springhead was ashore having a few days off. The brothers' father, Sprocket Sr. Pickett, was in the closet-size galley doing the cooking. Shortfinger still had gauze around his thumb. He took it off and admired the stump. He had caught the thumb between two sections of the chute as he was guiding one sec-tion into place. When the two sections came together, a quarter-inch of Shortfinger's digit was left between them. He thought that it might grow back, but maybe not for a long time.

Both boys had been raised on Flinders. Shortfinger had recently moved to the bright lights of Launceston (population 65,000). Max had decided to stay on the island. Sixteen-year-old Shortfinger squealed on his older brother,

Capt. Garth Simms checks his position as the *Lady Jillian* heads out of the River Tamar into Bass Strait.

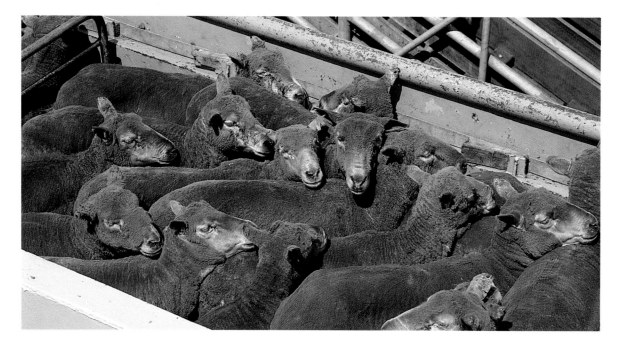

"Reason is, he's plannin' on gettin' married over there soon."

That revelation brought a scornful look from Max that told Shortfinger to shut up.

I asked the brothers what it was like sailing with their father, whether he gave them any trouble.

Max shook his head, "No, he's too little." A ferocious-looking Sprocket Sr. stuck his head out of the galley serving hole, where he had been listening. Both the boys laughed.

"He's a pretty good old man," Niel admitted. "He's been around for a long time."

Sprocket Sr. gave a satisfied nod and went back to his work.

Jass Cheema was at the wheel. From northern India, Jass had emigrated to Australia and liked what he found. In his soccer jersey, the effervescent young man seemed as though he would have no trouble fitting in, elbow at the bar, enjoying a pint. Jass had been sailing for three years before coming aboard the *Jillian*. I asked him if he had sailed for an Indian shipping company.

"No," he said, laughing, "a Greek one. I got my first job as a deck boy. We sailed around

everywhere. We were across the Atlantic, Mediterranean, Red Sea, America—all over the place."

"Any trouble finding a job in Australia."

Jass nodded. "If there wasn't his company, I wouldn't be able to get a job because I have to be a member of the seamen's union."

"And they don't take in foreigners?" I asked. Jass shrugged and looked away.

Night came. The wind had picked up. It was now blowing about twenty knots and coming from the starboard quarter. Spray came over the bow of the little *Jillian* and some of it landed on the five unhappy bulls in the hold.

Garth Simms, the *Jillian*'s captain, is an Aussie sailor through and through. He is heavyset, tough, but thoughtful. He told a little about himself. "All my family were at sea: brothers, father, everybody, even before they came from the old country—Ireland—opposite the coast of Cornwall. Curly Joe, the original Simms, came out in eighteen-some-bloody-thing, 1840 or something. They started off fishing out here, hand-line fishing. Some still are fishing."

Garth was interrupted by the radar; it quit. He stared at the blank tube for a second, flicked some switches, then tested the connec-

Red tries to prevent some errant woollies from escaping.

The view of Marshall Bay on Flinders Island, where there are more sheep and cattle than people.

tions. Nothing. It was black out and visibility was poor. Garth called Alf "Fred" Ess up from the engine room and together the two men tinkered with the radar. Ess came back in with tools and some electrician's tape, took apart a connection, and got the radar working again.

"How long we been down here, Fred?" Garth asked. "Sixty-nine? We're in the fifteenth year—constant. Before that Fred was on the little one, the *Triad,* and I was master on a similar one in Adelaide, sulphuric acid run. Twelve years there, for the Crouch company. They built the *Jillian.* She was originally called the *Jillian Crouch.* Built with a flat bottom for working shallow water: steel frames, wood hull, threemaster—fore and aft schooner. This scow type used to be typical construction in south Australia in the old days. She's good for this trade, too. At Whitemark [the western port on Flinders], when the tide's out, we sit on the bottom for two or three hours every trip."

Garth reflected on his work. "The cattle trade, it's a difficult one. We're worried about weather all the time. If it's too rough, we can't sail, especially with cattle. Once they go off their feet, the others fall over them and its bloody dif-

ficult getting them up again. Dangerous, too, in amongst them on a rolling ship. But we've lost very few due to weather. When we lose some, when they die on board, it's usually that they're sick when they come in. It's in the spring and they eat that young rye grass. They're okay until they are moved on board, then they die like flies.

"The crew on the *Jillian* is good with the animals," Garth continued. "It takes real skill. You have to know exactly what to do, especially with the cattle. The sheep aren't bad. They are small enough so that you can pick them up and move them by hand. The cattle, though, they are something else. Require thought and care in handling them. Ingenuity, too. One time we had a load of scrubbers on board—wild ones—and they got all boxed up, just refused to move up the chute. Well, old Sprocket got tired of waiting and went up to the pilothouse and blew the ship's whistle. Those cattle went shooting off—that had them on shore in a bloody minute. Another time he tried it and they scattered everywhere."

The captain took a sip of his tea. "Once a big steer got loose and somehow got into the galley. Well, he got stuck in there, knocking things about and making a terrible mess. It was a hell of

a job getting it out because nobody could get in there with it. Finally we put a man over the side with an electric prod. He stuck his head and arms in the porthole far enough to back the steer out. But he dropped the prod. He said that he and the steer were eyeball to eyeball before he could slowly reach down and pick it up again. He was able to back the steer out, but he said that the next time a steer got into the galley, someone else could go in the porthole."

Garth Simms's stories went on late into the night. The next morning the *Lady Jillian* navigated the rocky, shoal-strewn bay at the south end of Flinders. Razorback Mountain and the Strezelecki Peaks stood up in a clear blue sky, guarding the entrance to the harbor at Lady Barron.

The five Santa Gertrudis bulls were unloaded without difficulty. No doubt they were eager for the green pastures and young heifers of Flinders Island. The *Lady Jillian* took on a load of woollies and in an hour she was gone.

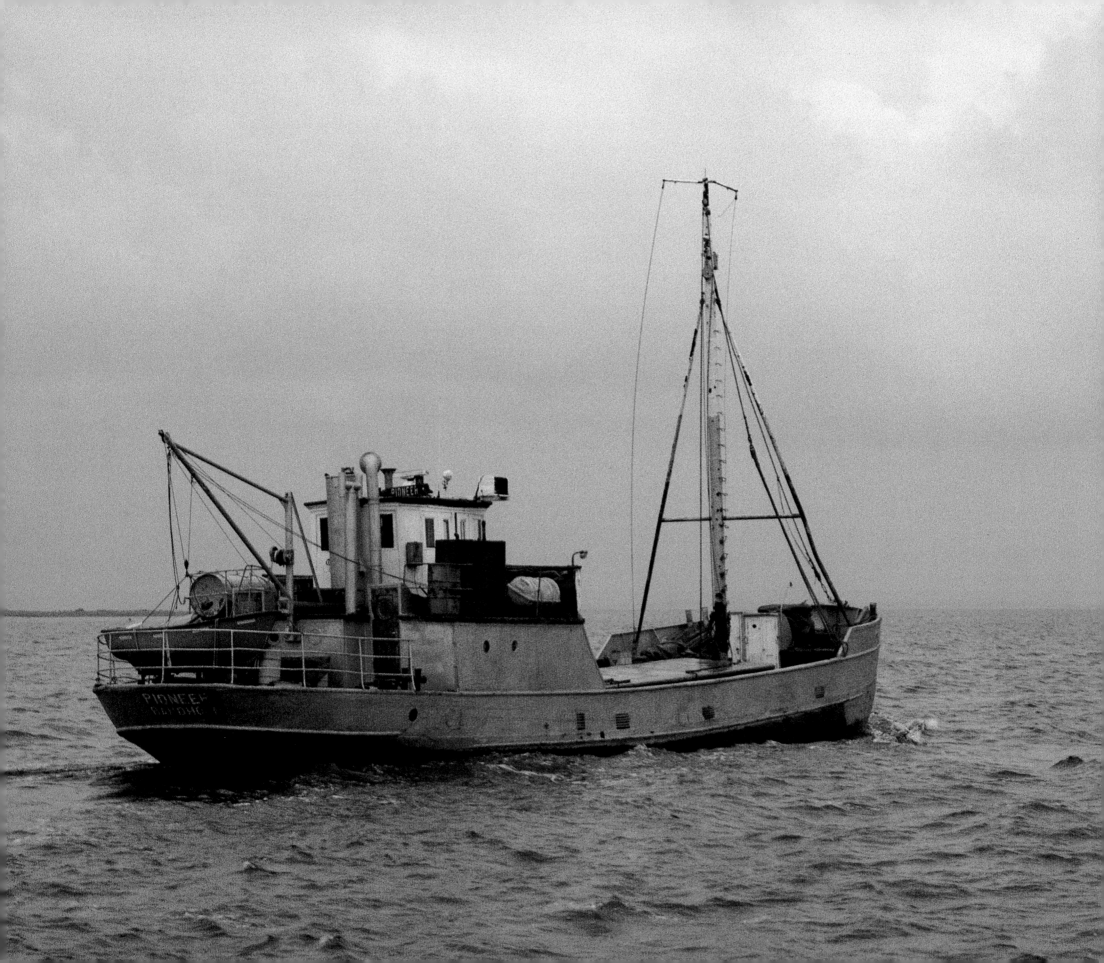

PIONEER

An Old Man, His Old Ship, and the Sea

L ying alongside the grain elevator at Aerøskøbing, Denmark, is a tired old coaster. Brave attempts have been made to keep her up: her bottom has been freshly scraped and painted, her anchor windlass just greased, and someone started to cover the old battleship gray of her hull with a new coat of black—until he ran out of paint. An old man comes out of the *Pioneer*'s deckhouse. Stooped, and with bent, gnarled fingers, he begins to retie the stern line. So firmly is his concentration focused on his task that if a bomb went off next to him it might not catch his attention. He is Otto Gregersen, owner and master of the *Pioneer*.

The *Pioneer* was built in 1899. She is probably the oldest dry cargo vessel in the world still operating as a freight carrier and still in her original condition (except for repowering from steam to diesel and a minor bridge modification). Otto Gregersen, her Danish owner, was born twelve years after his ship was built. He is probably the oldest single-handed sailor of a freighter in the Western world. Gregersen has been sailing almost continually for more than sixty years, and the *Pioneer* for eighty-five.

Time is running out, however. Parts of the *Pioneer*'s hull are so thin and rusted through that they can be peeled off with a thumb and forefinger. Otto is in a little better condition, but his years at sea and in a Danish (Nazi) prison have taken their toll. There is also another problem. Otto can barely make even a meager living with his ship. Some months he does not have enough revenue to put both bunker oil in the ship and food in himself. He could receive support from the Danish government, but while he owns the ship and is working, he is not eligible. To sell the *Pioneer* and live ashore, Otto says, would kill him. He is only happy when he is at sea.

Judy and I met Otto and his good friend Erik Nielsen in the quaint thirteenth-century sea captain's town of Aerøskøbing. Located on the little island of Aerø, it is the only completely preserved old town in Denmark. Otto had brought the *Pioneer* into a small yard there to repaint her bottom and to straighten her rudder. She was now being loaded with a cargo of rapeseed to

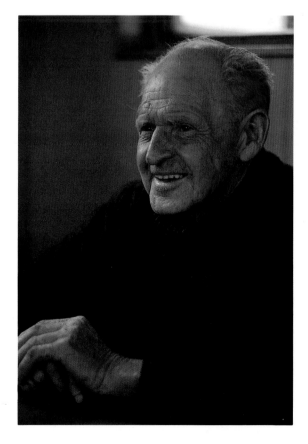

Time and a hard life have taken their toll, but they have not dampened the man's spirit.

The *Pioneer* heads out into the North Sea with a cargo of rapeseed.

Above the ship's wheel is the compass and its magnets. To the left of the wheel is (from top) the valve to open the ship's whistle's compressed air cylinder and the air-pressure gauge. Below, left of wheel, is the shift lever to engage the engine and to the right is the wheel that controls the variable pitch "freebar" propeller. Since the *Pioneer*'s engine does not reverse, this is used to back the vessel. At far lower right is the throttle.

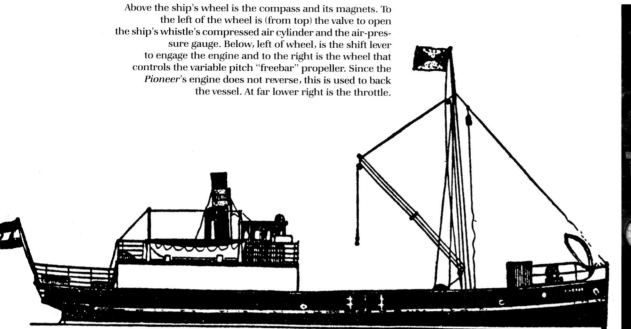

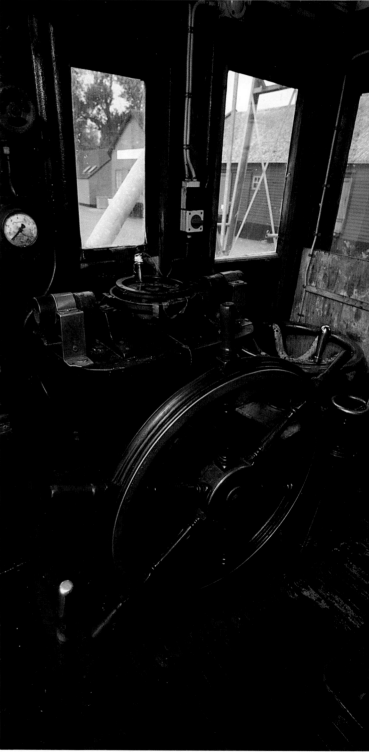

transship at a larger grain elevator in nearby Svendborg. Judy and I invited our new friends to lunch at one of the nearby seaside restaurants. Otto ate like an Olympic weightlifter and told us about the *Pioneer* and himself.

The *Pioneer* was built in Danzig, Germany, for Flensburg-Ekensunder und Sonderburger, a German steamship company. Named the *Express* and fitted with a 160-horsepower steam engine, she carried cargo and passengers all over the Baltic for the company until 1935. It was probably in 1935 that the *Express* collided one night with a passenger steamer near Flensburg and sank. She was raised and sold to a Mrs. Marie Rassmussen of Kiel, who repaired her, repowered her with a diesel, and moved her bridge aft five or six feet, the only major exterior modification made on the vessel in eighty-five years. The *Express* continued to carry cargo between German ports as well as to Sweden and Denmark. In 1939 she was sold to a Danish owner, P. P. M. Jorgensen of Aalborg, who renamed her *Rio*. Somehow the *Rio* survived the war, but all that is known of her activities during those years is that in 1943 she was sold to a gentleman from Copenhagen, who installed her

present three-cylinder Danish Volund diesel.

The Volund is started with compressed air, and since there is no reversing gear, backing the *Pioneer* is accomplished by means of a variable-pitch freebar propeller. She is, Otto says, very economical, burning less than seven gallons an hour at her eight-knot cruising speed.

She was sold four more times, once in 1947 and then in 1951 to Orla Nielsen of Bandholm, Denmark, who renamed her the *Pioneer* and who used her as a packet boat. She carried general cargo from Copenhagen to Saxkøbeing and fish and farm produce back to the city. There was another owner before Otto Gregersen bought her in 1981, for 53,000 kroner (then about $8,000).

The history of the *Pioneer* is tame compared to that of her owner. Otto Gregersen was born in 1911 in Thisted, a small town in northern Jutland. His father worked as a tree planter on the moors. When Otto was nine he was sent to work on a farm for the summer. He (his family) received fifty kroner, about ten dollars, for his summer's labor, and he worked from four in the morning until nine at night. He decided that nothing could be worse than that, so at twelve Otto went to sea on a fishing boat. Then, at fifteen, he got a berth on a 200-ton Swedish sailing ship carrying lumber to England. Otto says, "The food was not too good—herrings and potatoes. The captain," Otto laughs, "he drank a lot of schnapps, but he was good man."

Otto stayed on the first vessel for a year and then was on a three-master for four years bringing coal from northern Sweden to Denmark. As part of his duties he had to climb the rigging. When asked if he was scared, Otto adamantly shakes his head, *"Nein, nein, nein."* He didn't know anything about any "romance of sailing," he says. The local men were so poor then, it was just another working place, a place to make money to get food. The crew worked

A small old working vessel is anything but luxurious, as these photos of the ship's galley and outhouse testify.

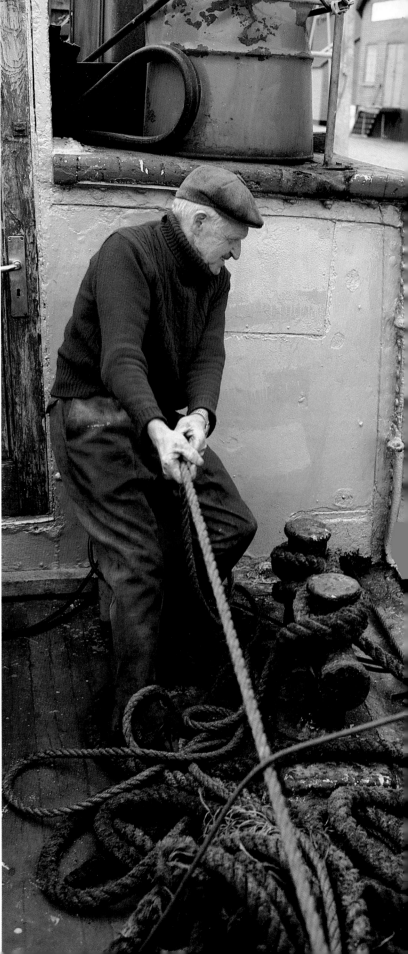

Aerøskøbing is a quaint thirteenth century sea captain's town on the island of Aerø. It is the only completely preserved old town in Denmark. Only the cars and the resident's clothing bring it into the twentieth century.

twelve-hour days, six or seven days a week, for which they were paid about twenty-five kroner or five dollars a month. Otto continued working on sailing ships until World War II.

By 1940 he was sailing on a small merchant vessel carrying coal to Holland. At night, with blackout restrictions, the vessel sailed without running lights. It was dangerous; there were mines all over. Otto remembers, on more than one occasion, seeing mines innocently floating past on each side of the ship. In 1942 he bought a thirty-five-foot wooden fishing boat and began fishing in the Baltic. After a while he was approached by a man from the fishermen's organization who asked him to smuggle some Danes wanted by the Gestapo out of then-occupied Denmark to Sweden. Otto began regularly smuggling Jews and others wanted by the Germans from Denmark and sometimes Holland to Helsingborg, Sweden. He hid the refugees under piles of fish, and on every trip his boat was searched by the Germans. The authorities, however, never discovered his passengers. Then, someone informed on him.

Otto was returning from Sweden, and when he came into the small port from which he had been sailing, the Gestapo were standing on the dock waiting for him. Otto was put into a Nazi prison in Denmark and tortured. He survived on one bowl of watery soup a day for three months. Just as he was about to be sent to a concentration camp, the war ended.

In the postwar years Otto sailed for the Danish coast guard and then with partners began buying and sailing small coastal freighters. At one time he was part owner of four vessels, some as large as 1,000 tons. He captained one or another of these ships, sailing all over Europe, even as far as North Africa. Then he retired, couldn't stand it on shore, and bought the *Pioneer*. Recently Otto has been sailing to Sweden, returning with cargoes of lumber to Denmark,

Germany, and Holland. He operates alone and plans his trips so that he usually anchors or ties up in a harbor every night. Otto has sailed the *Pioneer* for up to thirty-five hours at a stretch by himself.

I ask Otto if he had it to do over, would he go to sea again? With a laugh, all the lines showing on his wrinkled brow, he answers, "Sure, why not? Is there anything better?" He says he loves sailing, loves the mess on a ship—there is always a lot to do. He couldn't think of doing anything else.

That evening Otto slowly and carefully brings in his mooring lines, then he and his *Pioneer* head out into the Baltic.

A Ship for Disadvantaged Children

Erik Nielsen, captain of the *Mars* and good friend of *Pioneer* owner Otto Gregersen, has an all-child crew. Each trip Erik leaves with four young landlubbers and three weeks later puts ashore four "seasoned" young mates. The children range in age from twelve to twenty, though most of them are in their early teens. They are either emotionally disturbed or mildly retarded. Many have been cast aside by their families and are wards of the Danish government.

The children attend the Abaek School, which was founded in 1969 and is operated by Mons and Ruth Gens. Its enrollment capacity is sixty children, and its programs are designed to help the youngsters adjust to real living situations. The school places many of the students with Danish farm families for periods of up to a year. Some children apprentice in small woodworking or auto-repair shops. Abaek also owns the *Mars*, which it purchased from Erik in 1980 in order to add seafaring to its curriculum. The ship remains a working coaster, carrying grain and other bulk cargoes to Danish ports.

Most of the children love sailing and working on a freighter. They learn how to use the ship's gear and equipment and actually operate and maintain the vessel under Erik's gentle tutelage. They also do most of the cooking. Some youngsters, whose needs are particularly answered by life on the sea, are able to crew for as long as three months. Most of them, upon leaving the *Mars*, say they would like to make sailing their career. At sea cooperation is stressed, which develops bonds between the children and encourages them to share their problems and to help each other. They also gain confidence from mastering new skills and learn self-sufficiency.

Erik Nielsen, forty-two, has been sailing since he was fourteen. He feels that his present work is more rewarding than just operating a cargo vessel. The *Mars* is as old as the *Pioneer*, having been built in 1899 in Bremen, Germany, as a steam-powered fishing vessel. She has been

Kenneth, one of the teenage crew members on the *Mars*, feeds bread to the swans from the side of the ship, which is docked in Aerøskøbing.

extensively modified, however, and does not resemble her original configuration. Despite her small size, she and her master serve a function every bit as important as that of any supertanker and four-striper, though on a bit smaller scale.

The crew of the *Mars*: Kenneth, Lars, Frederick, and Claus, with Erik Nielsen, her captain.

ADRIATICO

Pasta and Pumps

A sleepy cock crows and its challenge is answered by a feisty rooster in the distance. Footfalls echo in the narrow cobblestone lanes as wooden shutters open to the cool morning air. The pastel-stuccoed village of Procida begins to awaken. The crew of the *Adriatico* is already on board. They raise her anchor and cast off the two mooring lines that hold her stern toward the quay. As the sun comes up over the island's little harbor, the *Adriatico* slips out of the encircling rock breakwater and heads into the Mediterranean to begin her day's work. Today she is loaded with bags of cement and lengths of cast-iron waterpipe; lashed alongside her is a barge on which is mounted a small pile driver. On her foredeck a crude but effective cement mixer has been constructed. The *Adriatico*, even towing the barge, is making a good seven knots. She is on her way to the western end of the island, where for some months she has been helping to lay a pipeline on the floor of the Mediterranean to bring fresh water from the nearby island of Ischia.

The sea is calm on this bright September morning and parts easily before the freighter's bow. To the northeast a pallor of smog lies over the metropolitan area of Naples, but neither it nor the polluted ocean fronting the city seems to have penetrated this far off the coast.

It takes the seventy-six-year-old *Adriatico* about forty-five minutes to sail to her destination, a small islet called Vivara, which is connected to Procida Island by a spiny outcropping that forms a natural causeway. When the ship reaches a point protruding from Vivara's single steep pinnacle, the anchor is dropped and a mooring line is rowed ashore and tied around a big boulder. The divers arrive in an outboard-powered Zodiac. The *Adriatico*, serving as a diving tender, as well as a construction vessel and cargo carrier, is a beehive of activity.

The *Adriatico* was built in 1906. She is one of the oldest cargo vessels left in southern Europe. Her owner, Sig. Gaetano Anzalone, is proprietor of a boatyard on the mainland. Like many old ships in service, she holds a special place in her owner's heart. In spite of these sentiments, she must keep on working and pay her own way. It is not easy to find work for her. She is

The winch operator's job is a delicate one. Handling 300-pound sections of pipe in an open seaway, sometimes in a strong chop, requires experience, agility, and excellent timing.

The *Adriatico*, her day's work finished, lies peacefully at anchor as sunset falls over Procida's harbor.

a tiny vessel, only 108 feet, and the capacity of her single hold is limited. Large cargoes or long voyages are out of the question, and so the *Adriatico* takes on any business that comes along. An old tramp must find work wherever she can. The waterpipe job is a good one. It will have kept her busy and paid the wages of her crew for almost half a year.

Her usual cargo is sand and crushed rock carried from a local quarry to building and road-construction projects on the islands of Ischia and Procida, which lie close to the Italian mainland, and the more distant Ponza and Tentotente, approximately thirty miles off the coast. Before Anzalone bought her, the *Adriatico*

was owned by some gentlemen from Palermo. In those days she spent her time carrying kaolin, a material used as a soap base, from a neighboring island where it was mined. She has also carried dirt, rock for breakwaters, fertilizer, and any other cargo that could be found for her.

She keeps on. Her four-cylinder Ansaldo diesel, built in 1946, is rated at only 120 horsepower, yet it continues to push her effortlessly through the water. A one-cylinder Lombardoni services both the anchor windlass and the single cargo winch. After a few starting-up coughs and sputters, the Lombardoni chugs away like a new lawn-mower engine. The *Adriatico*'s hull shows signs of age. A new bow section was added in

A microcosm of activity: the *Adriatico* is at once a cargo carrier, diving tender, and workboat. Here a section of pipe is raised from the hold prior to being dropped into the sea. Alongside is the piledriver that will hammer the brackets holding the pipe in place. The divers' Zodiac sits behind the ship.

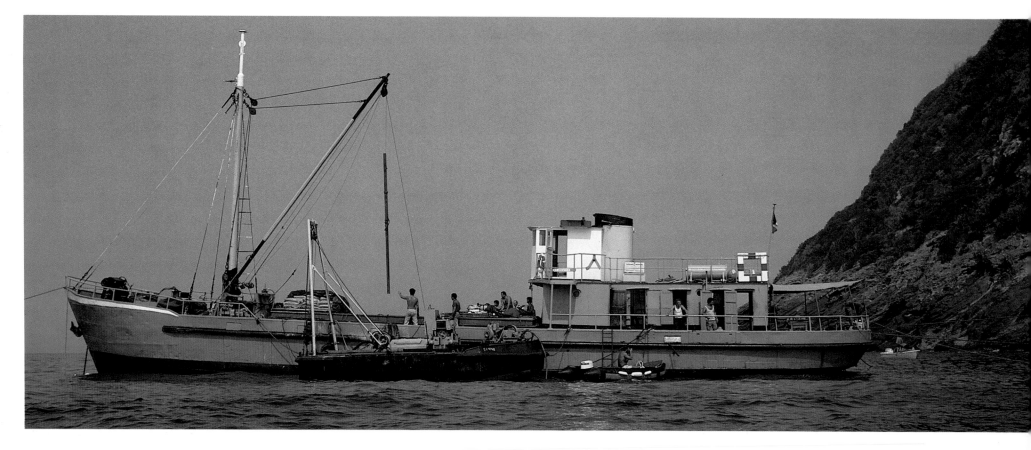

1969 to lengthen the cargohold, but one must look closely to see the welds. The work was carefully done: first the ship was cut in two just forward of the deckhouse, then the new section was inserted, and finally the pieces were welded together. The addition of a new hull section is not uncommon with small freighters; it can increase their cargo capacity by as much as 50 percent.

Both the hull and the deckhouse have recently been painted and, in fact, everything on the exterior of the *Adriatico* is shipshape. Below, she shows the normal workboat signs of long, hard use. Though the pilothouse was obviously rebuilt at some point in her career, she still resembles the way she originally looked in 1906.

Laying an undersea pipeline is not a simple operation, even in good weather. Once the route is surveyed and marked, all obstacles on the sea bottom must be removed, by blasting if necessary. Where there is no rock on the bottom on which concrete can be poured, the pile driver is put in place and steel bars are driven into the seabed to provide anchors for the concrete pads that will cradle and support the pipeline. Once the bars are in place, special quick-setting concrete is mixed and pumped through a long hose onto the ocean floor. Before the concrete sets, brackets are carefully placed in the pads. The brackets will hold each section of pipe in place.

Conversation takes place around the cement mixer. The men work hard but inject a sociability into all their tasks.

Not exactly up to the standards of the *Queen Mary*, this crew's cabin exhibits neither space nor luxury.

Sergio, the vessel's mate and engineer, operates the winch as well. His working uniform was chosen for comfort rather than stylish good looks.

Sailors feel closer to hazard than do their earthbound counterparts. For this reason, perhaps, there are often religious icons and pictures on the tramps, regardless of whether the crew is Christian, Buddhist, Moslem, or Hindu. These pictures are on the pilothouse bulkhead, directly behind the wheel.

Five-meter sections of waterpipe are lowered, one at a time, to the divers on the bottom, who fasten the pipe on the pads, then connect the sections and tighten the brackets. When the pipe is secure, the supply ship is moved to the next stretch on the pipeline route.

The men on the *Adriatico* work well together. They have been at the task long enough to know what needs to be done and how best to do it. Still, they are Italians, and every phase of the job is accompanied by affable conversation and good-natured banter. Sometimes an argument will break out, only to dissolve in the midmorning heat and to be forgotten within minutes.

Michele Mataren, the *Adriatico*'s captain, is a stern taskmaster. He brooks no nonsense from the men and maintains a constant vigil to ensure that the work goes as smoothly as possible. One is aware of a deep-felt responsibility in him, a sense of honor that compels him to see that he and his crew perform, that they do their utmost to fulfill *his* commitment to the task at hand. On a small vessel like the *Adriatico*, the captain must work right alongside the crew, and this Mataren does. Also, he is tough. Though he appears to be in his early fifties, he looks as though he could easily deck any of the younger men in the crew and, if the need arose, wouldn't mind doing so.

Like most shipmasters, Mataren seems instinctively aware of the need to keep a certain emotional distance between himself and the crew. This axiom is nearly universal: a captain must remain aloof in order to command a ship efficiently. There is a sense of respect, perhaps a tinge of awe, that is usually lost when men see that their captain is the same as they are, with the same fears, the same problems, and the same fallibilities. For this reason, among others, most captains are reserved and quiet, not what you would call conversationalists. Most captains are lonely men.

Concrete is being mixed on the *Adriatico* this morning, and it is a slow, dirty, and laborious process. Bag after bag of cement is slit and dumped into the electric mixer on deck, sand is shoveled in, and water added. Meanwhile the ocean breeze blows cement over everything and everyone on the ship. The crew, after a while, looks as though they had been costumed for Mardi Gras. The concrete is pumped down to the divers. In between pumpings the divers come up to refill their air tanks from a small compressor just forward of the pilothouse. One deckhand, who is also the cook, has had to hide on the stern to keep from getting cement on the potatoes he is slicing for lunch.

An argument breaks out between Sergio, the good-natured engineer-cum-mate, and the captain. The cause of the argument is not apparent, but it is obviously quite serious. Sergio, clad only in a brief pair of trunks and very aware of his physique, and the hard-as-nails captain verbally slug it out. As their argument becomes more heated, they come closer together, almost belly to belly, until it seems that they surely must come to blows. One waits for the first fist to fly. The other crew members try not to stare noticeably. Just when it appears that a fistfight will be the only recourse, Captain Mataren tells the mate, in effect, that if he doesn't like it, he can look for another job. Sergio backs off and turns away in disgust. Work goes on.

In the afternoon sections of pipe begin to be lowered to the divers. Unfortunately the breeze has become stronger and with it a chop that rocks the little *Adriatico*. This makes unloading the pipe a dangerous proposition. Each section is sixteen feet long and weighs close to 300 pounds. Sergio mans the winch. Two deckhands are in the hold. Two more are next to the hatch combing to try and guide the pipe as it is brought out. The divers are below, ready to detach the chain that encircles the pipe and is

Michele Mataren, captain of the *Adriatico*, works alongside his men. He is a stern leader who accepts no nonsense from his crew.

The ship's cook slices potatoes for lunch. He feeds not only the crew, but also the divers, government inspectors, and anyone else who happens to be on board.

wrapped around the cargo hook. If the *Adriatico* should suddenly pitch or roll when the divers are unfastening the hook, they could be badly injured.

The winch motor comes to life. A throw of the clutch and cable starts winding around the drum. With the *Adriatico* rolling in the chop, Sergio wants to get the pipe off the ship and into the water quickly. The first section rushes out of the hold. However, as one end rises above the hatch, the pipe swings wildly, smashing into the hatch combing before the rest of the section can clear. The pipe careens over the deck. One crewman ducks, the other tries to cup an end with his hand to steady it. He is lifted off his feet and nearly thrown over the side in the split second before he can pull his hand away. The pipe splashes into the sea.

When the slack cable shows that the pipe is on the bottom, everything stops. Moments pass. Then after a signal from the diver in the Zodiac, who is acting as tender for those below, the winch cable is raised, free of its load. The process repeats itself four more times with the only apparent ill-effects a few more dings in the hatch combing.

Later, when the divers come out of the water and remove their tanks, the results of the small chop are visible. The divers' heavy-set leader rummages through the ship's medicine chest. Finding an antiseptic ointment, he begins to smear it on his shoulder. He has a nasty gash and around it the skin is already beginning to turn black. He says that as he was detaching one of the pipe sections, the winch cable went taut from a roll of the ship, and before he could move, the pipe jerked off the seabed and smashed his shoulder. He says he was fortunate. The pipe almost hit him in the head.

Work for the day is finished. The divers roar off in their Zodiac. The crew of the *Adriatico* hauls the anchor and prepares to head home. For them it has been another day, another lira. And for the *Adriatico* it is just one more day to add to the more than 27,000 she has already served.

Smuggling

18 March 1981—0045 hours. Sixty-five miles southeast of Naples the grizzled captain of the *Celeste B* checks his compass as he slowly brings his vessel on to a new heading. The *Celeste* is a decrepit 450-ton coaster of Cypriot registration. She is the dregs of the maritime world, only slightly more impressive than a garbage barge, and for her entire thirty-three years of existence she has been carrying the cargo leavings of the Mediterranean.

Her captain has been at the helm for the last two hours. The *Celeste* is on a heading that would bring her into the Bay of Naples, so she blends into the normal coastal traffic appearing on the radar of passing Italian navy patrols. The small freighter's master has had little sleep, yet he is on edge and watchful. His eyes search the surrounding blackness for signs of other ships. Far to the west the lights of a large tanker glimmer as it plods its way up the Italian coast. Other than that there is nothing. The faint revolving green of the *Celeste*'s own radar and the binnacle light of her compass are the sole illumination.

Some thirty miles south of Naples, the *Celeste* gradually nears the coast. Before her lies the rugged Amalfi Peninsula. Its irregular cliffs jutting out to both north and south now shield the freighter from marine radar. The *Celeste*'s running lights are covered; all other lights on the ship have been doused. The seven crewmen, all Cypriots, are as nervous as the captain, except for the cook, who is asleep.

When she is less than a mile offshore, the *Celeste* loses way. At about one thousand meters, her engine telegraph rings her to a stop. A light blinks from a cove to the east, then blinks again. The *Celeste*'s boarding ladder goes down and there is a long, silent wait. The men on board fidget and curse the Italians. Five minutes pass, then another five. Finally a low throb echoes out of the gloom.

A fishing boat comes alongside and four Italians scramble up the ladder. One carries a briefcase; all are armed. It takes longer than the Italians would like for the captain to count the money. He tells them it would be faster if they had brought him dollars instead of lire. Finally he nods and three of the Italians as well as some of the crew begin carrying packages wrapped in black plastic down to the fishing boat. Each package contains ten one-kilo blocks of hashish. Altogether sixty packages exchange hands. The visitors leave and the *Celeste* continues on to Naples to await her cargo of grain for Limassol.

In Rome or Milan, where it would be sold, the street value of the kif, as hashish is called in North Africa, would be more than $2 million. The owner, captain, and crew of the *Celeste* might have received the equivalent of $75,000 to transport the kif from Lebanon or Egypt. Since the profits for this one trip probably exceed what the *Celeste* could earn in a year carrying legitimate cargoes, it is not difficult to understand why the owner and crew are involved in the drug trade, or why drug smugglers, today, are so numerous.

While this is a fictionalized account, it is typical of daily occurrences throughout the Mediterranean and, indeed, throughout much of the world. Smuggling is a gigantic business. Its gross receipts for a year would probably exceed the gross national product of any country on earth except perhaps the United States.

Drugs are the mainstay of smugglers, followed by firearms. The stories are legion: opium, heroin, and hashish shipped from Burma, Thailand, Laos, Turkey, the Middle East, and North Africa to the United States and to Europe; cocaine and marijuana moved to the United States from Mexico, Colombia, and other Latin American countries; military weapons smuggled into Asia, Africa, and Latin America; and the money gained from the illegal sales of one commodity often paying for the purchase of another.

But drugs and weapons, though they are the most lucrative items for smugglers, only account for a small portion of the total volume of smuggling. In the Mediterranean alone, an enormous number of more prosaic items are transferred surreptitiously from one country to another. Cigarettes and liquor are smuggled into Italy to avoid high import duties and sales taxes. Consumer goods are smuggled into Greece for the same reason. Western clothes, cosmetics, and other consumer goods travel illegally into the Soviet Union via Black Sea ports. There they are traded for whatever the Russians can steal from their factories, usually truck tires and batteries, gasoline, and sometimes ammunition. These things are then sold in Turkey, as are smuggled cigarettes, pharmaceuticals, auto parts, and other European and American products whose legal importation is banned by a government anxious to save its meager foreign-currency reserves. The list is endless; the traffic is unceasing. For every smuggler that is apprehended, there are thirty who are not.

Small coastal cargo vessels are the prime means of smuggling into many maritime countries. Since steel coasters are still prevalent, one carrying contraband is inconspicuous. They usually have a shallow draft, which permits them to enter isolated bays and estuaries, and yet they have sufficient cargo capacity to move contraband in large quantity. If the coasters are caught by the authorities, they are cheap enough to be written off easily by their owners.

In certain parts of the world, the tradition of smuggling is so deep-rooted that there is no stigma attached to it by much of society. The following story provides a good illustration. I once chartered a freighter to carry timber from Indonesia to the Taiwanese port of Kaohsiung. En route it stopped at Singapore for a few hours to take on bunkers. No sooner had the vessel been secured to the fuel dock than the whole Chinese crew fled the ship. The captain and the other Norwegian officers yelled for them to stop, screamed that they would lose their jobs unless they returned immediately. The twenty-odd Chinese running down the dock heard and under-

The 300-ton coaster *Hetty*, carrying 22,000 pounds of hashish with a street value of about $52,000,000, is escorted to port by the U.S. Coast Guard cutter *Vigorous*. The *Hetty* was seized ninety miles east of Cape May, New Jersey, on 2 November 1983, while on route from Port Said, Egypt to Philadelphia. The hashish was hidden in the cargo of lumber.

looking young fellow, was going through the usual cursory questions, asking the gentleman if he had anything to declare. Suddenly a look of suspicion appeared on the official's face, followed by an expression of wild delight. He yelled at the gentleman to open his two large suitcases. The unlocked suitcases were immediately upended by the customs agent, and dozens of women's girdles cascaded over the table and fell onto the floor. The apprehended girdle smuggler did not seem abashed in the least, only a little disgusted that his investment was lost. It is hard to calculate what the potential girdle profit-to-loss ratio was for the culprit, but you can rest assured that *he* had calculated beforehand and had decided that it was worth the risk. That is not the point, however. What was certain was that to this Chinese gentleman, there was nothing either immoral or unethical about what he was doing. Smuggling was just another form of doing business, and it was his inalienable right to engage in it if he wished. The same outlook pervades the thinking of a large segment of the world's population.

Social conscience is no longer a factor in what motivates much of mankind. Probably it never was. Therefore, only fear of punishment or lack of financial incentive limits smuggling, one of the world's most lucrative crimes. Even in countries where there are draconian penalties meted out to those who are caught, smuggling goes on, albeit somewhat more cautiously. Since the profit incentive seems unlikely to be removed, the world's *Celeste B*s, the gunrunners, the contraband carriers, and even the small-time girdle smugglers will continue to ply their dangerous trade as they always have.

stood every word, but they hardly bothered to turn their heads. They were rushing into Singapore to buy mainland-Chinese herbs, balms, and elixirs, highly esteemed by overseas Chinese but banned by the anticommunist Taiwanese government. The sailors felt that it was their natural right, their due, to smuggle if they wished, and they knew that the ship could neither find a new crew on short notice nor leave without them. The captain posted two officer-guards at the gangway to confiscate the contraband, but to no avail. Somehow the crew managed to smuggle an enormous amount of illicit pharmaceuticals onto the vessel.

As soon as the freighter dropped anchor in Kaohsiung harbor, a launch swept alongside and an invasion took place. Up the ladder swarmed dozens of uniformed customs officers. They knew their job. They proceeded to tear apart every inch of the ship. Piles of discovered contraband formed on deck. Of course none of the crew had hidden anything among their own possessions or in their own quarters, so it was impossible to say who had smuggled what. As was the practice in such cases, the vessel's owners were fined $10,000, payable before the ship could leave port.

Smuggling is not only big business, it also is little business, and enormous numbers of people try their luck at it. In the spring of 1968 I arrived in Taiwan by plane from Hong Kong. Ahead of me in the airport customs line stood a middle-aged, seemingly prosperous Chinese gentleman. The customs agent, a rather benign-

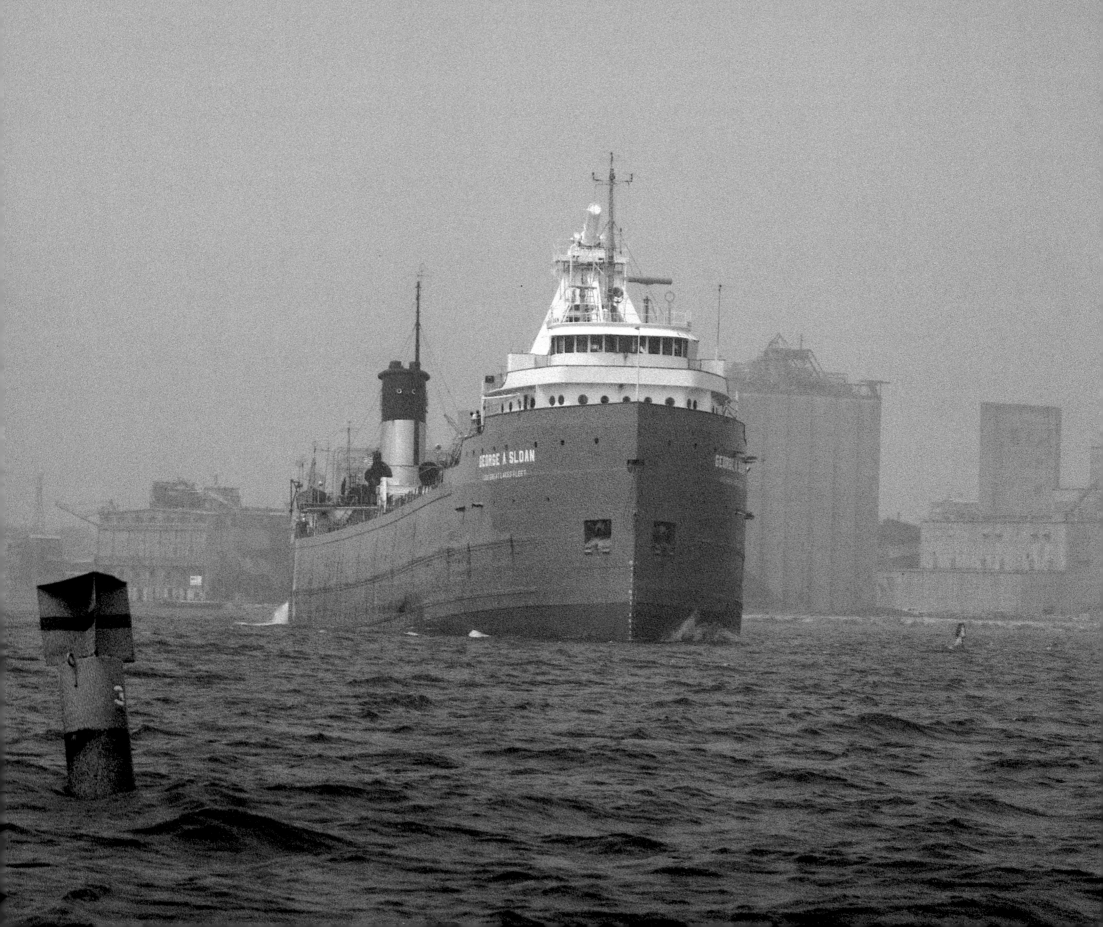

GEORGE A. SLOAN

Sailing on the Great Lakes

United States Steel, owner of the *George A. Sloan*, operates the largest fleet of bulk carriers on the Great Lakes. There are currently six steam (or steam turbine) and four diesel U.S. Steel vessels primarily engaged in transporting iron ore from the mines north of the Great Lakes to the Indiana, Ohio, and Pennsylvania steel furnaces. From 1901 to 1981 U.S. Steel ships carried more than 1 billion tons of ore, as well as massive amounts of coke, coal, limestone, pit iron, and even grain and salt.

The predecessor to the U.S. Steel fleet dates back to the turn of the century. In 1899 Andrew Carnegie developed his own ore-carrying fleet to feed the furnaces of Carnegie Steel. His fleet, then called the Pittsburgh Steamship Company, operated eleven steamers and two barges. When U.S. Steel was incorporated in 1901, as a result of a merger of Carnegie's company and other large American steel producers, Pittsburgh Steamship expanded with a vengeance. In one year it bought up five of its rivals, and by 1904, it owned seventy-one steamers and forty-three barges totaling 532,000 gross tons. Pittsburgh Steam continued to grow. By building larger and

larger ships it was able to reduce the number of vessels it owned and still increase its carrying capacity. For instance, in 1978, the company, now called U.S. Steel Great Lakes Fleet, commissioned the 1,000-foot-long *Edwin H. Gott*. Powered by two diesels delivering 19,500 horsepower, the *Gott* has a capacity of 61,000 long tons of iron-ore pellets and is capable of sailing through the icebound Great Lakes far into the winter, when many other vessels must be laid up.

The fleet, which became a full-fledged subsidiary of U.S. Steel in 1953, still maintains some older vessels. Besides the *Sloan*, which was built in 1943, it owns the motor vessels *Myron C. Taylor* and *Calcite II*, both built in 1929, and the steamship *Irvin L. Clymer*, dating back to 1917.

Along with the ships there are some older seamen still sailing the Great Lakes, and for them the old days were generally not very good days. Joe McKay, though not a U.S. Steel employee, is an old-timer. He has sailed as an engineer on the lakes for over forty years. Joe, a stocky, friendly

The crosshead assembly pictured here sits below the piston rod and above the connecting rod on one of the *Sloan*'s four cylinders. The crosshead on a steam engine acts like a knee joint to absorb the side thrust where the two rods meet.

The *Sloan* heads out into Lake Huron after discharging her cargo at the Huron Cement plant.

The coal in the holds of the *Sloan* (*below and opposite*) is offloaded by means of a conveyor belt that runs along the length of the ship and can deliver twelve tons of coal in six hours. The deckhands have to climb twenty feet into the hold with shovels and cajole the stubborn coal into this conveyor system. One careless move and the men could tumble down into the gates below.

man from northern Michigan, carefully wipes his glasses as he thinks back. He shakes his head and says, "It was really bad years ago. You had to really jump if they gave you an order. They kept you working night and day—it was like slave labor. Now we have a union and we work eight hours and no work on Sunday. Years ago there wasn't anything like that. And our meals weren't like they are today; they threw anything at you. I can remember having liver five days in a row. There wasn't anything else. I can't look at liver even today. But I stayed; everybody stayed. There wasn't much work then and you just had to have a job. These outfits now—when you look at these outfits now compared with those old outfits, you wouldn't believe the difference."

Don Ghiata, a second mate with over twenty years' experience sailing on the Great Lakes, speaks dramatically about the hazards of lake sailing. "We get some mighty bad storms on the lakes. We get waves they call 'the three sisters.' It seems like these waves, maybe twenty- or thirty-footers, come in threes. On the smaller boats, it really throws them around. You go up with the first one, come down with the second, and the third one really buries it. Lotsa times on a small boat you can have damage to the fo'c'sle. They have to put special bracing in on some of the boats.

"Then there's the ice," Don continues. "It can really get bad before they close down in winter. The ice builds up in windrows and sometimes it can get as high as the top of the pilothouse. When it really gets bad, if a ship is in trouble, they'll back a cutter or icebreaker until its stern is right up against the stuck vessel's stern, and using towing winches and two lines they'll tow her through until she breaks out of the ice. But usually there are tugs to pull a stuck boat out. Sometimes it will take three or four, and sometimes they don't get 'em out and they are stuck for the winter."

Some of the vessels that men like Joe McKay started sailing on forty years ago were twenty years old then. Many of those vessels are still sailing. More than thirty-five Canadian and American bulk carriers now in operation on the Great Lakes were built before 1940, and of those more than twenty were built before 1925. Since the Great Lakes are fresh water, there is very little corrosion. The hulls on many of the old vessels are almost in the same condition as the day they came out of the yard. While these ships are usually slower than new ones, the distances covered are generally not so great as to make speed the determining factor in the decision to scrap an old vessel. The older ships have all been modernized with updated crews' quarters, galleys, and sanitary facilities. Self-unloading apparatus, new engines, and bow thrusters have also been added to some ships. So it is likely that at least some of these vessels will be around for another twenty or thirty years.

Down in the *Sloan's* engine room her twenty-five-foot-high, four-cylinder (two low-pressure cylinders), triple-expansion steam engine turns slowly. An oiler feels for heat in the moving bearings. Carefully he reaches between

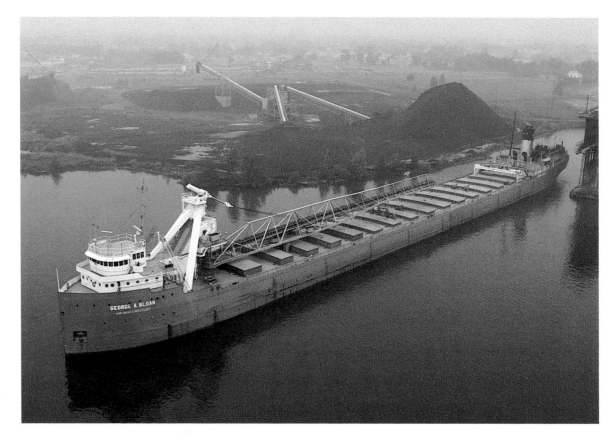

The *Sloan* backs into the coal dock at Huron Cement's Alpena, Michigan plant. She will discharge 13,000 tons of petroleum coke for Huron's private coal-fired power plant.

The white pipes supply steam to the two-cylinder steering engine that turns the massive steering quadrant (at right) controlling rudder movement.

the rods and extends his arm so that the rotating parts gently brush his hand. If the crank or the bearings feel hotter than normal, there could be a piece of dirt in the bearings or possibly a plugged oil line, either of which could burn up the crankshaft. The oiler moves from one point to another, nursing and checking like a mother hen fussing over her brood of chicks. He is completely absorbed in his work and gradually moves out of sight.

As the *Sloan*'s engine idles, her giant, slow-moving connecting rods leap and plunge like glistening steel dancers. They could be a row of oil wells pumping, and after awhile their steel ballet becomes hypnotizing. The warmth on a cold night, the sweet smell of the lubricating rapeseed oil, and the silvery undulating motion of those giant steel rods have cast their hypnotic spell over many a man. But as the remaining steamers are converted to diesel, this spell, like the sight of the great herds of buffalo that once covered the American prairies, will soon be no more.

A United States Steel Sailor

Jacqueline Wirgau of Rogers City, Michigan is a steward on the *Sloan*. When she started sailing in 1978, she was the first woman to sail for U.S. Steel. "It was hard at first," Jackie says, "because I didn't know what to expect. I remember the first time I was in a storm. The ship was rolling and pitching so much, I was so scared I started writing out my will. Now it doesn't bother me—hardly at all."

Jackie, a forty-two-year-old divorced mother of five and former beauty queen, reflected on what it was like leaving her children to work on the *Sloan*. "At first I missed my kids and my family terribly. I was homesick all the time. Every time I was ready to leave, my little ones would start to cry and drag on me to stay. Now they say, 'Mom, when are you goin' back to sea?'"

When asked whether it is difficult working on a ship with an all-male crew, she responds, "No, not really. Most of the men take you as just another sailor. One or two may bug you but you can't worry about them. You just do your job." Good-natured Jackie adds, "It helps to have a sense of humor, though."

Jackie does have a sense of humor and she takes great pride in her work. This is reflected in the comments of her shipmates. They enjoy her presence on board and consider themselves fortunate that she is on the *Sloan*. She is a good cook, and for a sailor, having a good cook on board is a matter of no little importance.

Jacqueline Wirgau was the first woman to sail for U.S. Steel. She is the steward and according to her crew mates, "a darn fine cook."

VÄTTERÖ

Mutiny and Murder—The Captain's Story

The following story is so incredible that at first I did not believe it. However, the way it unfolded, simply, and as just one episode in the life of Jan-Christer Sjööh, was convincing. Captain Sjööh was reluctant to describe his experiences, yet when questioned he provided answers and details without emotion and in a manner that suggested to Judy and me that he was telling the truth.

In answer to three intense hours of questioning, most but not all of the details held together. A few details would naturally be confused or forgotten given the stress resulting from the mutiny and murders. Captain Sjööh asked that the names of ship, owner, crew members, and ports visited be disguised. The reasons for this request will be obvious upon reading the story. I have put the occurrences down largely as they were narrated, though because of Jan-Christer's mediocre command of English and because the story came out in bits and pieces, certain elaboration was necessary to provide cohesiveness and aid understanding. Still, all important points are imparted as they were communicated to us. I will leave it to the reader to judge the veracity of the captain's story.

The life of Jan-Christer Sjööh, captain and owner of the *Vätterö*, is almost as fascinating as his tale of mutiny, so it is the place to begin. He was born in 1951, in a small town in central Sweden. His father had been a captain on a sailing ship, and from the time Jan-Christer was five he wanted to sail as well. At fifteen he got his first berth on the 2,300-ton freighter *Marie*, bound for Italy, Greece, and North Africa. Jan-Christer worked as a deck boy doing, as he says, every dirty job on the ship. After eighteen months he left the *Marie* in Genoa and took a job on a vessel heading to the Far East.

Eventually Jan-Christer put ashore in Jakarta, Indonesia, at the age of seventeen. He says, "I was there [stranded] for two weeks looking for another berth. I would go first to one ship, then another. The first night out in Jakarta I have to go to town. I have a drink, maybe two, maybe three, and see some Indonesian girls and good-bye to my money. Then I had no money so I slept in the streets. I had almost nothing to eat for the last ten days. Finally I got a job as carpenter on an old steamer, the *Golden River,* twenty-seven hundred tons, built in 1918. She was sailing between Indonesia, the Philippines, and Hong Kong, carrying

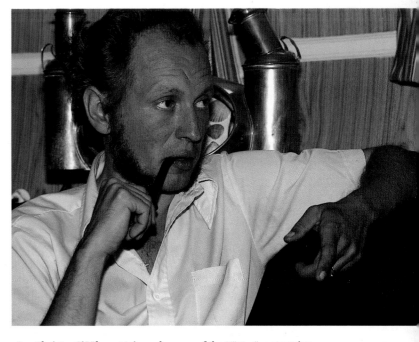

Jan-Christer Sjööh, captain and owner of the *Vätterö*, entertains guests in his cabin. The enigmatic captain leaves the impression that people are an imposition that he must put up with during his life but that he will never feel comfortable with them.

The *Vätterö*, empty after delivering a cargo of grain, sails in front of one of the many islands in Lake Mälar. The lake is connected by canals to the Baltic Sea and fronts the city of Stockholm, itself built on a number of islands.

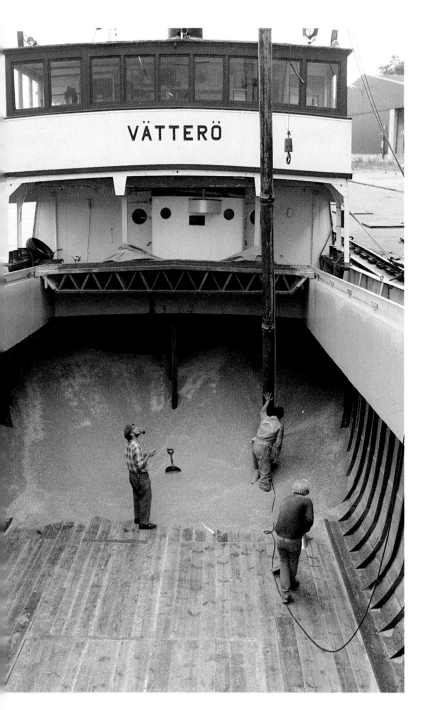

A large vacuum is used to suck the grain out of the hold. A small vessel like the *Vätterö* can discharge its entire cargo in three or four hours.

mostly timber. The captain was an old Englishman, Captain Jackson, who was sailing in the Far East for forty-five years. He was eighty-two then, but he looked like fifty. I left the *Golden River* and later signed on again as third mate. From books I teach myself navigation. The other officers were English and Swedish, the bosun was Finnish.

"Captain Jackson was like the devil himself—of the military style, very strict. Some days he would never talk to us. He would only say, 'You have to do that, that, and that.' Then he would go to his cabin and read or listen to music, Beethoven, Mozart, some things like this. If the crew doesn't obey, he just puts them ashore—anywhere."

Jan-Christer worked his way up to second mate, then chief mate. After six months he left the *Golden River* in Yokohama and flew home to Sweden. It was not long before he was at sea again, this time on a new Swedish motor ship sailing to the United States, Southeast Asia, and Japan. After a year he found himself back in Yokohama, where he was hospitalized for five weeks with pneumonia. After recovering, Jan-Christer found a small Indonesian ship bound for the Javanese port of Surabaya.

For four years the young Swede sailed native coasters all over the Indonesian archipelago. It was a life straight out of Joseph Conrad. Jan-Christer, acting as captain, bosun, and cook, was the only European on board the vessels, usually with a crew of ten or twelve Indonesians. Communicating with the crews was, at best, a difficult proposition. However, with a shrug, he explains, "I speak no Indonesian—just a few words. I speak English to them sometimes. Well, I have not so much to say to them. They come up at seven in the morning, have their coffee, and then they do their job. They are good seamen. They know their work. Yes, these places were very interesting. It was a good life, then."

Jan-Christer returned once more to his native country. This time he stayed long enough to marry a young woman he had met in a restaurant. Then he was gone again, sailing as captain on a Greek ship heading to the Far East. During the next nine years he captained both Greek- and Panamanian-registered freighters, usually sailing to Africa, Southeast Asia, and Japan. It was during this period that the mutiny occurred. Finally Britt-Marie, his wife, prevailed on him to work closer to home, and he set out to buy a small vessel with which he could make a living in Swedish waters.

The *Vätterö* (pronounced Vah-teer-ū') was built in 1916 on Lake Vätterö, southwest of Stockholm, for Vielle Montange Limited, a large steel producer. She carried steel from the company's plant at Ammeberg to Stockholm, Göteborg, and other cities connected by Sweden's extensive lake and canal system. She continued to carry steel for a second owner until Jan-Christer bought her in 1984. In all that time, he says, her only extensive modifications were the addition of electric steering and the replacement of her original steam engine with diesels. Her three-ton derrick was removed and the hatch size increased. Much of her original interior pine paneling and hardwood furniture remains.

Now the *Vätterö* carries grain eight months a year under contract to various flour mills in Sweden. Most of her trips last only two or three days. The work is steady and during the sailing season Jan-Christer has little time to spend with his family. In order to be together, Britt-Marie, a nurse, and their two small sons sometimes sail with him during the summer. Jan-Christer says he is happy finally to be working in Sweden and he is happy with his life. What else could a man ask for? Probably Jan-Christer should be happy just to be alive.

During the nine years that Jan-Christer was captain of Greek- and Panamanian-registered ves-

sels, he sailed for a Greek who owned an old freighter. Jan-Christer had already taken this vessel, the *Diane* (as I will call her), to North Africa and Asia and was scheduled to make another trip on her. Just prior to his next departure on the *Diane* the owner called Jan-Christer into his office. It was a time of scarce cargoes and an overabundance of hulls. Owners with idle vessels were insuring them to the hilt, then having them torched or sunk. The practice was becoming almost common. Marine insurance companies were furious as they paid out huge sums in claims, but they could seldom prove the acts were deliberate, since the evidence was normally covered by one or two hundred fathoms of water.

The meeting began with the owner lamenting the difficulty of making good profits with an old vessel. Even a captain sailing an old freighter could rarely make a good living, he added.* Eventually the owner said, "Maybe you could fix something for me and make yourself much money, too."

Jan-Christer asked what it was the owner wanted fixed. The reply was "I want you to sink the *Diane*. I'll pay you three million drachs if you take care of this thing for me.† You can easily make it look like an accident, and with an old ship like this the crew will never know—no one will ever know.... It's a great deal of money. What do you say?"

"Yes, of course it is a lot of money," Jan-Christer countered, "but I have my job. This is not my job. And, okay, three million drachs, maybe I have it [can live on it] about five years and what shall I do after that time, when the money is finished? And if I sink the ship, people will know [guess what happened] and nobody will like to hire me for master." Jan-Christer

*A captain often receives a base pay plus a share of the profits his vessel makes.
†Then, 3 million Greek drachma would have been about $27,000.

paused, then shook his head. "No, I won't do it."

The owner persisted and Jan-Christer continued to refuse. The meeting ended, and a week later Jan-Christer and the *Diane* sailed for Cyprus. When they arrived in Limassol, the shipowner's agent informed Jan-Christer that the crew was being put off the ship and would be sent back to Greece. A new crew had been hired and would be signing on the following day.

With grave misgivings Jan-Christer watched the new men come aboard. They were mostly Cypriots, Moroccans, and Algerians, and they looked as if they had been recruited at the local prison. The *Diane* completed loading and with a partial cargo sailed for Calcutta. It was clear early on that many of the new men had little or no experience at sea. Still, the crew seemed competent enough to enable the ship to reach her destination.

The first incident came four days out, in the Red Sea, that oppressive body of water surrounded by the deserts of the Arabian peninsula, Egypt, the Sudan, and Ethiopia. It was a typical inferno of an afternoon. There was no air to breathe, only a suffocating fog of condensed water vapor. A blistering sun hung over the ship as if some fool had nailed it atop the mast. The captain watched some of the crew approach single-file across the afterdeck. It occurred to him that he might be watching a mirage. The chief engineer, a swarthy Moroccan by the name of Ibn Mustafa, led the motley contingent of seamen, firemen, and two stewards to the bridge. Even Dimitri, the second mate, hovered in the background. Jan-Christer looked at faces intense with greed and, worse, determination. Mustafa, the spokesman, wasted no time getting to the point. "The owner has us to put this ship down," he began. "We are taking over this ship, but we want that you help us."

"You can't. You don't have to—you can't take over any ship from me," Jan-Christer stam-

The vacuum pipe is steadied and moved around the hold by the crew, who control it with a portable switch.

mered, his English failing him in his anger.

He was about to go on, but Mustafa interrupted him, "Don't be stupid. It's a lotta money. You be a rich man."

Jan-Christer found himself. "The money, yes, but you have to think a little longer. When all your money is finished, what do you do then— and maybe you be in jail. What about that?" He tried to reason with them and saw it was not working. "Besides," he added, "I'm not going to do it."

Mustafa was resolute. "Yes, you have to do it. We help you," he half pleaded, half ordered.

"No, never." The normally calm Jan-Christer almost screamed his reply, "*Never. I* am the captain of this boat and you do as *I* say."

The response was that of uneducated, unprincipled men. They cursed and heaped blasphemies on him. They wanted to kill him then, but they were too unsure of themselves. The group left the pilothouse, still threatening and swearing.

For the next three days nothing happened. A heavy air of hostility permeated every corner of the ship. The crew came together in small groups, meeting usually in the engine room, in the mess, or on the fantail. Jan-Christer took to wearing, even sleeping with, a .32 caliber Smith and Wesson. The *Diane* passed Aden, rounded the Arabian Peninsula, and headed east into the Arabian Sea.

On the third evening after the argument, Jan-Christer was on his way to the saloon, two decks beneath the bridge, to have his supper. Mustafa, Dimitri, and the youngest steward, a tough Algerian, cornered him in the narrow passage beneath the ladder from the boat deck. They probably could have killed him there. Perhaps at that point they thought he could still be persuaded to join them. No doubt they realized that if Jan-Christer were dead, they would have to explain both his death and the ship's sinking to

the authorities. Better to have the captain on their side, to have *him* explain the ship's sinking. Finally, though, they must have concluded that further talk was useless. They simply threw Jan-Christer against a bulkhead and started beating him, two working at once, smashing him in the stomach and the face. The space was so cramped that he could not draw his revolver or do much except try to cover himself. Finally Jan-Christer managed to catch the second mate's arm. Dimitri, off balance, was spun around into the other two men while his arm was pinioned behind his back. A furious Jan-Christer, using all his strength, thrust the arm upward until there was a dull crack. The second officer's scream filled the passage. The engineer and steward started to close in but stopped when they faced a cocked revolver. Jan-Christer dumped Dimitri on the deck and went back to the bridge.

Jan-Christer began having all his meals brought to his cabin or to the pilothouse. He still did not know how many of the crew had been bribed by the owner, how many were conspiring against him. He considered sending a radio message, but to whom and saying what? With the owner *and* the crew implicated, and having no witnesses, everything would simply be denied. He knew also that a captain who informs on a ship's owner has a hard time finding another berth.

A week passed. Mohamed, the Nigerian bosun, and a Pakistani sailor by the name of Rashid came to him with their concerns. They had both been approached but wanted nothing to do with a mutiny or the sinking of the ship. They were afraid. Jan-Christer tried to reassure them. The *Diane* was then in the Bay of Bengal, only four days out of Calcutta.

Teodoro, the chief mate, was another unknown. The usually good-natured young Greek had been very quiet and nervous for the past few days. He might be involved with the others, but

Jan-Christer didn't bother to ask him. If Teodoro was with the crew, he would only deny it. Of the thirty-one-man crew Jan-Christer had only the bosun and one sailor that he knew to be on his side. That left as many as twenty-nine men against him. He refused to think about the odds.

The weather continued to be hot and the humidity increased. Every morning gigantic banks of clouds formed and each afternoon they broke their wrath on the ocean beneath them in blinding torrents of rain.

The second morning in the Bay of Bengal a stillness swept the *Diane.* To Jan-Christer it felt as though he were alone on the ship except for those with him in the pilothouse. He sensed danger. Feeling in his pocket he found the key to the locked gun cabinet in the saloon. He located the bosun and told him to find Rashid and bring him to the bridge. Then the captain returned to his pilothouse, where Teodoro was on duty with a sulking Cypriot at the wheel. When Mohamed and Rashid entered the pilothouse, Jan-Christer dismissed the Cypriot. The four men on the bridge silently watched the horizon before them. Periodically Jan-Christer or the bosun took a turn around the bridge deck, since from the pilothouse there was no visibility aft. Mohamed set out on one of these patrols, then almost immediately came racing back into the wheelhouse. "Captain, you better come look. Mens on number three."

Jan-Christer and Teodoro followed the bosun to the aft rail of the bridge deck. A line of heads appeared behind the No. 3 hatch combing. More men were running, crouched, from the deckhouse on the poop. Two carried rifles.

Jan-Christer turned and looked hard at the first mate. "Are you with us or are you with them?"

The reply from Teodoro was immediate and with conviction. "Of course, Captain, I am with you."

Jan-Christer gave Mohamed the key to the gun cabinet and told him to bring up the rifle, pistol, and cartridges he would find there. Teodoro ran back to the wheelhouse and returned a moment later with a welcome surprise, a revolver that he had hidden. So at least the four of them would be armed.

The captain saw Mustafa poke a rifle over the hatch combing. Jan-Christer dropped to the deck and a bullet smacked into the smokestack behind him. Then began a war. All the crew must have been armed. Bullets seemed to be crashing off everything, though most of the crew's fire was very inaccurate. The captain and the first mate lay flat on the deck. Mohamed returned with a Winchester 30.06 and a pistol. Jan-Christer gave the pistol to Rashid and told him to guard the interior stairway that connected the captain's cabin to the pilothouse. Mohamed kept the rifle.

Teodoro proved to be an accurate marksman. With his second shot he hit a fireman in the chest, bowling the man over backward into a winch platform. Jan-Christer fired his revolver, trying to hit Mustafa. He saw one bullet glance off the hatch combing in front of the engineer, who could not move laterally because of the men around him. The bridge offered the advantage of being able to fire down on the mutineers.

The shooting continued. Suddenly Jan-Christer dropped his pistol and clutched the side of his head. He thought it was on fire. His hands came away covered with blood. Big drops of blood splattered on the deck beneath him. Jan-Christer blotted his temple with a handkerchief and tried to keep firing. Fumbling with bloodstained hands, he reloaded from his box of cartridges. Mohamed's 30.06 was deafening each time the bosun fired next to him. One of the crew yelped as a rifle bullet hit him in the hand. A minute later Teodoro, firing slowly but with a steady aim, killed the second fireman.

Jan-Christer aimed at the hatch combing

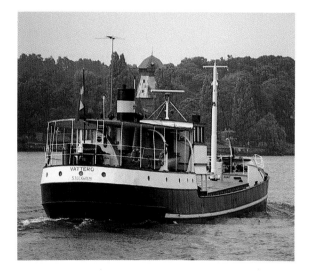

The empty Vättero sails in Lake Mälar after delivering a cargo of grain.

where he had last seen Mustafa. The engineer's head popped up again and stayed up to train his rifle on the bridge. Jan-Christer carefully took aim, held his breath, and squeezed the trigger. Mustafa half stood up before his legs went out from under him and he toppled over. Even from the bridge there was no mistaking the hole directly above and between the engineer's gaping eyes. The mutineers' firing slowed.

Jan-Christer, wiping the blood from the crease in his temple, called out to the men behind the hatch, "Take it easy now. Three is enough. No more shooting. Put your guns down."

The men, without their leader, hesitated. Finally all firing stopped. Some of the remaining mutineers put up their hands. A few guns were thrown overboard; the rest were stuck in belts or inside shirts. There was a long silence as the crew behind the hatch and the three men on the bridge stared at each other.

The bodies of the chief engineer and the two firemen went seaside. Three other crewmen had been wounded, but none seriously. Jan-Christer brought up bandages and a bottle of whiskey and passed them around to those in need.

Two days later when the ship docked in Calcutta, Jan-Christer packed his suitcase and walked off the *Diane.* He never looked back.

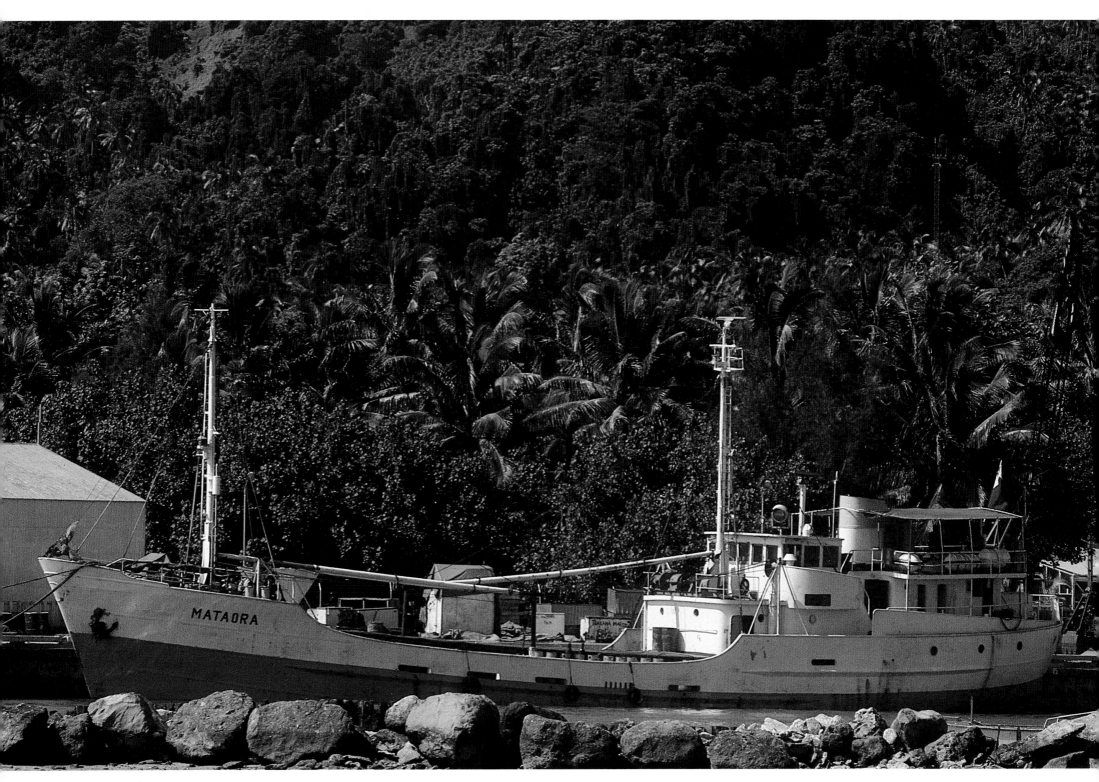

The *Mataora* lies in the postage-stamp-size harbor of Avarua. Behind her
is the dense foliage that covers most of the center of Rarotonga.

MATAORA

Stormy Sailing in Paradise

The warning should have been apparent. Don Silk, co-owner of the *Mataora*, while bidding Judy and me farewell on his vessel, had said in his offhand way, "It's liable to be a little rough tonight, but it'll be okay tomorrow when the crew sobers up." Then with a droll smile, the wiry, balding ex-New Zealander added, "By the way, there's a passenger in the galley doing the cooking tonight."

Unfortunately Don Silk was not being facetious. The *Mataora*'s regular cook had decided there were better things to do than to make the voyage. He had disappeared. However, this non-event is forgotten during the confusion preceding the ship's departure. Flower-garlanded Cook Islanders fill the quay. They are returning to Aitutaki and Manahiki, their home islands, for Christmas. Four or five well-wishers are on hand to see off each departing passenger. A mountain of suitcases, twine-tied boxes, transistor radios, and miscellaneous possessions accompanies each traveler. Children roam freely, blowing up balloons and chasing each other around stacks of cargo. Dogs sniff for their owners. A black-plastic-wrapped coffin comes over the side on a

forklift, then is reverently lowered into the hold by eight brawny islanders. Bunker oil is still being pumped on board from two quayside tanker trailers, so the *Mataora*'s departure will be delayed. While there is a festive air on the quay, many of the Polynesian passengers, in spite of their gay farewells, obviously are working up their courage for what they know will be a difficult voyage. Many of them are predisposed to seasickness, and their dread becomes more apparent as departure time nears.

The Cook Islands are thirteen major and a number of smaller flyspecks in the middle of the vast Pacific. Scattered over 750,000 square miles of ocean, 2,000 miles northeast of Wellington, New Zealand, the whole Cook Islands group, lumped together, would form only a nine-by-ten-mile island. Avarua on Rarotonga Island is its Paris. It is a one-horse town with palm trees and a delightful, easygoing manner. More than half the Cook Islands' 18,500 people live on the coastal fringe surrounding Rarotonga's famous steepled peaks, and an accurate gauge of its size

This tarp forms a tent on the foredeck that serves as the living quarters for deck-class passengers during journeys that may last as long as two weeks.

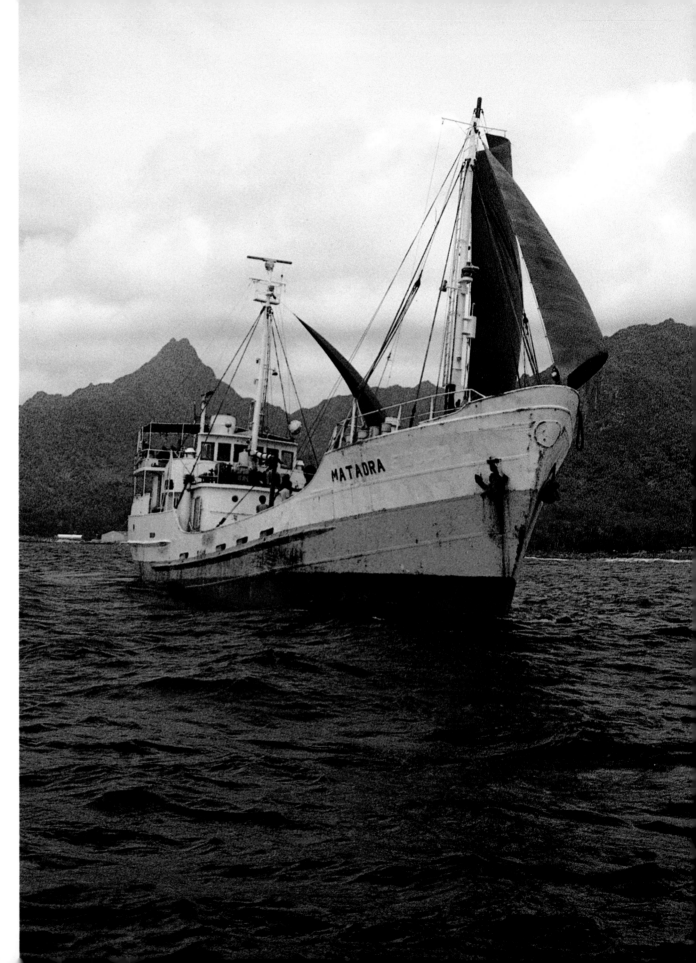

The *Mataora* raises her sails only infrequently. They are kept as an emergency substitute should the engine fail. Since the *Mataora* often journeys to remote areas of the Pacific where she could expect no help from other vessels should a malfunction occur, an auxiliary is important. Rarotonga's famous peaks rise in the distance.

is that this, the largest island of the group, requires one whole joyful hour to circumnavigate on a motor scooter. On the way around Rarotonga the scooterist passes lush vegetable gardens, trimmed lawns, and a well-cared-for bungalows interspersed with bright red flame trees. A New Zealand-derived sense of neatness and order is combined with the innate Polynesian *joie de vivre*. It is a wonderful marriage.

In 1959 two carefree young New Zealanders, one with his wife and two-year-old daughter, sailed in to Rarotonga together on their homemade ketch. Don Silk, having grown up on a farm and having decided that he never wanted to see a cow again, had worked as a truck driver, and then as a crewman on freighters sailing between England and Australia and schooners carrying salt around southwestern Australia. Bob Boyd had been a sign painter and dinghy sailor. With Ollie and Patsy, Don's wife and little daughter, they were sailing to Vancouver, Canada, when they made a fateful decision to stop in Rarotonga.

No sooner had they landed than they saw a derelict "trading schooner," with gaping holes in her hull, rotting in a merchant's vacant lot. The next day they were the proud owners of the *Siren*, a forty-five-foot wreck posing as a ketch. Bob and Don spent the next two years rebuilding the *Siren*, but, Bob said, "A lot of that time was spent sitting under trees thinking how we were going to spend all the money we were going to make on her."

What better way to see the South Pacific than to operate a trading schooner? Don and Bob decided they would start tramping. They

studied the local shipping movements and saw, for instance, that no vessel had been to, say, Mangaia for the last month. So they would advertise in the local paper and, presto, cargo would appear. But they soon became intrigued with pearl-shell trading. With the backing of a local trading company, they started a shanty trading store on the little island of Manihiki, 750 miles north, where the lagoon had just been reopened to pearl-shell diving.* Silk and Boyd's timing was perfect, and their business was an instant success. It continued to boom until a moment two years later when it quite literally went on the rocks. The *Siren* hit the reef outside Rarotonga and sank. At that time Don and Bob were having

an eighty-two-foot steel coaster built for them in Hong Kong, and suddenly they had no means with which to pay for it. They sold shares in their new company to pay for the ship and went back to New Zealand to support themselves by painting houses and selling encyclopedias while it was being built. When the *Tagua* was completed, Don and Bob returned to Rarotonga and to running a shipping company.

A few years later one of Silk and Boyd's shipowning competitors died and another sold out to one of their major stockholders. Don and Bob bought the *Akatere* from the one owner's estate and received the 120-foot *Bodmer* from their shareholder. In a single year they went from

being the smallest to being the largest shipping company in the country. As time passed, they lost vessels to the reefs or replaced older ones with newer ships. In return for guaranteeing the Cook Islands government two ships to provide service to all the islands, Silk and Boyd received a financial subsidy. This enabled them to operate throughout the tiny, far-flung island group, within which the small cargoes seldom justified the long distances that had to be sailed. That situation still exists today. Many of the little islands have only 100 or 200 inhabitants and rely solely on the Silk and Boyd vessels for everything coming from or going to the outside world. These men have become the country's lifeline and are aware of their great responsibility.

Late in the afternoon the *Mataora* leaves Rarotonga's postage-stamp, notch-in-the-reef harbor. Waves break on each side of the ship as she slips through the narrow channel and heads into open ocean. The *Mataora*'s first stop is the island of Aitutaki, 150 miles north. From there she has three days' steaming to reach Manihiki, one of the most northerly islands in the 800-mile chain. Then she will go on to her final destination of Samoa.

Flying fish skim like bullets over the sea. They cover amazing distances, 300 or 400 feet at a stretch, before ricocheting off a wave crest and zooming away in a different direction. A wily sun blinks on and off as it dodges between clouds, first turning the ocean deep gray, then brilliant blue-green. The peaks of Rarotonga begin to fade into the masses of cumulonimbus covering the island.

A large tent has been erected over the sealed hatchcover. This will serve as home for the fifty-three deck passengers, most of whom are

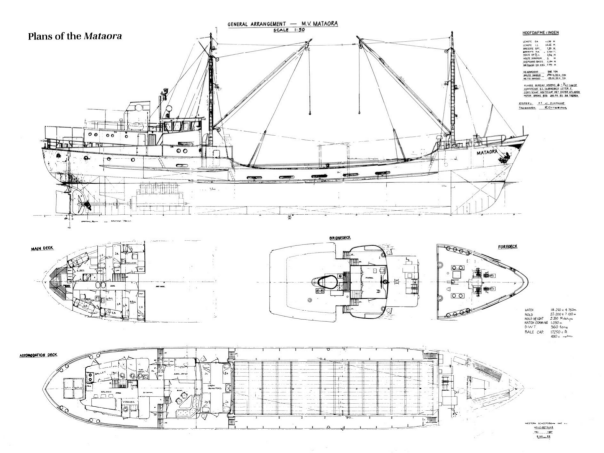

Plans of the *Mataora*

*Pearl shell, a source of mother-of-pearl, in this case comes from a large, plate-sized clam native to the South Pacific. Though the clam may contain a pearl, it is no relation to the oyster.

going all the way to Manihiki. Already it has become rough. A beam sea smashes into the starboard side of the ship as she rolls in the trough of each preceding wave. Islanders line the rail and the vomit begins to spew. No wonder the local people dread the crossings. Most of them will have four days of this before reaching their home island. The weather patterns are such that beam seas can be expected for the entire voyage.

As night falls the wind picks up and the seas become larger. Waves crash over the weather rail and cascade the length of the main deck before running out through the scuppers. Green passengers are sprawled everywhere. One, somehow, is sleeping atop the pilothouse. Two girls, feeling the pangs of mal de mer, are curled up in misery on a mattress underneath the lifeboat. An old wooden picnic table and benches that serve as deck chairs are filled with people wishing they were back on Rarotonga. On a lazaret at the aft end of the boat deck two boys alternate throwing up over the side. An old man sitting uneasily next to them tries not to watch. Even my photographer colleague, a stalwart sailor, has turned pale yellow and eventually makes her way to the rail. So far I am fortunate. I go down to the galley to see what is for dinner. Spam and taro. No thanks. For a while I watch the seas battering the ship, then decide to go to bed.

The little cabin is stifling. Built for trading in the North Sea, the *Mataora* has six cabins all adjacent to the engine room, and so leaving a cabin door open helps not at all. My upper bunk has no weather rail on it and runs fore to aft. Thus each time the ship rolls I am nearly pitched six feet to the deck. To avoid this I wrap one leg and one arm underneath the mattress. I am now secure but I am being sautéed in my own sweat. There is a closed porthole eighteen inches above my bunk. Do I dare? Yes, I must. It is a preserver thrown to a drowning man, a sexy girl to a lifer,

filet mignon to the starving; the fresh, cool air is better than anything I have ever felt. I luxuriate in it for two or three minutes before falling asleep.

It is, of course, too good to be true. The ship smacks into a trough and twenty gallons of cold Pacific Ocean pour through the open porthole. I close the port, but twenty minutes later the heat has become so intense that I have to open it again. For the rest of the night I sleep with my foot holding the port open. Whenever my unconscious feels the ship hitting a trough, it tells my foot to shut the port. Now both arms and one leg are tucked under the mattress and the other leg alternately opens and closes the port. Unlikely as it sounds, I am able to sleep this way

and get soaked only once more during the night.

The next morning the sea is still abeam but it has begun to diminish. Some of the *Mataora*'s weary passengers line up on deck to wait for one of the two working toilets. A young dark-haired mother stands patiently with her small son clinging to her like a little koala. Many of the Cook Islanders are still asleep in their tent on the foredeck. I sneak a glance in the tent and see nothing but bodies rolled up in mats. The smell of vomit is overpowering.

In the galley a short, stocky Cook Islander with long oily hair and a bad case of acne has been pressed into service as cook. He tells me that my breakfast is on the table. It is, but I can

Don Silk (left) and Bob Boyd, lifelong friends and partners for over thirty years, operate in one of the most problem-fraught shipping environments in the world—and make it look easy.

This pretty Australian visitor takes advantage of a delayed departure to develop her already considerable tan. Once at sea the bikini will be exchanged for more practical jeans.

hardly believe what I see. Two fried eggs gallop across the plate with each roll of the ship. They are riding in their own miniature ocean of grease. Next to them is a pile of spaghetti in tomato sauce, and sitting on top of the spaghetti, like a conquering hero, is a big, greasy sausage. It takes only a moment to decide that coffee is sufficient for breakfast.

The *Mataora* and her sister ship, the *Manuvai* (built in 1960, 400 gross tons), were never designed to carry seventy passengers, as well as cargo, over long distances. When Silk and Boyd bought the *Mataora*, they added a deckhouse forward of the bridge for crew accommodations and extended the superstructure aft to enlarge the mess and galley. Still, the passenger accommodations are woefully inadequate. To make matters worse, the closest maintenance facilities are nearly 1,000 miles away, in either Papeete or Pago Pago (American Samoa), or 1,500 miles away at Suva, Fiji. To replace the *Mataora* and *Manuvai* with newer ships configured to provide better passenger accommodation as well as cargo space is nearly impossible. Such vessels simply do not exist. Therefore, the only solution is to build new vessels, but Don Silk figures that would cost two to three million dollars per ship. With the small cargo revenues generated by the islands and the fact that the local people can only afford low passenger fares, Silk and Boyd can't even consider building new vessels. Unfortunately, the Cook Islands government is in worse financial shape than the shipping company, and so the status quo is likely to remain for the near future.

Sixty-five passengers breathe a collective sigh of relief when the *Mataora*'s anchor rumbles out into the clear blue water off the Aitutaki reef. The weather has cleared though, and the rest of the journey is likely to be more pleasant. Too bad Judy and I won't get a chance to find out.

The volcanic peaks of Rarotonga rise from the lush jungle.

The isolated white beaches and aqua water of Motu Raku, near Aitutaki, Cook Islands.

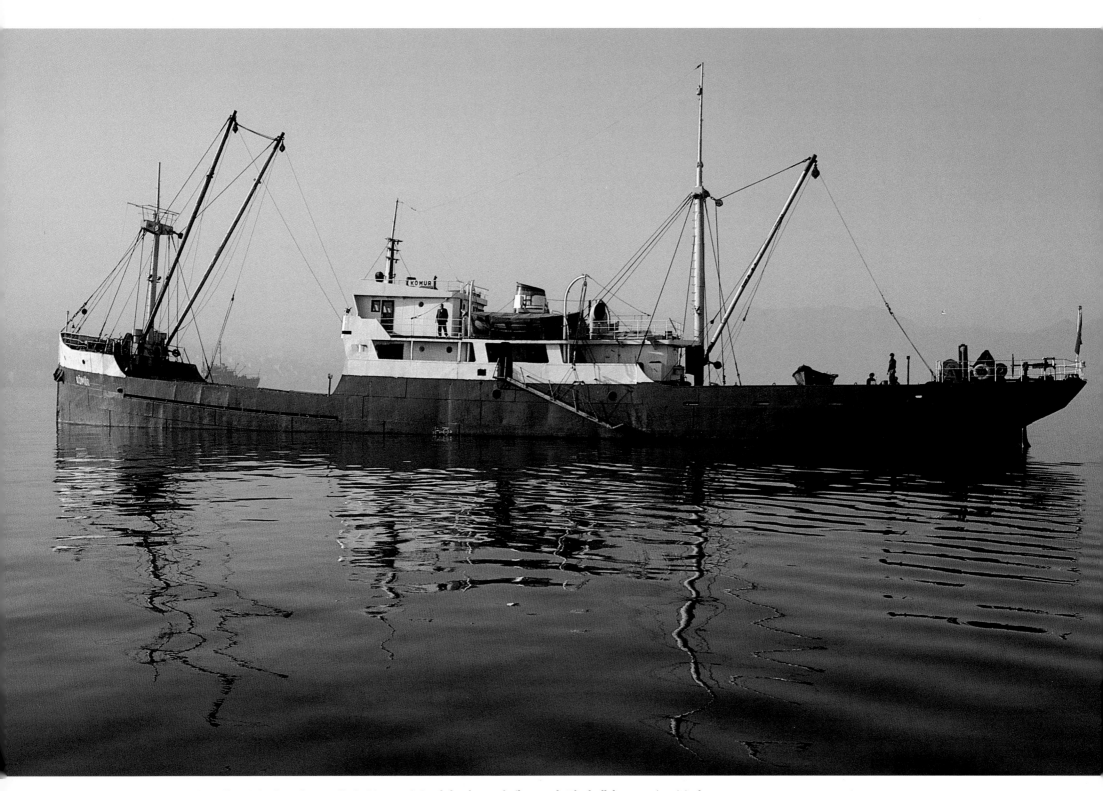

The *Kömür* lies at anchor off Izmir harbor. The vessel's deckhouse obviously has been rebuilt recently. The hull, however, is original.

KÖMÜR

Caught in the Middle

The old man dozes in his chair, bald head nodding as his chin slumps against his chest. It is warm and quiet in his glass-partitioned office. The October sun filters through windows bespeckled with slow-moving galaxies of dust. The old head nods forward again, then, as if pricked by an unseen pin, snaps awake. There is a ferocious stare in those old eyes, but it is also a blank, uneasy look. English is being spoken in the outer office, and the old man doesn't understand it. He feels left out and helpless with the foreigners. But that penetrating stare tells visitors in no uncertain terms: Look out—there is still a lion here!

Rumors are that the old man, Huseyin Eminoglu, was a smuggler. He came from the Turkish village of Rize, on the Black Sea, about sixty miles from the Russian border. Eminoglu was a fisherman, but if the rumors are true, he also used his small wooden boat to carry food, clothes, maybe a few rifles—whatever would fetch the best price—into the Soviet Union during the thirties. Traveling by night and putting in at any of the hundreds of small coves on the Russian side of the border, he would have been taking great risks. If he had been caught, probably

he would never have been heard from again. But almost everyone was dirt poor then. If he was a smuggler, it would have been understandable. A few good trips could feed his wife and children for months.

The old lion is mute when asked about those days except to say that he was a fisherman. At any rate, Huseyin must have prospered. In 1953, with two partners, he was able to buy his first steel vessel, the steamship *Kömür*. The little freighter was thirty years old when he and his associates purchased her. Her name means "coal" in Turkish, and that is exactly what she carried during most of her previous existence in Turkey.

Not long after the partners purchased the *Kömür*, her Dutch steam engine gave up the ghost. This was a major problem. The partners had invested almost all their money in the vessel. They couldn't even think of buying a new engine, but there were payments on the *Kömür* that had to be met, payments that certainly could not be paid with a ship that was not operating.

Then, fortunately, they heard about Balakis. This village, like many other remote Turkish towns, used a small generator to

Because of lack of loading facilities, the *Kömür* often spends extended periods waiting to load or discharge. Thus the crew has provided themselves with a steady source of eggs to supplement their diet. These seagoing chickens appear to be doing well aboard ship.

127

produce a limited amount of electricity for its residents. The Balakis generator was powered by a seven-cylinder diesel made by the Buckeye Machinery Company of Lima, Ohio. The city fathers had decided to replace the Buckeye with a new engine, and the old diesel was for sale—cheap. In it went, and the *Kömür* was sailing again.

Little is known of the *Kömür*'s history other than that she was built in Hälsengborg, Sweden, in 1923. Lloyd's *Registry* shows her builder to be Vulcan-Varf, but that is likely to be the fabricator of her original steam engine. She sailed in northern Europe until after World War II, when she was sold to a Turkish company.

Since then the *Kömür* has sailed the eastern Mediterranean or has worked as a coastal trader in the waters around Turkey.

In 1966 the *Kömür*'s owners received a double whammy. She had sailed from Italy with a general cargo bound for Istanbul. According to Huseyin, the *Kömür* loaded her cargo and sailed before receiving the bills of lading. Bills of lading (B/Ls) are the documents that show the type and quantity of a particular consignment of cargo, as well as identify the shipper and receiver. The "original B/L" conveys title to the merchandise. A ship's captain or agent presents the B/Ls to customs at the port of discharge, and the original is released to the receiver (or consignee) of the

The morning sun reflects a million small sparkles on the sea. Beyond stands part of Turkey's rugged Mediterranean coastline.

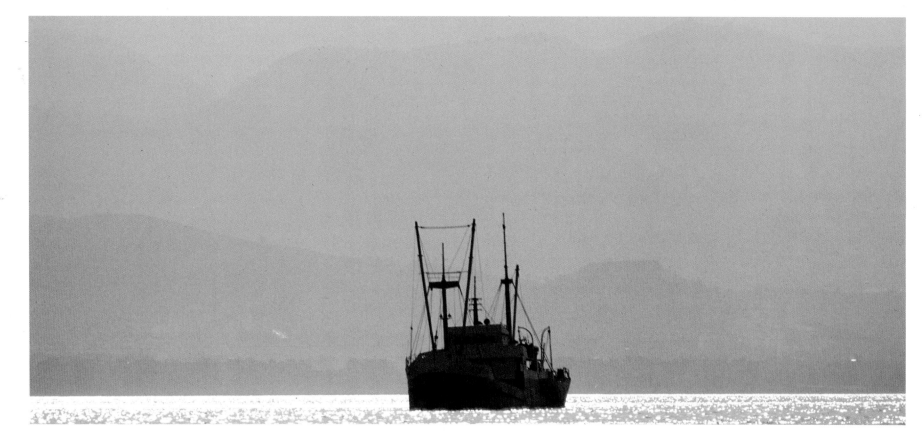

cargo when the shipping charges are paid.

The Turkish buyer of the *Kömür*'s cargo had promised Huseyin that he would deliver the bills of lading to Huseyin before the ship reached its destination of Istanbul. On the way, however, the *Kömür*'s crankshaft broke, and she had to be towed into the Turkish port of Trabzon for repairs. While the *Kömür* was in Trabzon, the buyer somehow was able to smuggle part of the cargo into the country. Turkish customs discovered that cargo was missing and demanded that Huseyin surrender the bills of lading. Of course, he couldn't provide documents he didn't have. The buyer, realizing his crime had been discovered, fled the country. So with neither the shipper nor the receiver of the smuggled cargo inside Turkey, the authorities went after the only individual connected to the contraband whom they could put their fingers on.

The Turkish government confiscated the *Kömür*. It took Huseyin three years of legal wrangling and the posting of a $10,000 bond to get his ship released. During the three years the *Kömür* was laid up in Trabzon, however, she had run up a moorage bill of more than one million Turkish lire (approximately $6,000) with the Trabzon Port Authority. Huseyin could not pay the charges; he had received no income from his only ship for more than three years. The situation looked bleak. The authorities would not release the *Kömür* until Huseyin paid the charges, and Huseyin could not pay the charges unless he had a ship with which to earn the money. It may have been at this time that poor Huseyin went bald. Finally the authorities relented and allowed him to pay the debt in installments.

Somehow the Eminoglu firm managed to survive. Old Huseyin was having difficulty coping with the rapidly changing methods of doing business. Through a translator he says, "When I started with the *Kömür*, the commercial peoples are very honorable—you could load or dis-

charge cargo on a man's word alone. Now there is great [financial] pressure [on everyone], and you can't take anyone's word."

With a vigorous shake of his head, he adds, "I wouldn't again start as a shipowner today."

To help him run the business, Huseyin took in one of his sons, Fikret, who had previously owned a small movie theater in Istanbul. Huseyin also took in Attila, his young grandson, who was just graduating from university. Unfortunately neither Fikret nor Attila had previous experience in the shipping business.

The years following the Trabzon incident were profitable ones. In 1977 the Eminoglus decided that business was good enough to have a new ship built. Construction started on the *Uesilrizey*, a 3,000-deadweight-ton motorship. It took the Turkish yard two years to build her, a job that would have taken six months in Japan. The latter was not possible, since the Eminoglus could get government financing only if their ship was built in Turkey, but the extra eighteen months that their money was tied up proved costly. Financing (anything) in Turkey is expensive. The government offers 12 percent loans for shipbuilding, but it will only finance 25 percent of the cost of construction. The rest has to come from the private sector. Commercial banks charge 27 percent interest, and if the borrower is delinquent in his payments, the interest rate skyrockets to 52 percent per year. Because construction delays are the rule in Turkey rather than the exception, most shipowners cannot meet their payments. The result is that almost everyone is paying 52 percent interest on his loan, and not too many ships are being built in Turkey these days.

Attila, now a handsome twenty-four-year-old with straight black hair, is intelligent and realizes the difficulties that confront his family. "The main problem for me and for all the Turkish

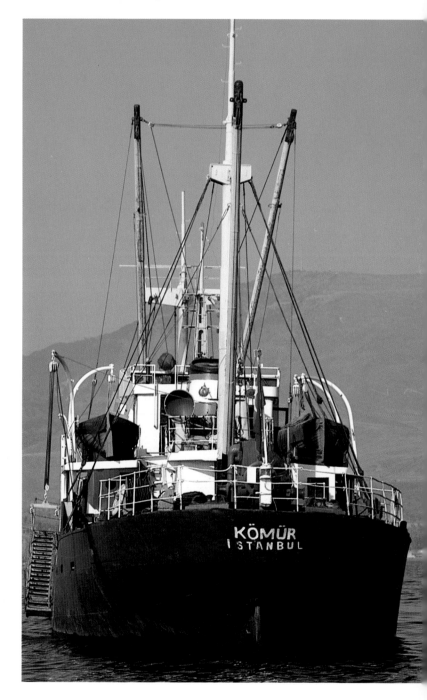

A dispute has arisen with the agent in Izmir. He feels that the *Kömür*'s owners owe him money from a previous shipment and is delaying cargo scheduled to be loaded. Huseyin denies the agent's charges, but until the matter is resolved the *Kömür* sits off the harbor cargoless.

Plans of *Kömür*

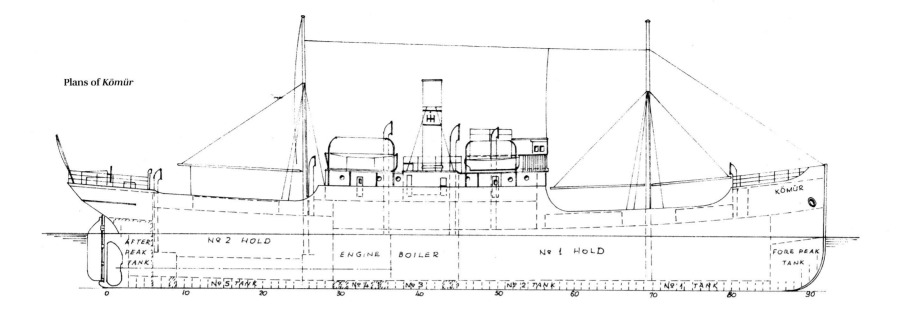

owners," he says, "is we don't have so many ideas about the shipping. This is not the Turkish people's business, I believe. The work [here] is not operating the ships with computers, you know. We operate the ships ourselves, in the old way. So this is not the modern way to do it. Even the big companies do it the old way. Nobody uses the computers. It takes so much time and [causes] so many problems [setting up a computerized system and learning how to operate it]. Even if we knew how to use these things, we probably could not afford to buy them."

Attila feels that the key to success in their shipping business is to keep costs down and to maintain a simple operation. He likes the old *Kömür* better than new vessels, which are much more complicated and difficult to maintain. The

Kömür is simplicity itself. She has little in the way of sophisticated communications or navigation equipment. The anchor and mooring windlasses are Yugoslavian one-cylinder diesels of (it appears) World War I vintage, and the two winch motors are newer British Lister diesels, which are also one-cylinder. The equipment and machinery on board, when it is working, is sufficient to do the job.

In 1966 when the Buckeye diesel's crankshaft broke, Huseyin went back to the village where he had bought the first engine and found its mate, still generating power for the town. He purchased it and it is still powering the *Kömür*. Unfortunately it is now having problems, and the village of Balakis is fresh out of Buckeyes. Finding replacement parts for the obsolete Buckeye and,

indeed, for all the systems on the old vessels still being used in Turkey is a major problem.

The *Kömür* usually carries bulk coal from Black Sea ports to Istanbul and Izmir. She also carries timber and cement (in bags), traveling mostly along the Turkish coast, but sometimes going to Syria or Lebanon. Her longest journeys are occasional trips to Italy or western Greece, returning with three-cubic-meter blocks of marble.

There is great loyalty among the *Kömür*'s eleven-man crew. Apparently Huseyin has treated them well. Captain Ali Sahin has been master for ten years. Even more unusual, Yasar Cirak, the jovial chief engineer, who is a wizard at keeping his old machinery operating, has been aboard the *Kömür* for more than twenty years. The men lead simple lives. Though their pay is very low by European standards, they are sel-dom away from home for long, since the *Kömür* only sails in the eastern Mediterranean or the Black Sea.

Food on board is plain but good. Com-pared to may people in Turkey, the men eat well. Along with the staples of rice, bread, and the ubiquitous bell pepper, they have fish and some-times a bit of lamb or beef. They keep live chick-ens on board to provide a fresh supply of eggs and an occasional dinner. There is also a feeling of camaraderie among the crew. They have sailed together a long time, so they feel like a family.

While the *Kömür*'s hull still exists as it was built in 1923, there have been numerous modi-fications topside. Originally there were two small hatches forward with a mast between them carrying derricks serving both the hatches. They have been rebuilt into one large hatch, more convenient for loading bulk cargoes, and the mast has been moved forward, just aft of the forepeak. The deckhouse and the bridge have been modernized, and the tall funnel has been shortened in keeping with the *Kömür*'s replace-

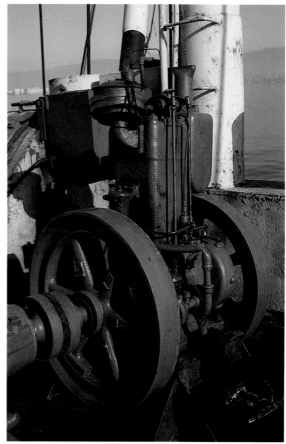

ment diesel power. Sadly, much of the original joinery below has been replaced with plastic laminate paneling and counter tops.

The greatest difficulty currently facing the Eminoglus and other Turkish shipowners is that there are too many ships vying for the small amount of local cargo. It is a shippers' market, and rates are so low that many vessels are carry-ing cargo for no profit. The revenue is just enough for the shipowners to make payments on the loans that are outstanding with the govern-ment and the local banks. The situation for many firms is desperate.

Though it is little consolation to Huseyin and his family, they are in a better position than many of the larger shipping companies who have borrowed more and have correspondingly greater debts to repay. The *Kömür* is old, but because they own her outright, they can afford to ask 10 percent less in freight rates than their competitors with newer vessels. As long as the Eminoglu firm can keep the *Kömür* running, it stands a good chance of continuing to run as well.

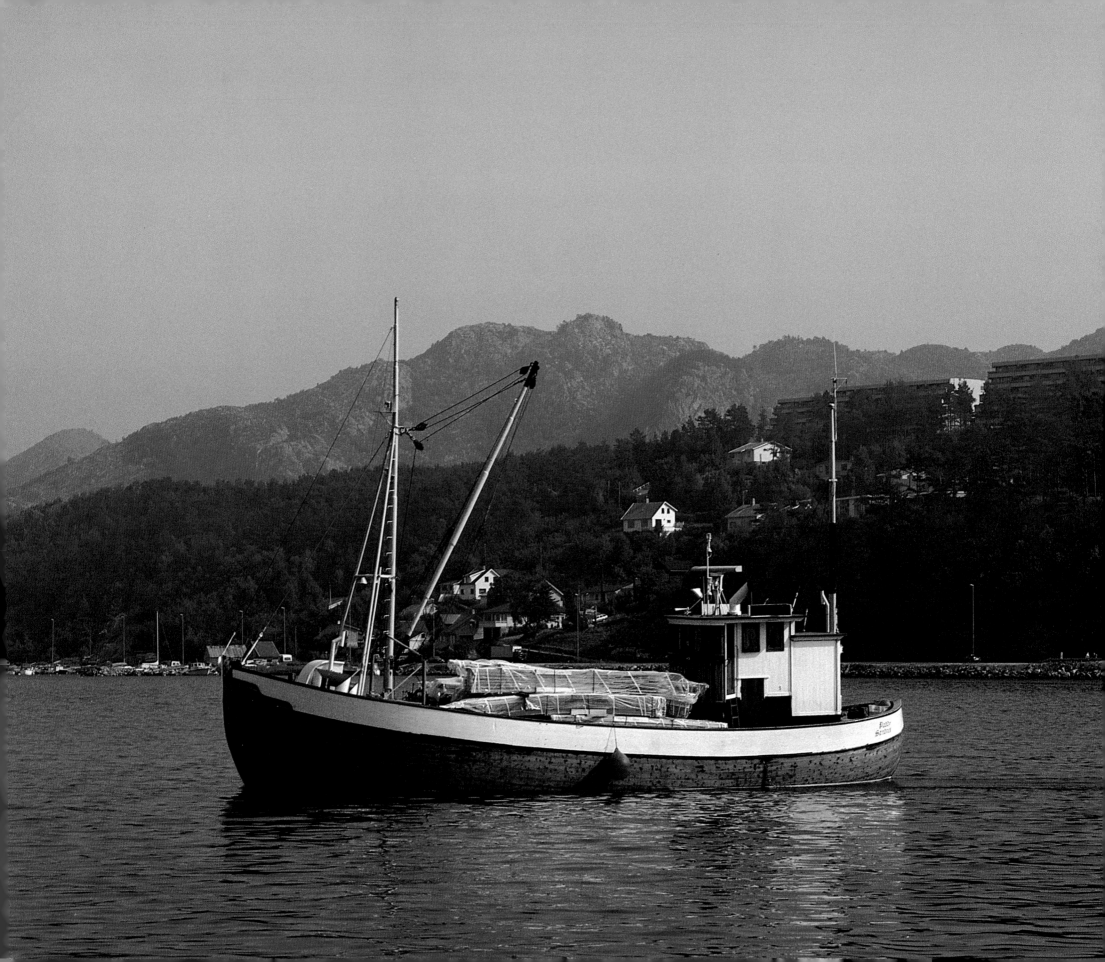

Chapter Twenty

SAILING AWAY

ntangled green jungle forms a canyon on each side of the *Norse Transporter* as she thrashes upriver. Saplings, rattans, bamboo, and lianas, all struggling to reach the sun, intertwine into inviolable walls that not even the eye can penetrate. You have the helm yourself, for only you know the winding, swollen river whose ever-changing sandbars can have your freighter aground in seconds. And if your vessel goes aground in the middle of the Sumatran jungle, there is no one to come to your rescue. You are on your way into the heart of Sumatra to load a cargo of rubber from an isolated plantation. As captain and owner of the *Transporter*, you are taking your vessel where few men have ever been and where few will ever go. Your heart dances with excitement.

Ahead is a sharp bend in the river and, clustered about it, a grove of rengas trees. Rengases are seldom cut because of their poisonous sap, so they stand high above the second-growth rain forest. On the slight chance that a vessel might be coming downriver, you give a tug on the whistle lanyard. A gigantic *hurunnhh* vibrates over the jungle, and from the treetops

thousands of startled egrets flash into the air, painting the sky white with their wings.

The empty *Transporter* beats upriver hour after hour. The dense walls of jungle slide by unevenly. Suddenly the rain forest is broken by a clearing. Twelve or fifteen atap huts on stilts appear, flanked by a few hectares of rubber trees. The entire sarong-clad population of the village stands open-mouthed to watch your giant apparition thunder past. Only the children react. Small boys dash to their frail little canoes. As fast as they can, they paddle out to mid-river in time to bob in the wave of the *Transporter*'s wake and to shout unheard calls as you pass out of sight around the next bend.

Occasionally tribes of monkeys swing above you through the highest branches of overhanging trees. The jungle swallows them in seconds, leaving only empty branches where colonies of black and brown bodies have just been.

The huge pistons boom a pattern into your soul. Awake, asleep, eating, reading. At every moment those pistons stamp themselves into your existence. There is no escaping the rhythm. It is the background for conversation

The "Valium" thumps with the soothing regularity of a tiny metronome. Her owner rebuilt her himself when he bought the *Paddy.*

The *Paddy* ventures into a fjord near Stavanger to deliver her cargo of one prefabricated vacation cabin.

Building materials are lowered into the hold by a truck-mounted hydraulic derrick. While this could be done with the boat's gear, it would be considerably slower.

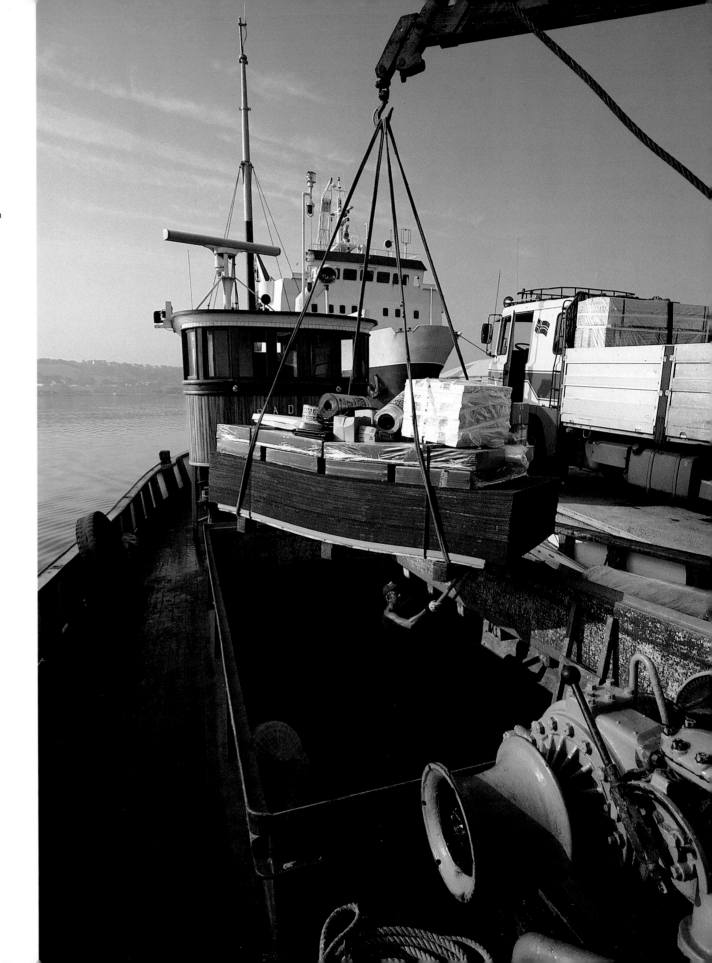

and for solitude. It is the stage on which the radio receiver parlays its static, whine-filled messages in Malay, English, and Cantonese from distant and unknown senders to disconnected receivers. It is behind the orders given to your Scandinavian officers. It sounds a foil to the rapid, incomprehensible dialogue of the Chinese crew. It is everywhere. Years after leaving the ship you will still hear those pistons and their hammering rhythm, and for the rest of your life their impact will never quite leave you.

The stories of Joseph Conrad still unfold dramatically before our eyes, and the dream of sailing off into the unknown, to operate an old tramp in some remote paradise, still stirs our imaginations. It is becoming more and more difficult to accomplish, but it is still possible. Many men have tried and failed. Too often the dream obscures the reality. Owning or even chartering a tramp is a dangerous, risky business. Often the novice commits himself to the ship before he has a guarantee of the cargo. Often the economics or the potential pitfalls are not properly taken into account. Many ships are purchased without complete hull and engine surveys. Local regulations concerning the registry of vessels and who may sail them are not discovered until it is too late. The neophyte captain who thinks he has taken everything into consideration may end up putting his ship on a reef. There is no substitute for experience and that can be expensive to gain. In many parts of the world there are already too many ships for the amount of cargo and in many areas cargo rates don't cover the costs of carriage. Still, there are people who are successfully living their dream. Johannes Tveita is such a man.

For fourteen years a Norwegian air force fighter and helicopter pilot, Johs Tveita now flies forty-four-passenger Boeing Chinook helicopters carrying crews and supplies to oil rigs in the North Sea. The work is most stressful: often he must fly in bad weather and land on small platforms in high winds. As compensation, however, Johs has two weeks off for each two weeks he flies, and this allows him to have a second occupation operating a small cargo carrier.

Tveita bought the *Paddy* for $15,000 in 1958. She was built in Risor, Norway, in 1904, and served first as a fishing boat, then as a tender carrying fish from the fleet to the markets. Johs now uses the *Paddy* to haul prefabricated cabins from her home port of Stavanger all over the fjords of southern Norway. The little fifty-eight-foot vessel is just the right size to carry the components for one cabin. Her one-cylinder, fifty-horsepower Norwegian Wickman diesel, nicknamed "Valium" for its soothing effect on its owner, was made in 1947 from a design that dates back to 1910. It burns only seventeen liters of fuel an hour at eight knots. The *Paddy* has a fir hull, an alder deck, and a Norwegian oak stern. Johs has restored her to the 1904 design, and her exterior profile looks original except for an in-

The *Paddy's* wheelhouse, while small, is as efficient as it is beautiful. Built right over the engine it is well designed for the cold Norwegian climate.

Johs Tveita, owner and captain of the *Paddy*, operates the winch to unload building materials in Sjølvik, a village in the fjords.

Johs Tveita is a helicopter pilot who carries crews and supplies to the North Sea oil rigs. He bought the *Paddy* as a means of staying in touch with the beauty of his home and the people who live there, as well as for the adventure of operating his own cargo vessel.

board rudder, a larger keel, and a one-and-a-half-ton derrick and hydraulic winch.

Johs Tveita's father owned and operated old coasters that carried gravel around southern Norway. Johs was, of course, the crew, until he opted for the excitement and higher income of a pilot. But he couldn't dispel the desire to work on the water. While the *Paddy* has no competitors in her field, cabin hauling is not a lucrative business. Still, she pays for herself, and her owner's second occupation brings him the rewards of operating his little tramp in some of the most beautiful country in the world and of sailing into a new adventure with each cabin he delivers. Johs Tveita always dreamed of sailing a tramp and now he is fulfilling that dream.

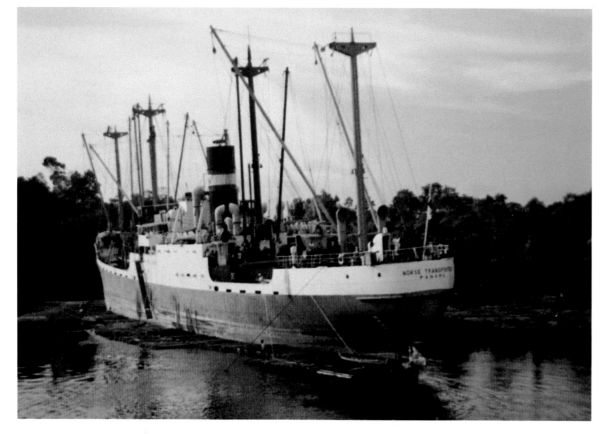

The *Norse Transporter*, chartered by the author in 1968, loads logs in the Siak River, Sumatra. The 335-foot-long *Transporter* (5,325 deadweight tons), was, at that time, the largest ship ever to have sailed up the Siak River. There was great difficulty in turning the loaded vessel around in the narrow jungle river and the author wondered if he would ever be able to get her out again. The *Transporter*, built in Glasgow, Scotland, in 1939, has long since been converted into refrigerators and beer cans.

SHIPS' PARTICULARS

Chapter 1

Name of Vessel/Nationality: *Lambros L*/Greece
Built in/Year: Saint Nazaire, France/1940–49
Name of Builder: Saint Nazaire-Penhoêt
Hull Material: Steel
Length/Breadth/Draft: 541' (164.9m) / 64' (19.50m) / 28'11" (8.81m)
Net/Gross/Deadweight Tons: 5,084/8,696/10,034
Number and Type of Engine(s)/Cylinders/Horsepower: 2 diesels/8 each/6,000 each
Description of Engine(s)/Builder/Date: Sulzer 8SD72/1949

Speed Maximum/Cruising: 17 kn/16 kn
Fuel Consumption: 37 tons per 24 hrs
No. of Derricks and Their Tonnages: Twelve 3-ton; four 5-ton; four 10-ton
No. of Crew: 38
Name of Owners: Callipus Shipping Limited, Monrovia

Chapter 2

Name of Vessel/Nationality: *Aksel I*/Turkey
Built in/Year: Liverpool, England/1913
Name of Builder: R. Williamson & Son
Hull Material: Steel
Length/Breadth/Draft: 181' (55.16m) / 27' (8.23m) / 13'4" (4.0m)
Net/Gross/Deadweight Tons: 295/496/900
Number and Type of Engine(s)/Cylinders/Horsepower: 1 diesel/6/550
Description of Engine(s)/Builder/Date: Ansaldo, Genoa, Italy/1962

Speed Maximum/Cruising: 9 kn/7.5 kn
Fuel Consumption: 90 kilos per hr
No. of Derricks and Their Tonnages: Two 2.5-ton
No. of Crew: 10
Name of Owners: Gazanfer and Yilmaz Akar, Istanbul

Chapter 3

Name of Vessel/Nationality: *S. T. Crapo*/USA
Built in/Year: River Rouge, Michigan/1927
Name of Builder: Great Lakes Engineering Works

Hull Material: Steel
Length/Breadth/Draft: 402' (122.5m) / 60' (18.28m) / 22' (6.7m)
Net/Gross/Deadweight Tons: 2,942/4,769/8,800
Number and Type of Engine(s)/Cylinders/Horsepower: 1 recip. steam/3/1800
Description of Engine(s)/Builder/Date: same as ship

Speed Maximum/Cruising: 12 mph/11 mph
Fuel Consumption: 1.5 tons of coal per hr
No. of Derricks and Their Tonnages: none
No. of Crew: 34
Name of Owners: Huron Cement Division of National Gypsum Corporation, Alpena, Michigan

Chapter 4 (one of two)

Name of Vessel/Nationality: *Bergseth*/Norway
Built in/Year: Risor, Norway/1915
Name of Builder: Unknown
Hull Material: Steel
Length/Breadth/Draft: 139' (42.36m) / 21'6" (6.55m) / 11' (3.35m)
Net/Gross/Deadweight Tons: 99/199/300
Number and Type of Engine(s)/Cylinders/Horsepower: 1 diesel/3/300
Description of Engine(s)/Builder/Date: Wichmann 3ACA/1959

Speed Maximum/Cruising: 11 kn/10 kn
Fuel Consumption: 55 lit. per hr
No. of Derricks and Their Tonnages: One 4-ton
No. of Crew: 3
Name of Owners: Ove Bernes, 5255 Fotlandsvag, Norway

Name of Vessel/Nationality: *Opsanger*/Norway
Built in/Year: Karlshamn, Sweden/1917
Name of Builder: A. B. Karlshamns Skepsvarv
Hull Material: Wood (double-planked Swedish elm)
Length/Breadth/Draft: 104' (31.67m) / 22' (6.7m) / 11' (3.38m)
Net/Gross/Deadweight Tons: 108/198/355
Number and Type of Engine(s)/Cylinders/Horsepower: 1 diesel/12/365

Description of Engine(s)/Builder/Date: General Motors/1968

Speed Maximum/Cruising: 9 kn/7.5 kn
Fuel Consumption: 61 lit per hr
No. of Derricks and Their Tonnages: One 3-ton
No. of Crew: 3
Name of Owners: Nils and Mons Vik, Stamnes, Norway

Chapter 5

Name of Vessel/Nationality: *Savilco*/Greece
Built in/Year: Lübeck, Germany/1938
Name of Builder: Lubecker Maschinenbau Gesellschaft
Hull Material: Steel
Length/Breadth/Draft: 261'6" (79.7m) / 39'9" (12.1m) / 15' (4.58m)
Net/Gross/Deadweight Tons: 744/1420/1620
Number and Type of Engine(s)/Cylinders/Horsepower: 1 diesel/5/1450
Description of Engine(s)/Builder/Date: M.A.N./Schiffan und Maschinen fabrik Augsburg-Nuremberg/1940

Speed Maximum/Cruising: 13 kn
Fuel Consumption: 4.8 tons per 24 hrs
No. of Derricks and Their Tonnages: Six 3-ton; two 5-ton; two 10-ton
No. of Crew: 26
Name of Owners: Pythagoras Compania Naviera S.A., Piraeus

Chapter 6

Name of Vessel/Nationality: *Belama*/Fiji Islands
Built in/Year: Hong Kong/1958
Name of Builder: Whampoa Dockyard
Hull Material: Steel
Length/Breadth/Draft: 127' (38.6m) / 26' (8.1m) / 9'9" (2.9m)
Net/Gross/Deadweight Tons: 202/285/?
Number and Type of Engine(s)/Cylinders/Horsepower: 2 diesels/8 each/144 each
Description of Engine(s)/Builder/Date: Gardner 8L3/Gardner Engines, Manchester, England/1958

Speed Maximum/Cruising: 8 kn
Fuel Consumption: 10 gals per hr
No. of Derricks and Their Tonnages: Two 5-ton
No. of Crew: 22
Name of Owners: Wong Shipping Co. Ltd., Suva

Chapter 7

Name of Vessel/Nationality: *Peter P*/England
Built in/Year: Sunderland, England/1915
Name of Builder: Sunderland Shipbuilding Company
Hull Material: Steel
Length/Breadth/Draft: 110′ (33.52m) / 23′ (7m) / 9′ (2.74m)
Net/Gross/Deadweight Tons: 63/185/?
Number and Type of Engine(s)/Cylinders/Horsepower: 1 diesel/6/210
Description of Engine(s)/Builder/Date: Kelvin Diesel, Glasgow, Scotland/1978

Speed Maximum/Cruising: 7.5 kn
Fuel Consumption: 3 gal per hr
No. of Derricks and Their Tonnages: —
No. of Crew: 3
Name of Owners: J. J. Prior Transport Limited, London

Chapter 8

Name of Vessel/Nationality: *He Ping 23*/People's Republic of China
Built in/Year: Gdansk, Poland/1955
Name of Builder: Gdansk Shipyard
Hull Material: Steel
Length/Breadth/Draft: 355′ (108.25m) / 47′ (14.64m) / 23′ (7.22m)
Net/Gross/Deadweight Tons: 1,888/3,815/4,928
Number and Type of Engine(s)/Cylinders/Horsepower: 1 recip. steam/3/2,300
Description of Engine(s)/Builder/Date: same as ship

Speed Maximum/Cruising: 12 kn/10 kn
Fuel Consumption: 18 tons per 24 hrs, bunker C
No. of Derricks and Their Tonnages: Eight 2.5-ton
No. of Crew: 42
Name of Owners: Coastal Transportation Bureau, Shanghai

Chapter 9

Name of Vessel/Nationality: *Buga*/Yugoslavia
Built in/Year: Newcastle-on-Tyne, England/1926

Name of Builder: W. G. Armstrong & Whithworth & Co., Ltd.
Hull Material: Steel
Length/Breadth/Draft: 427′10″ (130.10m) / 68′8″ (20.73m) / 33′6″ (10.18m)
Net/Gross/Deadweight Tons: 4,454/7,315/10,446
Number and Type of Engine(s)/Cylinders/Horsepower: 2 diesels/4 each/1,750 each
Description of Engine(s)/Builder/Date: M.A.N./Schiffan und Maschinen fabrik

Speed Maximum/Cruising: 10 kn/9 kn
Fuel Consumption: 7 tons per 24 hrs
No. of Derricks and Their Tonnages: Six 5-ton
No. of Crew: 28–30
Name of Owners: Losinjska Plovidba, Mali Losinj, Yugoslavia

Chapter 10

Name of Vessel/Nationality: *Henry Bonneaud*/Vanuatu
Built in/Year: Lobith, Holland/1951
Name of Builder: DeHoop N. V.
Hull Material: Steel
Length/Breadth/Draft: 150′5″ (45.7m) / 25′ (7.6m) / 9′9″ (2.9m)
Net/Gross/Deadweight Tons: 225/397/430
Number and Type of Engine(s)/Cylinders/Horsepower: 1 diesel/6/390
Description of Engine(s)/Builder/Date: Krupp Mak Maschinenbau, Kiel, West Germany/1951

Speed Maximum/Cruising: 8 kn/7 kn
Fuel Consumption: 12 to 15 gal per hr
No. of Derricks and Their Tonnages: One 4-ton; three 3-ton
No. of Crew: 20
Name of Owners: Puichee Lo, Jackson Lo, Manwah Leong; Santo, Vanuatu

Chapter 11

Name of Vessel/Nationality: *Nebil*/Turkey
Built in/Year: Sweden/1914
Name of Builder: A. B. Lodose Varf
Hull Material: Steel
Length/Breadth/Draft: 143′ (43.58m) / 28′ (8.53m) / 12′ (3.65m)
Net/Gross/Deadweight Tons: 285/499/675
Number and Type of Engine(s)/Cylinders/Horsepower: 1 diesel/8/480

Description of Engine(s)/Builder/Date: Crossley, HR8, Manchester, England/1943

Speed Maximum/Cruising: 10 kn/9 kn
Fuel Consumption: 73 kilos per hr
No. of Derricks and Their Tonnages: Four 6-ton
No. of Crew: 9
Name of Owners: Huseyin Avni Kalkavanlar, Istanbul

Chapter 12

Name of Vessel/Nationality: *Kolpino*/USSR
Built in/Year: Rostock, East Germany/1957
Name of Builder: Unknown
Hull Material: Steel
Length/Breadth/Draft: 334′ (102m) / 46′ (14m) / 19′6″ (5.9m)
Net/Gross/Deadweight Tons: 1,376/2,997/3,700
Number and Type of Engine(s)/Cylinders/Horsepower: 1 recip. steam/4/?
Description of Engine(s)/Builder/Date: same as ship

Speed Maximum/Cruising: 12 kn
Fuel Consumption: 20 tons per hr, bunker C
No. of Derricks and Their Tonnages: Eight 3-ton
No. of Crew: 30
Name of Owners: Baltic Shipping Company, Leningrad

Chapter 13

Name of Vessel/Nationality: *Lady Jillian*/Australia
Built in/Year: Port Adelaide, Australia/1948
Name of Builder: Unknown
Hull Material: Steel sides, wood bottom, jarrah planking
Length/Breadth/Draft: 125′ (38.1m) / 25′ (7.6m) / 9′ (2.7m)
Net/Gross/Deadweight Tons: 98/243/?
Number and Type of Engine(s)/Cylinders/Horsepower: 1 diesel/6/425
Description of Engine(s)/Builder/Date: Caterpillar Tractor Company, Peoria, Illinois/1975

Speed Maximum/Cruising: 10 kn/9 kn
Fuel Consumption: 18 gal per hr
No. of Derricks and Their Tonnages: One 5-ton
No. of Crew: 7
Name of Owners: Flinders-Strait Shipping Company, Launceston, Tasmania

Chapter 14

Name of Vessel/Nationality: *Pioneer*/Denmark
Built in/Year: Danzig/Germany, 1899
Name of Builder: Unknown
Hull Material: Steel
Length/Breadth/Draft: 95′ (29m) / 20′ (6.1m) / 8′6″ (2.67m)
Net/Gross/Deadweight Tons: 69/115/183
Number and Type of Engine(s)/Cylinders/Horsepower: 1 diesel/3/240
Description of Engine(s)/Builder/Date: Volund Diesel, Copenhagen/1943

Speed Maximum/Cruising: 11 mph/8 mph
Fuel Consumption: 27 lit per hr
No. of Derricks and Their Tonnages: none
No. of Crew: 1 or 2
Name of Owners: Otto Gregerson, Bandholm, Denmark

Chapter 15

Name of Vessel/Nationality: *Adriatico*/Italy
Built in/Year: Olanda, Holland/1906
Name of Builder: Unknown
Hull Material: Steel
Length/Breadth/Draft: 108′ (33m) / 21′ (6.8m) / 8′5″ (2.6m)
Net/Gross/Deadweight Tons: 140/200/?
Number and Type of Engine(s)/Cylinders/Horsepower: 1 diesel/4/120
Description of Engine(s)/Builder/Date: Ansaldo, Genoa, Italy/1946

Speed Maximum/Cruising: 9 kn/8 kn
Fuel Consumption: 22 lit per hr
No. of Derricks and Their Tonnages: One 3-ton
No. of Crew: 4
Name of Owners: Gaetano Anzalone, Pozzuli, Italy

Chapter 16

Name of Vessel/Nationality: *George A. Sloan*/USA
Built in/Year: Rouge River, Michigan/1943
Name of Builder: Great Lakes Engineering Works
Hull Material: Steel
Length/Breadth/Draft: 620′ (189m) / 60′ (18.28m) / 25′ (7.62m)
Net/Gross/Deadweight Tons: 6,793/9,057/15,538
Number and Type of Engine(s)/Cylinders/Horsepower: 1 recip. steam/4/2,800
Description of Engine(s)/Builder/Date: same as ship

Speed Maximum/Cruising: 12 kn/11 kn
Fuel Consumption: 375 gal per hr, bunker C
No. of Derricks and Their Tonnages: —
No. of Crew: 30
Name of Owners: United States Steel, Great Lakes Fleet

Chapter 17

Name of Vessel/Nationality: *Vätterö*/Sweden
Built in/Year: Motala, Sweden/1916
Name of Builder: Unknown
Hull Material: Steel
Length/Breadth/Draft: 105′ (32m) / 22′ (6.9m) / 10′ (3.1m)
Net/Gross/Deadweight Tons: 112/230/300
Number and Type of Engine(s)/Cylinders/Horsepower: 2 diesels/4 each/153 each
Description of Engine(s)/Builder/Date: D-11 Scania Saab, Sodertalje, Sweden/1967

Speed Maximum/Cruising: 12 kn/7–8 kn
Fuel Consumption: 30 lit per hr
No. of Derricks and Their Tonnages: none
No. of Crew: 3
Name of Owners: Jan-Christer Sjööh, Torsas, Sweden

Chapter 18

Name of Vessel/Nationality: *Mataora*/Cook Islands
Built in/Year: Hellevoltsluis, Holland/1957
Name of Builder: Niestern Schps. Unie N. V.
Hull Material: Steel
Length/Breadth/Draft: 147′ (44.8m) / 25′ (7.62m) / 9′4″ (2.8m)
Net/Gross/Deadweight Tons: 139/300/360
Number and Type of Engine(s)/Cylinders/Horsepower: 1 diesel/6/395
Description of Engine(s)/Builder/Date: Brons Ed/Appingedammer Brons, Holland/1957

Speed Maximum/Cruising: 9.5 kn
Fuel Consumption: 1.4 tons per 24 hrs
No. of Derricks and Their Tonnages: Two 2-ton
No. of Crew: 10
Name of Owners: Silk & Boyd Ltd., Rarotonga, Cook Islands

Chapter 19

Name of Vessel/Nationality: *Kömür*/Turkey
Built in/Year: Halsingborg, Sweden/1923
Name of Builder: Vulcan-Varf

Hull Material: Steel
Length/Breadth/Draft: 190′3″ (58m) / 30′ (9.25m) / 14′ (4.45m)
Net/Gross/Deadweight Tons: 272/498/1,100
Number and Type of Engine(s)/Cylinders/Horsepower: 1 diesel/8/787
Description of Engine(s)/Builder/Date: Buckeye Machinery Company, Lima Ohio/?

Speed Maximum/Cruising: 8.5 kn/7 kn
Fuel Consumption: 3.2 tons per 24 hrs
No. of Derricks and Their Tonnages: One 20-ton; two 10-ton
No. of Crew: 11
Name of Owners: Fikret Eminoglu, Istanbul

GLOSSARY

Accomodation ladder
A set of stairs that is lowered from the side of a ship to permit people to embark or disembark.

Aft
Toward the stern of the ship.

Ballast
Weight placed near the keel to stabilize a ship; usually seawater is pumped into tanks for this purpose.

Beam
The distance across a ship at its widest part.

Beam-ends
The ends of a ship's beams; in a severe storm a ship may be thrown on her beam-ends and her deck would be vertical instead of horizontal.

Beam sea
A sea (waves) that hits the ship along its side, and which may make the ship roll.

Boat deck
The deck on which the lifeboat(s) are kept.

Bow
Foreward section of the ship.

Bridge
The quarters from which the vessel is controlled; usually contains the ship's wheel, radar, loran, and other instruments.

Bridge wing
A (usually) open area on each side of the bridge providing good visibility especially for docking.

Bulkhead
An interior wall.

Bunkers
Fuel or the area in which it is stored.

Con, the
To have the con is to direct the steering and speed of a ship, particularly when it is underway.

Chop
Small waves, usually close together.

Counter stern
A stern design used in ships built during the first quarter of this century.

Davit
A crane for hoisting a small boat, often a lifeboat.

Deadweight tons
The weight of cargo, fuel, water, and stores necessary to submerge a vessel to her loaded draft.

Deckhouse
A cabin on deck, usually toward the stern.

Demurrage
Rental charges for a ship.

Derrick
A hoist used to raise and lower cargo employing a tackle rigged at the end of a spar or boom.

Draft
The depth of water a ship draws.

Dunnage
Lumber carried on a freighter used to brace the cargo and hold it in place.

Fathometer
An instrument (same as depthsounder) for measuring the depth of the water underneath a ship.

Fo'c'sle
Abbreviation for forecastle; an interior space built into the bows of some ships.

Foreward
Towards the bow or the front of the ship.

Galley
The kitchen.

Gross tons
The total interior volume of a vessel (in cubic feet) divided by 100.

Hatch
An opening in the deck, usually referred to as the opening to a cargo hold.

Hatchcombing
The raised sides of the hatch that are above deck.

Hatchcover
The covering of the hatch; on older ships beams are fitted across the open hatch, hatchboards are placed on the beams and a tarpaulin is secured over the boards to seal the hatch.

Hawsepipe
The hole in the hull through which the anchor and chain are lowered. May also refer to holes through which mooring lines pass.

Hold
The area in which cargo is placed.

Keel
Timbers or plates extending along the centerline at the bottom of a vessel.

Kingposts
Two masts joined at the top to provide greater strength for hoisting cargo.

Ladder
A stairway on large vessels, but may also refer to an actual ladder.

Lay-up slip
A dock used to store ships when they are not being used for a long period of time.

Lazaret
Horizontal cabinets on deck used to stow gear.

Loran
A navigation system employing shorebased radio signals utilized by the navigator to determine his ship's position.

Net tons
Gross tons less all the noncargo spaces.

Packet boats
Small boats used early in the century to provide (usually) coastal or river cargo and passenger transport.

Pilothouse
Same as wheelhouse; an enclosed space that includes the bridge and usually the chart and radio rooms.

Plumb bow
A vertical bow used on ships late in the nineteenth century and early in the twentieth century.

Port
Left or left side.

Range lights
Fixed lights on shore, one in front of the other which, when lined up, show the correct course for entering a channel.

INDEX

Ro-Ro vessel
Abbreviation for a roll on-roll off freighter on which the cargo is driven on and off.

Saloon
The dining room.

Starboard
Right or right side.

Stern
The aft end of the ship.

Supercargo
The individual on a freighter who is responsible for placement of the cargo.

Superstructure
The structural part of the vessel above deck containing cabins and the bridge.

'Tween decks
Decks in a cargo hold used to carry less bulky cargoes.

Tramp
A cargo vessel that operates on no scheduled routes but travels whenever and wherever her owner or agent finds her a cargo.